American Paintings and Related Pictures
in The Henry Francis du Pont Winterthur Museum

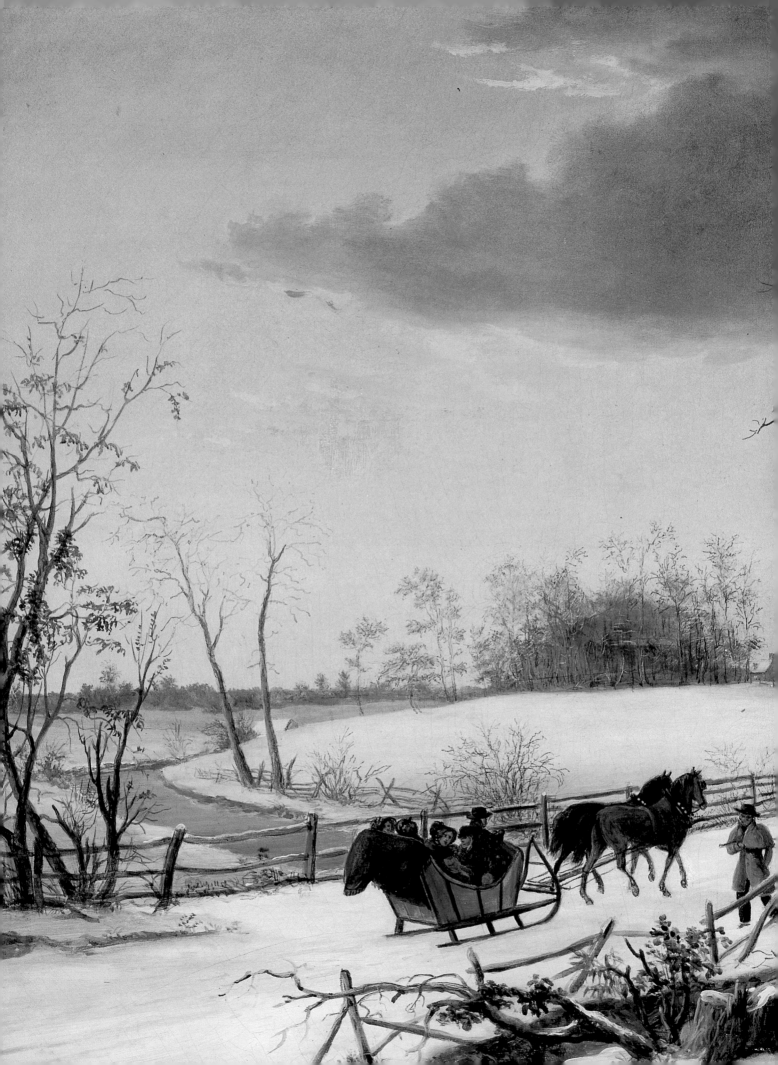

American Paintings and Related Pictures in The Henry Francis du Pont Winterthur Museum

Edgar P. Richardson

Published for The Henry Francis du Pont Winterthur Museum
by the University Press of Virginia, Charlottesville

Editors' Note: Edgar P. Richardson died March 27, 1985, following a long illness. We are indebted to E. McSherry Fowble for her assistance in preparing the manuscript for publication.

The Henry Francis du Pont Winterthur Museum
Winterthur, Delaware 19735

First published 1986

The University Press of Virginia

Library of Congress Cataloging-in-Publication Data
Henry Francis du Pont Winterthur Museum.
 American paintings and related pictures in the
Henry Francis du Pont Winterthur Museum.

 Bibliography: p.
 1. Painting, American—Catalogs. 2. Painting,
Colonial—United States—Catalogs. 3. Portraits,
American—Catalogs. 4. Portraits, Colonial—United
States—Catalogs. 5. Decorative arts—United States—
History—18th century—Catalogs. 6. Decorative arts—
United States—History—19th century—Catalogs.
7. Art—Delaware—Winterthur—Catalogs. 8. Henry
Francis du Pont Winterthur—Catalogs. I. Richardson,
Edgar Preston, 1902–85. II. Title.
ND207.H46 1986 759.14'074'01511 85-29505
ISBN 0-8139-1098-6
ISBN 0-8139-1099-4 (pbk.)

Printed in Japan

CONTENTS

FOREWORD

Henry Francis du Pont's interest in the work of colonial limners began well before James Thomas Flexner raised national awareness of the validity of painting in America and gave it the status of art with the publication of *America's Old Masters* (1939) and *First Flowers of Our Wilderness, American Painting* (1947). His interest had been piqued even before Alan Burroughs wrote *Limners and Likenesses: Three Centuries of American Painting* (1936) or Louisa Dresser completed *Seventeenth-Century Painting in New England* (1935). Beginning a decade earlier, H. F. du Pont had considered paintings to be an integral part of the room settings in which he arranged what has been long recognized as the largest, richest collection of American decorative arts yet assembled.

From the outset, du Pont's collection of painting subjects and media was catholic. While he collected only furniture produced by American craftsmen, he was quick to recognize that colonial and early republican households from north to south, belonging to yeomen or to merchants and planters, were likely to include imported items of accessory and decoration. Over the years the examination of countless inventories has revealed the use of English and Continental ceramics, glass, and metals as well as prints and maps published in Europe. And newspaper advertisements from the first years of the eighteenth century have documented an ever-growing market in imported pictures, both printed and painted, to complement the native product.

Until his house was opened as a museum in 1951, du Pont alone chose and hung each painting with a critical eye to its color, texture, style, and geographical and historical reference. Often before a particular painting was actually purchased, he had decided in which area it was to be displayed and had satisfied his extraordinary sensibilities as to its appropriateness to surrounding furnishings.

On occasion, he deliberately planned to acquire one painting, knowing full well that he needed another of equal quality to balance or complete a room installation. As an example, on February 3, 1930, he wrote to a southern dealer: "I have decided to keep the picture. . . . As it fits a certain place I would be foolish to let it go by. I am looking for another picture just that size and shape, and if you should come across one, will you be good enough to let me know."[1]

Among du Pont's earliest acquisitions was an oil-on-wood overmantel painting of a great country house with garden, waterfront, neighboring estate, and distant cities. Then believed to be an actual view of a colonial plantation, the panel subsequently was matched to woodwork from Morattico in Virginia. Several years later, in 1930, du Pont purchased the monumental group portrait *Audience Given by the Trustees of Georgia,* painted by London artist William Verelst in 1734/35 to honor the visit of James Oglethorpe and a group of American Indians. Benjamin West's group composition *American Commissioners of the Preliminary Peace Negotiations with Great Britain,* painted between 1783 and 1784, was acquired from the J. P. Morgan collection in 1948. The elegant portraits of Capt. John Purves and his wife, Eliza Ann Pritchard, and of Mrs. William Mills (Rebecca Pritchard) and her daughter Eliza Shrewsbury, both by colonial artists working in the South, were purchased in 1930. These were followed by the acquisition of portraits by Hudson River and New England limners as well as the stylish portraits of William Hall and his brother David

1. H. F. du Pont to Miss Eunice Chambers, Hartsville, S.C., February 3, 1930, du Pont Correspondence, Registrar's Office, Winterthur.

Hall painted by William Williams, Sr., and the theatrical *Gentleman and Lady in a Landscape* by William Williams, Jr.

The collection of paintings pertaining to America grew as particularly interesting works came to du Pont's attention or as family portraits passed into his care. Maintaining the rule of thumb that objects would be acquired only for permanent exhibition, du Pont imposed the same terminal date of 1840 on the paintings collection that he had established for the decorative arts collection. By 1951 the Winterthur paintings collection included Frederick Kemmelmeyer's *General George Washington Reviewing the Western Army at Fort Cumberland, the 18th of October 1794* and Thomas Serres's *Forcing of the Hudson River Passage,* as well as a set of six paintings of naval battles of the War of 1812, painted by French artist Louis Garneray from engravings.

With the opening of Winterthur Museum to the public in 1951, du Pont turned to a professional staff for assistance and consultation. In succeeding years the museum's paintings were studied, catalogued, and evaluated not only as appropriate accoutrements for individual rooms but also as documents of American art. Each was critiqued as representative of major developments in style and regional variation. Important artists or schools not already represented were noted as a focus for future acquisition.

By June 1961, du Pont had decided to purchase John Trumbull's *Washington at Verplanck's Point* from M. Knoedler Galleries. A favorite of Martha Washington's, the painting had hung at Mount Vernon and later was passed through four generations of her descendants. In January 1962, Edgar Preston Richardson succeeded Charles F. Montgomery, the latter an outstanding authority on American furniture and furnishings, as director of Winterthur Museum. Previously, as director of the Detroit Institute of Art, editor of the *Art Quarterly,* and author of *Painting in America* (1956), Richardson's reputa-

tion as the leading scholar in American art was widely acknowledged. Richardson at once congratulated du Pont on his acquisition of the Trumbull *Washington.* In succeeding years Richardson worked closely with du Pont and the curatorial staff in strengthening the paintings collection through the acquisition of such great works as Charles Willson Peale's *Edward Lloyd Family,* Gilbert Stuart's portrait of Mrs. Perez Morton, John Singleton Copley's portrait of Mrs. Roger Morris (Mary Philipse), and a nostalgic recollection, *A View on the Susquehanna River,* believed to have been painted by West in London circa 1767. Yet, less than a year before H. F. du Pont's death in April 1969, Richardson wrote to him of his conviction that Trumbull's *Washington at Verplanck's Point* was "one of the great portraits in the minds of all who see it," a fitting salute to a renowned collector from a first-rank scholar.

Richardson retired to study and write in 1966, but he remained as a consultant to du Pont and continued to counsel museum staff whenever a painting came up for consideration. In 1968 he enthusiastically encouraged the purchase of Nicolino Calyo's gouache-on-paper *Harlem, the Country House of Dr. Edmondson,* painted in Baltimore about 1834. The last painting purchased before du Pont's death, this gouache of a house with sculpture garden, flower gardens, and orangeries on the outskirts of Baltimore is in many respects a tribute to a long tradition of the art collector–horticulturalist that had flourished in America since the eighteenth century, a tradition of which du Pont was so remarkably representative.

In the years since 1969 the Winterthur collection of paintings has grown through purchases and through the generosity of donors, some close friends of H. F. du Pont, and others who recognize that this numerically small collection of paintings contains some of the great pictorial monuments to life in America before 1840.

E. McSherry Fowble

PREFACE

Before it became a public museum, Winterthur was the country house of one branch of the du Pont family. The paintings that hang in it have the character of both the possessions found in an old family home and the works of art purchased by a great collector, one who, although not primarily interested in painting, showed flair in whatever he acquired.

Henry Francis du Pont (1880–1969), the collector, is difficult to describe. Busy with his farm and prize-winning dairy herd and with developing his gardens, he thought of himself, I believe, as a country gentleman living in an old-fashioned way on the estate he had inherited. Singularly inarticulate in words, he was a man of great energy and remarkable visual sensibility and memory.

Walking in his gardens, du Pont would notice among his azaleas a blossom of a different hue from any other among thousands of blooms, and he would propagate that special plant. In a booth at an antiques show, among a bewildering display of gaudy Dutch dishes, he would spot one that seemed to him unlike any that he owned, buy it, and be proved right. As is often the case among collectors of decorative art and furniture, he had little interest in painting per se, and the frame might mean more to him than the painted image. But an educated eye guided him: he sensed quality,

and a feeling for history was bred in him. He knew his way among picture dealers, and, although he did not search them out as he did country antiques dealers, they would bring paintings to his attention.

H. F. du Pont began collecting at a time when few others were interested in the American material he searched for, and thus he had great opportunities. On the shores of the Delaware River and Chesapeake Bay, beautiful eighteenth-century houses were being demolished, their furniture and panelings available for purchase. His courtesy to dealers was also a great asset in collecting. If the humblest "picker" came late in the day to Winterthur with something to show du Pont, he would be given dinner and entertained overnight. As a result, du Pont was many times given first sight of a new discovery. His opportunities were of a kind that will never recur.

The collection of paintings that adds vitality to the rooms of the Henry Francis du Pont Winterthur Museum does not provide a systematic review of art in America before 1800. It does contain notable works by major artists, portraits of great historical importance, and many pleasant surprises. The selection in this book was made to illustrate the collection's interest and its charm.

EDGAR P. RICHARDSON

PART ONE
The Family Connection

[Artist unknown, probably French]

1. Pierre Samuel du Pont de Nemours as a Child (ca. 1743)

[Artist unknown, probably French]

2. Pierre Samuel du Pont de Nemours with the Bust of Turgot (1790–91)

Pierre Samuel du Pont de Nemours (1739–1817) was the founder of the du Pont family in America. An economist, a disciple of the finance minister to Louis XVI, Anne-Robert-Jacques Turgot, an assistant in Turgot's forlorn effort to reform the finances of the French monarchy, a diplomat used by Louis's foreign minister Charles Gravier, count of Vergennes, to negotiate peace with England in 1783, a journalist who spoke with great courage on public issues, and a moderate who opposed both the Jacobins and Napoleon, du Pont de Nemours had a distinguished career in France before coming to the New World. After being twice imprisoned (escaping by a hairbreadth execution or exile to Guyana) and having his printing plant twice wrecked by mobs, in 1799 he immigrated with his family to the United States, where his son Victor had already lived for some years as French consul in Charleston and New York. In 1802, the year his son Eleuthère Irénée founded the powder mill in Wilmington, Delaware, which was to become a giant chemical business, Pierre Samuel du Pont returned to France. There, he and Robert Livingston, the American minister to France, negotiated the Louisiana Purchase for President Jefferson. Du Pont refused to take any part in Napoleon's government, but he was active in the Institut de France and in the chamber of commerce of Paris. After Napoleon fell from power, Pierre Samuel du Pont served as secretary of the provisional government that recalled Louis XVIII. When Napolean came back to France from Elba in 1815, du Pont returned to the United States and to his sons in Wilmington, where he died in 1817.

Intelligent, liberal, and idealistic, a prolific writer, a convinced democrat, and a friend of Jefferson, du Pont left a legacy to both America and France. Regarding his homeland and himself, he wrote of the portrait of himself as a child:

> Vous le voyer, dis sa plus tendre enfance,
> De fragiles chateaux l'occupaient tout entier.
> Il travailla depuis au bonheur de la France:
> Ce n'est pas changer de metier.

The Winterthur collection owns two portraits of Pierre Samuel du Pont. One shows him as a child building a house of cards (no. 1), which he later called a symbol of his life. The other shows him as a mature man, engaged in writing (no. 2). He is seated beneath a bust of Turgot by Houdon, a cast of which he gave to the American Philosophical Society, where it may be seen today. The portraits are of a kind commonly painted in the eighteenth century. They provided a family record for those who could afford them but who were not patrons of the painters serving the court and the world of fashion.

Pierre Samuel du Pont as a Child
Oil on canvas; 24¼ × 21 in.
Unsigned.
Provenance: Probably Evelina du Pont Bidermann; Henry A. du Pont; H. F. du Pont.
Acc. no. 61.1744.

Pierre Samuel du Pont
Oil on canvas; 47⅛ × 40¹⁄₁₆ in.
Unsigned.
Provenance: Evelina du Pont Bidermann; Henry A. du Pont; H. F. du Pont.
Acc. no. 60.502.
Reference: Jolly (1977), *Du Pont de Nemours,* for the best account of P. S. du Pont's career in France.

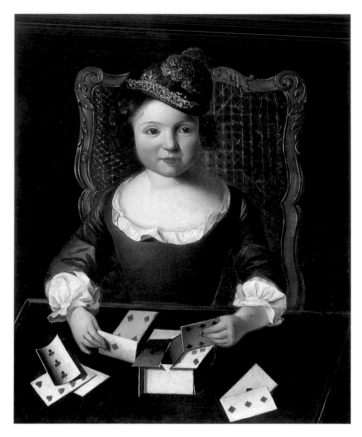

1

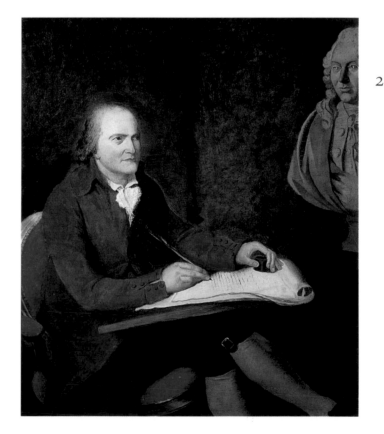

2

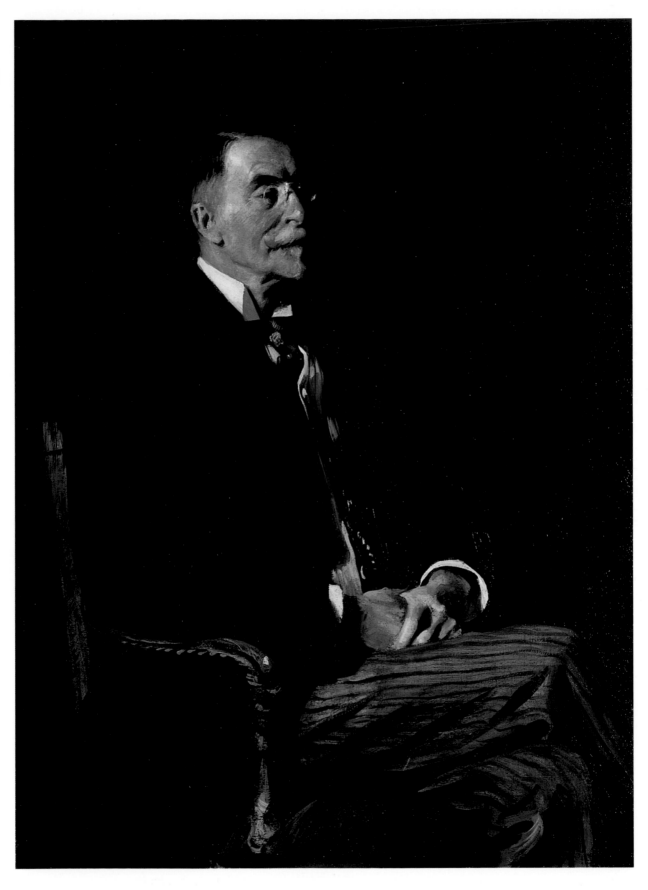

ELLEN EMMET RAND (1875–1941)

3. Henry Algernon du Pont (1906)

ELLEN EMMET RAND

4. Henry Francis du Pont (1914)

ANDREW WYETH (b. 1917)

5. Henry Francis du Pont (1950–51)

AARON SHIKLER (b. 1922)

6. Henry Francis du Pont (1965)

Henry Francis du Pont, creator of Winterthur Museum and its collections, was born in 1880. He was the son and grandson of men who were both graduates of West Point and officers in the regular army. His grandfather Henry, who was promoted to general in 1861, served for almost forty years as head of the du Pont family company, America's largest manufacturer of black powder. His father, Henry A. (1838–1926), had commanded a battery of regular artillery in the Civil War and served so brilliantly at the battle of Cedar Creek that he was awarded the Medal of Honor. Henry A. du Pont was later a member of the board of the Du Pont Company, a United States senator from Delaware, and patriarch of the family. He had his portrait painted by Ellen Emmet Rand in 1906, when he was sixty-eight. Although he is shown seated and in civilian dress, his military background comes through clearly in the stiff, authoritative set of his head. H. F. du Pont did not follow his grandfather and father into the army, yet something of the system and careful planning of military life was nevertheless in his character. A graduate of Harvard (1903) and a lifelong member of the board of the Du Pont Company, he lived as a country gentleman at Winterthur, devoting his energies to his three great passions: the farm, the gardens, and the collections.

Ellen Emmet Rand painted H. F. du Pont when, at age thirty-four, he was managing the family estate that he would later inherit from his father. Rand, a friend of H. F. du Pont, was the best known of the four gifted Emmet sisters, a woman of great social charm, and a portrait painter of talent and sensibility. She painted a most successful likeness; it shows her subject to be handsome, well groomed, and urbane—a gentleman, privi-

leged to live a life of dignified elegance in the world as it was before World War I.

When H. F. du Pont was seventy, his wife decided that his portrait should be done again. She chose as painter her friend Andrew Wyeth, who lived a few miles up the Brandywine Creek from Winterthur. Wyeth did not consider himself a portraitist but had done an imaginative and evocative study of Margaret Handy, a local physician who had cared for the Wyeth children. To understand his new subject, Wyeth began by carefully exploring the Winterthur house (just then being turned into a museum). Struck by the sense of lift in the tall, narrow building, he posed H. F. du Pont on a staircase and painted him on a tall, narrow canvas.

The two men, young and old, got on well together. Wyeth found du Pont to be a great personality but one who never really posed; too talkative, too nervous, too busy, he could sit for the artist only in brief snatches of time. Looking back in 1980, Wyeth wished that he had given his subject the intense, close scrutiny of the head that he has given to other portraits since. Yet a strong presence emerges from the picture. In the thirty-six years following the Rand portrait, H. F. du Pont had grown into a formidable, driving personality; a leader in three major fields—dairy farming, horticulture, and the collecting of American decorative arts; and a man with a passion for careful planning, a sensitive eye, and an acute visual memory. Wyeth's portrait evokes a person of large scale, seen in his home among his collections.

Aaron Shikler painted H. F. du Pont four years before du Pont's death, at the age of eighty-five. Shikler's subject was an older, a quieter, and a gentler man than was seen in the earlier portraits, but he was still enormously active. Shikler posed him

in his new conservatory among his flowers in the house to which he and his wife had moved when the museum opened to the public. He stands in a most characteristic attitude, his head a little bent, and is dressed in the loose country tweeds of the sand colors he always favored. Shikler captured less of the driving personality that Wyeth painted, showing instead the old man whose informal country appearance has been remembered by friends and colleagues.

Rand (Henry Algernon)
 Oil on canvas; 47¾ × 35⅛ in.
 Signed at upper right "Ellen Emmet / 1906."
 Acc. no. 64.1190.

Rand (Henry Francis)
 Oil on canvas; 55¼ × 31½ in.
 Signed at upper left "Ellen Emmet Rand / 1914."
 Acc. no. 59.2623.
 Reference: Hoppin (1982), *The Emmets,*
 pp. 30–38.

Wyeth
 Tempera on composition board; 47⅞ × 24¼ in.
 Signed at right in script "Andrew Wyeth."
 Acc. no. 64.1191.

Shikler
 Oil on canvas; 49¼ × 36 in.
 Signed at lower left "Shikler '65."
 Acc. no. 70.561.

4

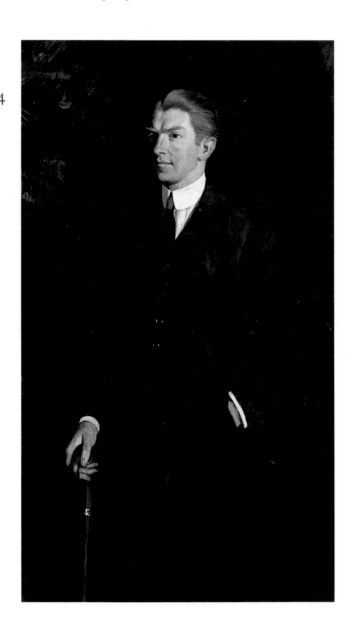

5

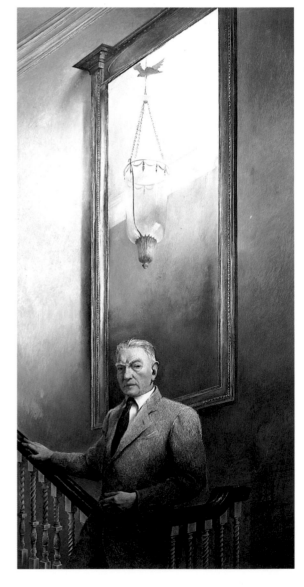

6

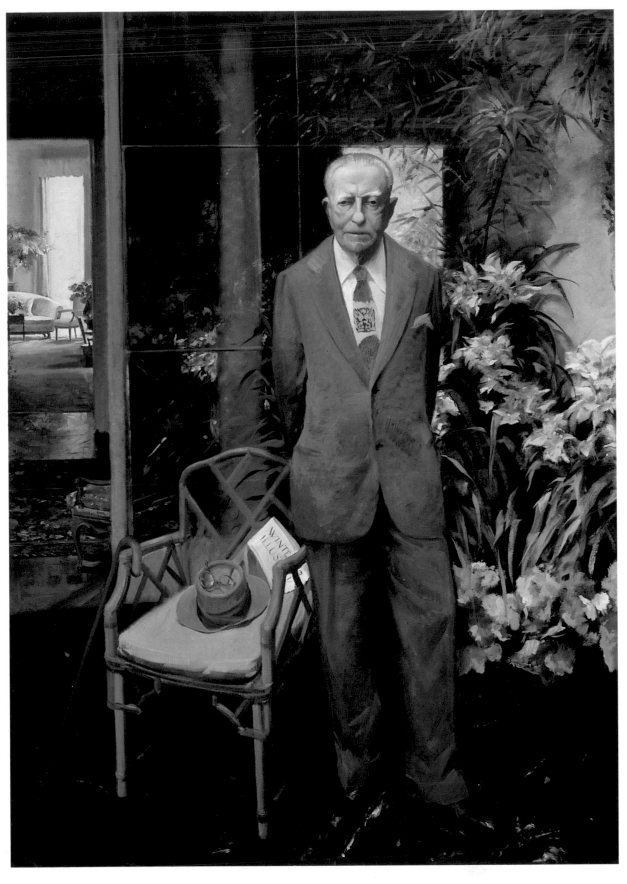

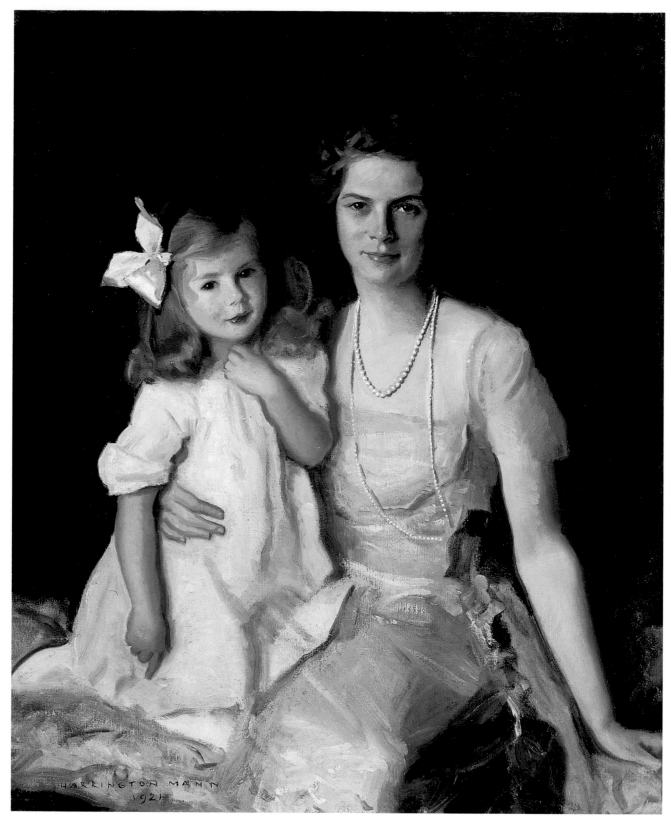

HARRINGTON MANN (1864–1937)

7. Mrs. Henry Francis du Pont (Ruth Wales) and Her Daughter Pauline Louise (1921)

Ruth Wales of New York City married Henry Francis du Pont on June 24, 1916, and became the witty, gracious hostess in a house where guests from all over the world were entertained in the opulent style of pre–World War I America. She once remarked that no more than half of these visitors were friends she and her husband had invited; the additional guests came at the request of others—the State Department, the Du Pont Company, and the United Nations. Two daughters were born to the couple, Pauline Louise (Mrs. Alfred C. Harrison) and Ruth Ellen (Mrs. du Pont Lord).

Harrington Mann, of Scottish origin, worked primarily in England but visited the United States often, where he painted many leaders of American society.

Oil on canvas; 38 × 31 in.
Signed at lower left "HARRINGTON MANN / 1921."
Acc. no. 70.560.

8

ANDREW WYETH (b. 1917)

8. Quaker Ladies (1956)

To observe some very small part of nature with great intensity and affection is one eloquent characteristic of Andrew Wyeth's art. This study of *Houstonia caerulea,* the small bluish white flower known commonly as quaker-ladies, exemplifies his approach. It is executed with all the delicacy and freedom of his watercolor style and is an exquisite example of the poetry of nature in his work. We can easily understand why H. F. du Pont, catching sight of the picture in the back of Wyeth's car, at once wanted it.

Dry brush watercolor on paper; 13½ × 22 in.
Signed at lower right "Andrew Wyeth."
Provenance: The artist; H. F. du Pont.
Acc. no. 70.916.
Reference: London, Royal Academy of Arts (1980), *Andrew Wyeth,* no. 10.

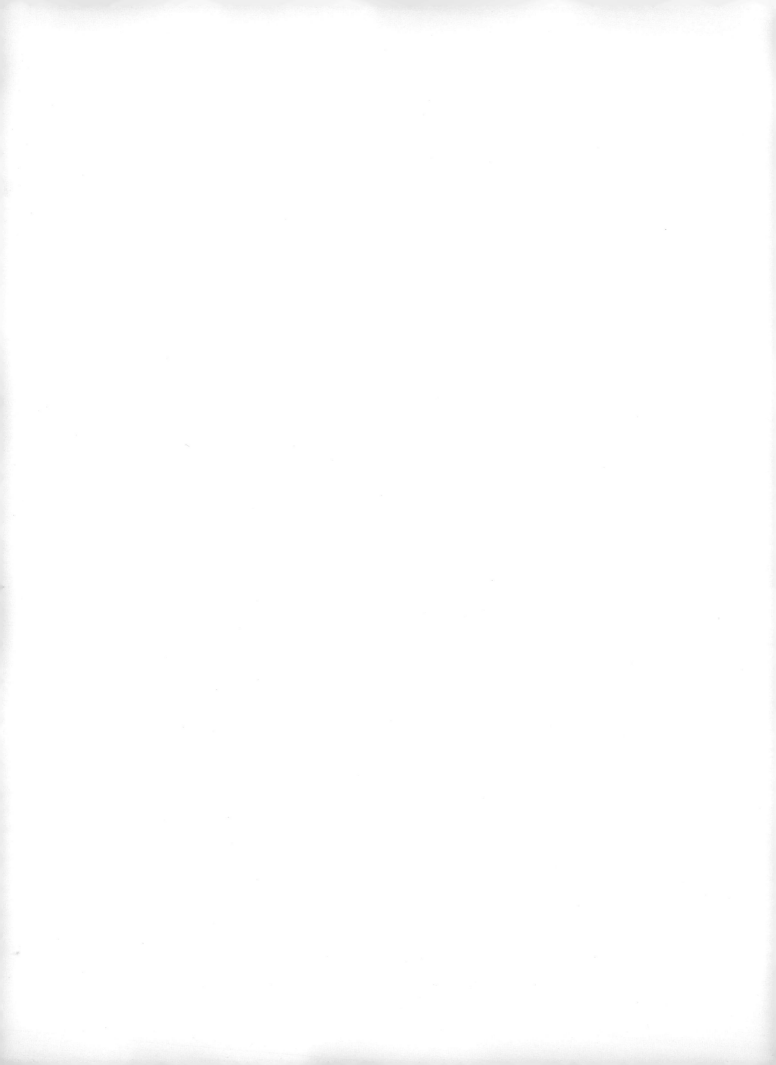

PART TWO

The American School to 1776

GERRET DUYCKINCK (1660–1710)

9. A Woman (1690–1710)

Although Gerret Duyckinck has long been known from New York City records as an artisan, no paintings were attributed to him by scholars until early in this century. Gerret's father, Evert Duyckinck, the first of the Duyckinck family in America, was born in Holland and came to New Amsterdam (New York City) in 1638. Evert is documented as a limner and glazier who made painted glass windows for churches and private homes. Gerret, his youngest son, was baptized into the Dutch church at New Amsterdam in 1660. In 1679 Gerret was referred to as a *schilder* (painter), and in 1698/99 he was called a limner. In 1921 a painting in the New-York Historical Society, which has every appearance of being a self-portrait, was attributed to him by John Hill Morgan. Around that picture a group of related works has gradually been assembled to form the oeuvre of Gerret Duyckinck. The picture reproduced here is one example.

Gerret Duyckinck was a prominent citizen of New Amsterdam, and, as one might expect of an artist in a seaport city, his work is more sophisticated than that of the painters in the Dutch tradition working around Albany. He followed as best he could the realistic style of painting practiced in the Duyckinck family's homeland. The young woman in this portrait, for instance, is painted with the softened contours and rich modeling of the Dutch tradition. She is elegantly dressed in silk and lace, wears a coral necklace and earrings, and holds a Chinese fan. Over the table beside her is spread a Turkish rug. Such evidence of wealth and luxury, like the relative sophistication of the painting itself, speaks for the subject's position in a growing colonial metropolis that was in touch with international taste and markets.

Oil on wood panel; 31½ × 24¼ in.
Unsigned.
Acc. no. 56.565.
References: Morgan (1921), *Early American Painters*, pp. 19, 30–31; Belknap (1959), *American Colonial Painting*, pp. 107–11, pl. 60, no. 4.

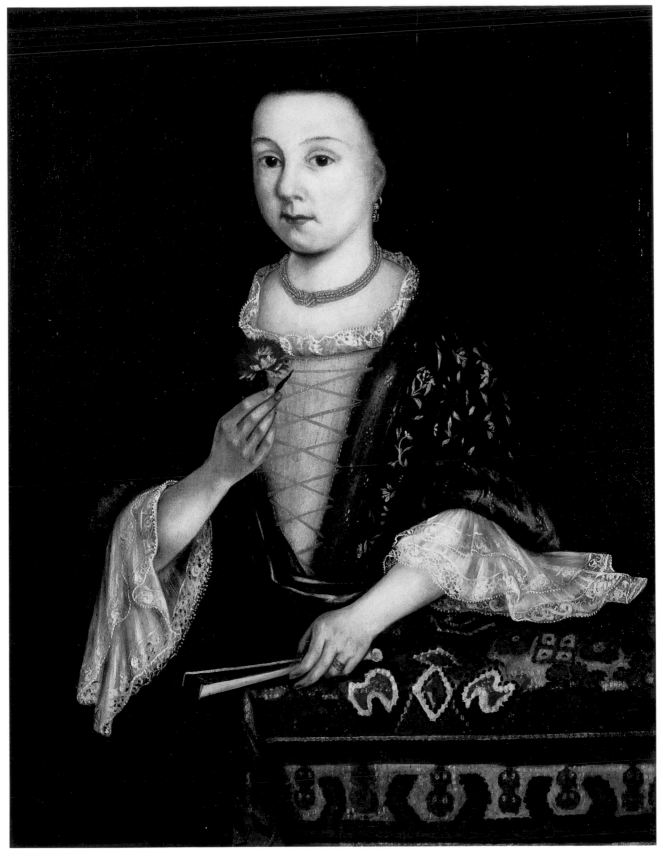

[Artist unknown]

10. Overmantel painting (ca. 1720)

Henry Francis du Pont bought this oil-on-wood overmantel painting by itself in the 1920s, and for several years it hung in a room at Winterthur filled with late seventeenth- and early eighteenth-century furniture. Then, in 1938, du Pont purchased paneling from a building in Richmond County, Virginia, and his architect, Thomas Tileston Waterman, soon realized that the overmantel painting had originally formed a part of the newly acquired paneling. Upon Waterman's advice, du Pont reinserted the painting in the paneling for an installation in Winterthur's northeastern wing.

In his *Mansions of Virginia, 1706–1776*, Waterman describes the paneling and its first home. Known as Morattico, the building was located on Hale's Point along the Rappahannock River and was probably the last remaining wing of a Georgian mansion. It was further believed in H. F. du Pont's time that the large building at the extreme right of the painting represented an actual American structure. Waterman accordingly suggests in his book that, although Morattico itself was apparently of too plain a style to be the structure in the painting, other Virginia mansions such as Rippon Hall of York County may have inspired the impressive image.

Later scholars have not shared Waterman's high estimation of colonial architecture. John Harris, in *The Artist and the Country House,* states that nothing in early eighteenth-century America could have come close to the mansion in the painting. He therefore concludes that it represents an English building, specifically the now-destroyed ancestral home of Frances Jennings Grymes, wife of Charles Grymes, first owner of Morattico. However, Harris's theory implies that the painting was done in England and then sent to America. This scenario could not be accurate, since a heavy buildup of the original pigments along the adjacent molding indicates that the painting was done after the panel

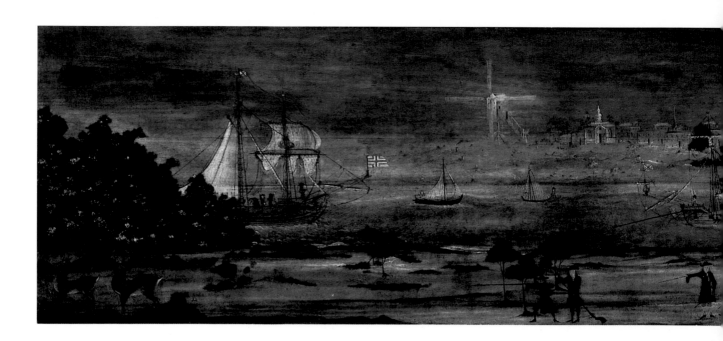

had been installed in its American location.

Most likely, then, the mansion depicts no structure ever built but was simply the artist's invention. From English engraved views or architectural guides the artist could readily have concocted the grandiose structure, its facade covered with colonnades and its wings capped with vaguely Jacobean cupolas. The use of grisaille—shades of gray—in depicting the buildings in the background further suggests that prints were the source of this architectural fantasy.

No imagination, however, was needed to paint the building's surroundings; there we see typical scenes of life in colonial Virginia. The men in the foreground, some of the ambitious planters who constituted the wealthiest level of Virginia's society, hunt deer in what, on an English estate, would have been a carefully conserved deer park, but in the New World was the still-rich natural setting. Beyond them runs one of the many rivers that connected the sprawling plantations of Tidewater Virginia, busy with ships bringing merchandise from England and the northern colonies or departing with cargoes of tobacco. Taken together, the imaginary mansion and village and their true-to-life surroundings indicate not only the planters' gentlemanly pastimes and geographical advantages but also the material aspirations, still dictated by English fashion, of this increasingly powerful class.

Oil on wood; 20 1/16 × 91 3/4 in.
Unsigned.
Provenance: Morattico, Hale's Point, Richmond County, Va.
Acc. no. 69.1985.
References: Waterman (1945), *Mansions of Virginia,* pp. 62–65; Harris (1979), *Artist and the Country House,* p. 147; Kaynor (1985), "Thomas Tileston Waterman."

10

Among the Dutch along the Hudson River

[Artist unknown]

11. Mrs. Harme Gansevoort (Magdalena Douw) (ca. 1740)

PIETER VANDERLYN (1687–1778)

12. Adam Winne (1730)

JOHN WATSON (1685–1768)

13. Edward Collins (ca. 1740)

[Artist unknown]

14. The Annunciation (ca. 1730)

The Dutch merchants who were settling the Hudson River valley early in the seventeenth century soon saw the importance of the place where the Indian trail from Niagara to Massachusetts intersected the Hudson River. In 1614 the Dutch built a fort at this junction. A village named Beverwyck (Beavertown) grew up about it and prospered, in spite of disputes over authority between the Van Rensselaer patroons and the West India Company. When English rule came, Beverwyck was renamed Albany. By 1700 Albany and the settlements around it contained a few hundred freeholders who formed an enclave surrounded by Indian country. War was always near. The French to the north, ready either to make war against the settlers or to trade with them for European goods through Indian intermediaries, were always a danger to the peace of the region. With the Iroquois, however, Albany established good relations; it never suffered the fate of Schenectady, eighteen miles to the west, which was burned in 1690 by a raiding party from Canada. The island of Dutch settlement in the forest was a tight, self-enclosed community that clung to its Dutch ways. English influence, in fact, did not become strong until about 1750. Its people were shrewd, tough merchants or farmers who spoke Dutch and went to churches where the Bible was read in Dutch and sermons delivered in Dutch.

For a period of some thirty years, roughly from the end of Queen Anne's War in 1713 to the outbreak of King George's War in 1744, these settlers commissioned scores of portraits. Household inventories and travelers' accounts from the eighteenth century bear witness to the abundance of paintings—scripture histories, genres, still lifes, landscapes, seascapes, town views, as well as portraits—in Dutch homes in America just as in the Netherlands. Then, toward the end of the eighteenth century, these pictures fell out of fashion: Pierre Eugene Du Simitiére, artist, naturalist, antiquarian, and art collector in revolutionary America, spoke of them as being neglected in attics, to be picked up cheaply. Colonial Albany was a surprising place for such a sudden and brief flowering of painting. Winterthur is the only museum, aside from those along the Hudson River, where one can see a good representation of the work from this time by the painters of the Albany region.

The painters of this school were trained as artisans. They did not sign their works, and individual painters are only now beginning to be identified by name. They painted with bright colors and strong outlines, often inscribing the date and the age of the sitter on the face of the canvas in ornamental letters. The colors, if well preserved, are strong and gay. How these pictures must have enlivened the small, low-ceilinged, dark rooms of early eighteenth-century houses may be imagined. But these painters were not creating decorations only; often their portraits make a clear statement about a sitter's personality.

The portrait of Magdalena Douw conveys the freshness and grace of a young girl with colors that are bright and cheerful. Tradition holds that the picture was once rescued from a burning house, but Winterthur conservators have found no evidence of fire damage. Although repairs in the picture's structure can be detected by X ray, we may

assume that what we see at present approximates the original. The portrait was presumably painted shortly before Magdalena Douw (1718–96) married Harme Gansevoort (1712–1801) in 1740, to become the mother of seven children. In his study of the picture, Robert G. Wheeler related it to an anonymous painting, *The Marriage of Cana,* in the Albany Institute of History and Art.

Adam Winne, dated 1730, shows a gentle, dreamy child holding his tricorne hat under one arm and a branch of cherries in his hand. He wears a long, loose Steenkirk neckcloth, which preceded the style worn by Edward Collins (no. 13). On the basis of the handwriting inscribed on the canvas, *Adam Winne* and a group of similar portraits from the upper Hudson River have been attributed to Pieter Vanderlyn, grandfather of nineteenth-century artist John Vanderlyn. Pieter Vanderlyn was born in the Netherlands, migrating to America in 1718 from the Dutch colony of Curaçao. A number of portraits in his style, chiefly of children, were painted in Albany and Kingston between 1730 and 1745. All are in subdued color harmonies and are quiet in mood.

Edward Collins is a powerful statement—brilliant in color and evocative of a strong, rather grim personality. The subject's long, ruffled white tie dates the portrait as late in this school—near 1740—as the portrait of Magdalena Douw. John Watson, to whom the portrait of Edward Collins has been attributed, was a Scot who settled in Perth Amboy, the capital of East Jersey, in about 1714. Some miniature portraits in either India ink or plumbago (graphite pencil), which are perhaps the earliest done in America, are the only works surely by him. A number of life-size portraits in oil have also been atrributed to him. They represent government officials and Dutch and English merchants or landowners of the lower Hudson River. In style, these oil portraits more closely resemble those of the Albany region than the work of the Duyckincks in New York City (see no. 9).

The Annunciation, like almost all other biblical subjects by the painters of the Albany region, was based on an engraved prototype, although its pro-totype has not been identified. Such an elaborate composition showing figures in space was beyond the capacity of an artisan painter without the help that engravings supplied. Indeed, only thirty-eight scripture histories of this school are known today.

Mrs. Harme Gansevoort
Oil on canvas; 51$\frac{1}{16}$ × 33 in.
Unsigned.
Provenance: Leonard Gansevoort; Magdalena Gansevoort Ten Eyck; Maude Ten Eyck Gansevoort Griffiths.
Acc. no. 63.852.
References: Belknap (1959), *American Colonial Painting,* pl. 72, no. 4; Wheeler (1968), "Albany of Magdalena Douw"; Kenny (1969), *Gansevoorts of Albany.*

Adam Winne
Oil on canvas; 32 × 26½ in.
Unsigned.
Inscribed at lower right "Adam Winne / Ae 1730–."
Acc. no. 58.1146.
References: Belknap (1959), *American Colonial Painting,* pl. 72, no. 1; Black (1971), "Limners of the Upper Hudson," p. 239.

Edward Collins
Oil on canvas; 50 × 40 in.
Unsigned.
Provenance: Mrs. Dudley C. Lunt, Wilmington, Del.
Acc. no. 80.25.

The Annunciation
Oil on wood panel; 12⅝ × 15 in.
Unsigned.
Provenance: Probably from John Sanders, Scotia, N.Y., to John Sanders II; Mary Elizabeth Wilson; Anne and Jane Wilson, Germantown, N.Y.
Acc. no. 59.119.
References: Wheeler (1953), "Hudson Valley Religious Paintings"; Piwonka and Blackburn (1980), *Remnant in the Wilderness,* no. 17, p. 42.

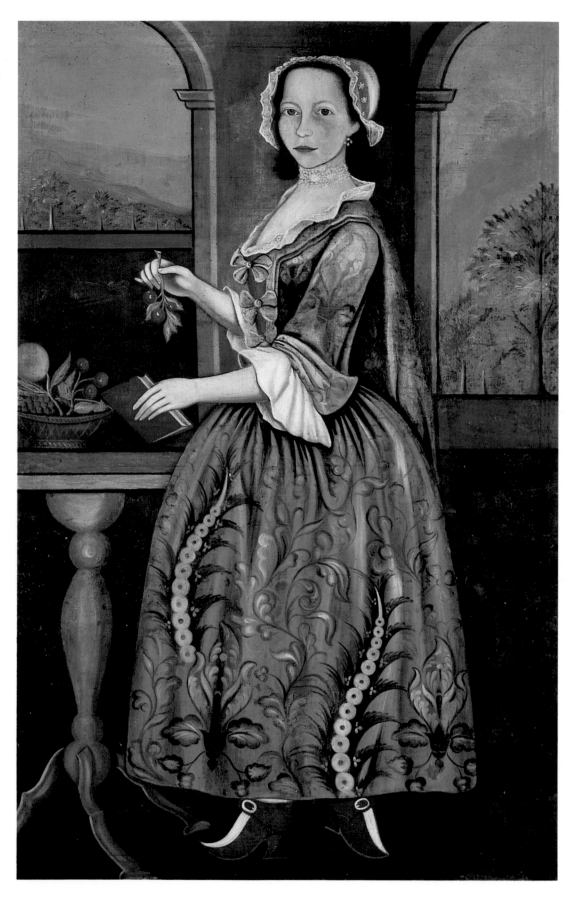

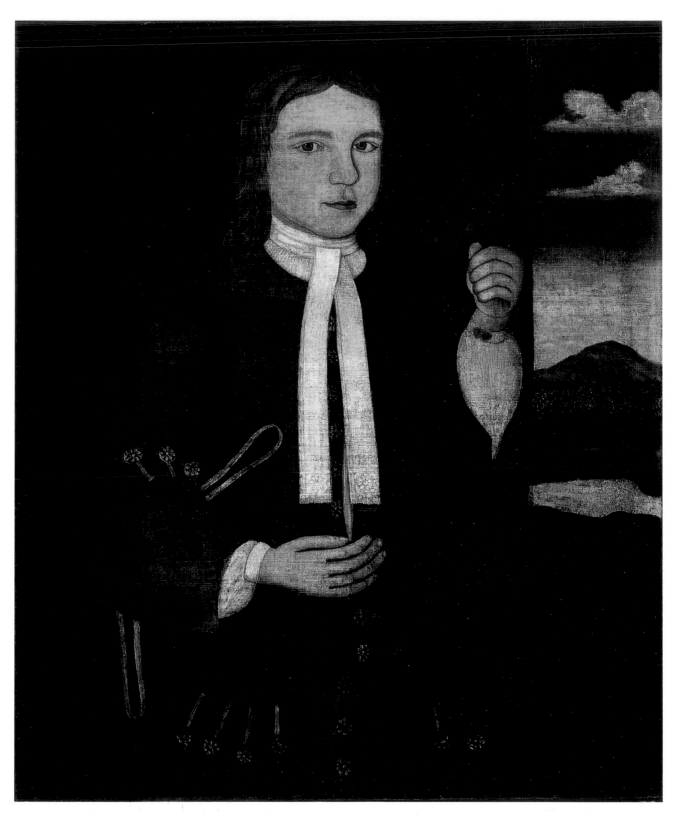

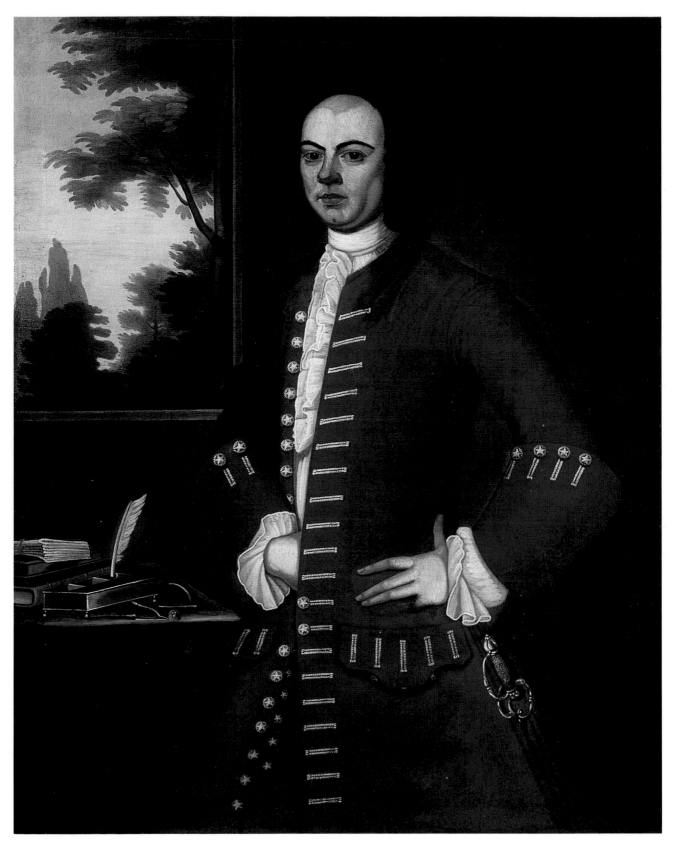

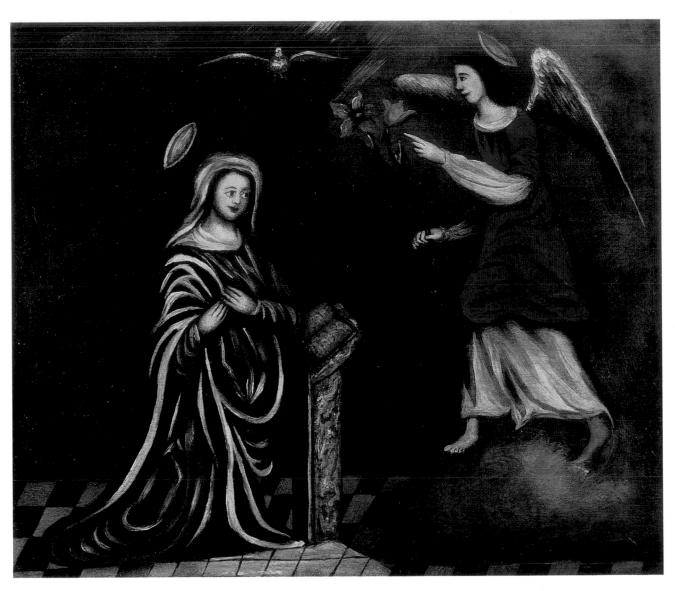

JOHN SMIBERT (1688–1751)

15. Mrs. Louis Boucher (Sarah Middlecott) (1730)

Although effective both as decoration and as a symbol of social position, this portrait shows little effort at individual characterization. Such an approach to portrait painting was perfected in England by Dutch-born Sir Godfrey Kneller (1646–1723), a prolific artist who was enormously successful in his day. His technique spread to New England through John Smibert, who arrived at Boston in 1729.

Born in Edinburgh on March 24, 1688, Smibert served his apprenticeship there as a house painter. In 1709 he went to London, where he earned his living as a coach painter and by copying pictures for dealers. After 1719, having saved enough money to go to Italy for three years in order to equip himself for a career as a portraitist, he spent nearly twelve months in Florence and six months in Rome, painted portraits at Livorno for a time, and returned to Rome. While in Italy, he struck up a friendship—which was to be of importance later in his life—with the brilliant young clergyman-philosopher George Berkeley. In 1722 Smibert was back in London, having brought with him a considerable number of pictures that he had bought in Florence (presumably for resale) and some copies of paintings in the Pitti Palace. For the next six years he was a busy and modestly successful portrait painter in London; but when Berkeley invited him to become part of a projected university at Bermuda, he accepted. Berkeley stopped at Newport to wait in vain for a grant from Parliament for the university, while Smibert went on to Boston, where he spent the rest of his life.

Smibert came to Boston at age forty-one, already past his prime by eighteenth-century standards. He established himself with a painting room, a gallery where hung his copies of paintings in the grand ducal collection at Florence, and a shop, selling colors, prints, frames, and the like. A similar collection had never before been seen in New England. Smibert's experiences in London and Italy also lent prestige to his work, and he was soon able to ask more than twice his price in London for a kit-cat size portrait—a portrait including the hands but less than half-length, named after the Kit-Cat Club of London because the club's dining room had a ceiling too low to accommodate standard half-length portraits of its members. As recorded in the artist's notebook, Smibert's career throve until 1745, when failing eyesight caused him to give up painting. He died in Boston in 1751.

Mrs. Boucher, born Sarah Middlecott, was the widow of Louis Boucher, a member of one of the French Huguenot refugee families—the Bowdoins, Reveres, and Bouchers—who played a large role in Boston life in the eighteenth century. Smibert painted Sarah Boucher in her widow's weeds in February 1730, early in his Boston career. The portrait appears in his notebook as "Mr. Cuninghams Mother," priced at forty pounds. The artist also had painted Mrs. Boucher's daughter, Ann, who was married to Nathaniel Cunningham, in November of the same year. Not a keenly perceptive artist (his clients often did not wish him to be), Smibert could nevertheless create a likeness and add to it magisterial dignity.

Oil on canvas; 51 × 40 in.
Unsigned.
Provenance: By descent to Alexander S. Porter; his son, Alexander Breese Porter; his widow, Mrs. Alexander Breese Porter; her son, Alexander B. Porter; Vose Galleries.
Purchased in part with funds given in memory of Mrs. Brooks Thayer.
Acc. no. 78.112.
References: Foote (1950), *John Smibert*, p. 135; Smibert (1969), *Notebook*, no. 33, p. 89.

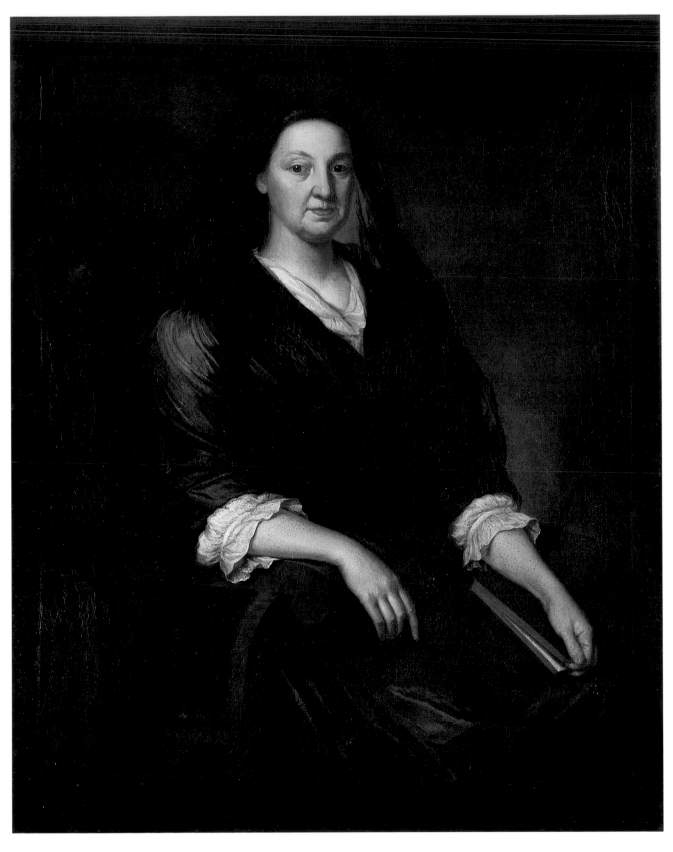

WILLIAM DERING (w. 1735–51)

16. Dr. John de Sequeyra (1745–49)

A Portuguese Sephardic Jew by origin, Dr. John de Sequeyra (1712–95) practiced medicine at Williamsburg, Virginia, from as early as 1745 to the time of his death. From 1773 to 1793 he was attending physician at the town's Hospital for the Reception of Idiots, Lunatics, and Persons of Insane or Disordered Minds (the earliest such hospital in America) and was a member of its board of directors from 1774. Sequeyra is remembered today largely for his connection with the history of the tomato. Originally considered just an ornamental fruit that could be given as a sign of affection, the tomato, or "love apple," was long thought poisonous. Sequeyra is said to have shown his neighbors that, far from causing death, tomatoes eaten regularly would help one lead a long and healthy life.

William Dering is first recorded as working in Philadelphia, where he advertised his dancing school in the *Pennsylvania Gazette* (April 10, 1735). Two years later he was advertising in Virginia, and in 1742 he bought a house in Williamsburg. Dering got along well with the planters who headed the colony's society. William Byrd of Westover noted in his diary that he showed his print collection to Dering (July 31, 1741), and Dering was often hired to supervise both public and private balls. At the same time, he added to his income by painting portraits. Only one work signed by him has survived, but nine other portraits of notable Virginians share certain characteristics with the signed example. The typical combination of almond-shaped eyes, a long thin nose, accentuated lips, and stiff drapery is perfectly demonstrated by the portrait of Sequeyra. Here the subject looks at us from within an ornate trompe l'oeil frame, with shelves of books as a backdrop. An array of symbolic objects lies on a painted shelf before the painted frame—an armorial shield for Sequeyra's ancestry, an inkwell and pen for his writings, and ancient and modern books for his learning.

Dering's two occupations were not enough to keep him solvent, his house and property being mortgaged soon after he bought them. He left his wife in Williamsburg when he moved to Charleston, South Carolina, in 1749. He is last heard of there in 1751, the same year that his wife seems to have auctioned off whatever property he had left behind in Williamsburg.

Oil on canvas; 23½ × 19⅜ in.
Unsigned.
Provenance: E. Randolph Braxton.
Acc. no. 56.568.
References: Blanton (1931), *Medicine in Virginia,* p. 321; Hood, *Charles Bridges and William Dering;* Sweeney, "Identification of Portrait."

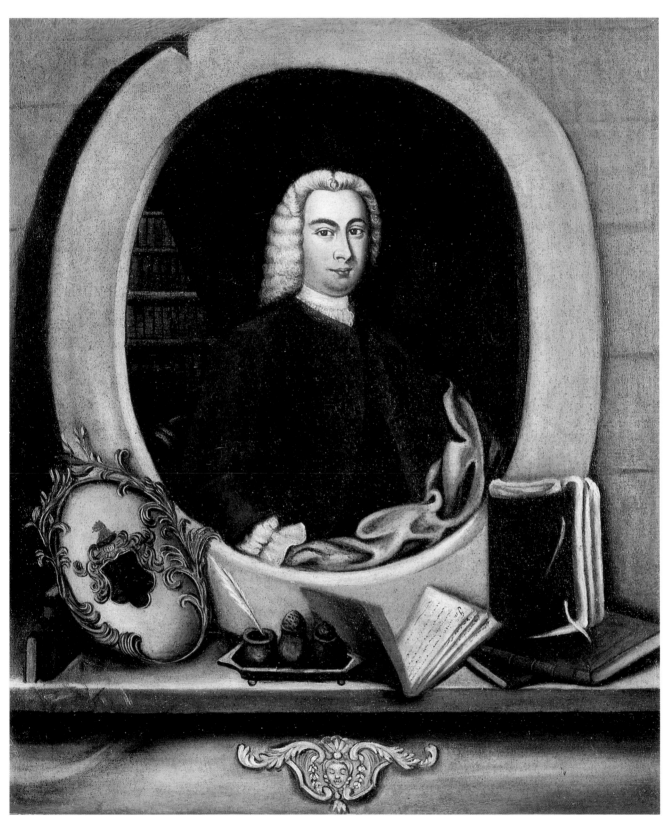

ROBERT FEKE (ca. 1707–ca. 1752)

17. Mrs. Charles Willing (Anne Shippen) (1746)

Mrs. Charles Willing (1710–91) was at the center of one of eighteenth-century Philadelphia's most influential families. Her father, Joseph Shippen, was a successful merchant, able to give his daughter an ample dowry. At the same time, Shippen was a man of scientific and intellectual interests and one of the original members of Benjamin Franklin's political and philosophical club, the Junto. One of Anne Willing's brothers was an officer of a Pennsylvania regiment in the French and Indian Wars, serving as lieutenant colonel under General Forbes in the capture of Fort Duquesne (Pittsburgh) and afterward becoming a much-respected secretary of the province. Mrs. Willing's husband, Charles, whom she married January 21, 1730, was one of the leading merchants of the city and twice mayor of Philadelphia (1748 and 1754). He died of ship fever, a form of typhus, which he contracted while inspecting a newly arrived vessel in 1754.

Almost all of Mrs. Willing's many children lived to maturity. Several married into other families of prominence; Mary, for example, became the wife of William Byrd of Westover, Virginia, and Elizabeth married Samuel Powel, last mayor of colonial Philadelphia and first mayor after independence. After Charles Willing's death, "Aunt Willing" lived in her house on Third Street, surrounded by sons, daughters, and nephews who built their own homes on Third and Fourth streets. Her house is no longer standing, but a great, handsome mirror that must have given her much pleasure survives from its furnishings in the home of one of her daughters, Mrs. Powel, a stone's throw down Third Street.

Anne Willing was thirty-six years old and the mother of seven children when her portrait was painted in 1746 by Robert Feke. Feke, like most of the itinerant artists who painted portraits before 1750 in the British colonies, is a mysterious figure.

An unproven tradition has it that he first went to sea and learned to paint while a captive in Spain. His known painting career lasted from 1741 to 1750. It is certain that Newport, Rhode Island, was his primary residence; that he worked in Boston, where John Smibert's portraits exerted a potent influence; and that he painted portraits in Philadelphia in 1746 and again in 1749–50. After 1750, he disappears; he is supposed to have died in the West Indies. The paradigm of his work was the portrait as an image of personal dignity and social status, as introduced to New England by Smibert. Feke's handsome image of Mrs. Willing tells us that she was the proud wife of an influential man and the matriarch of a distinguished family.

An almost identical portrait now owned by the Newark Museum depicts Mrs. Edward Shippen (Mary Gray Newland), wife of Mrs. Willing's brother. It was once attributed to Feke, but its incorrect proportions and unrealistic depiction of fabric have led scholars to believe that its composition was in fact copied from Feke by an unknown artist.

Oil on canvas; 50 × 40 in.
Signed at lower left "R. Feke Pinx / 1746."
Provenance: Thomas Willing; Thomas Mayne Willing; Dr. Charles Willing; Edward Shippen Willing, Lady Ribblesdale; Vincent Astor; E. Shippen Willing, Jr.
Gift of Mr. and Mrs. Alfred E. Bissell in memory of Henry Francis du Pont.
Acc. no. 69.134.
References: T. Balch (1855), *Papers Relating to Pennsylvania;* Wharton (1900), *Salons Colonial and Republican;* Foote (1930), *Robert Feke;* Mooz (1970), "Art of Robert Feke"; Klein (1975), *Early American Family;* Newark Museum (1981), *American Art in the Newark Museum,* p. 292.

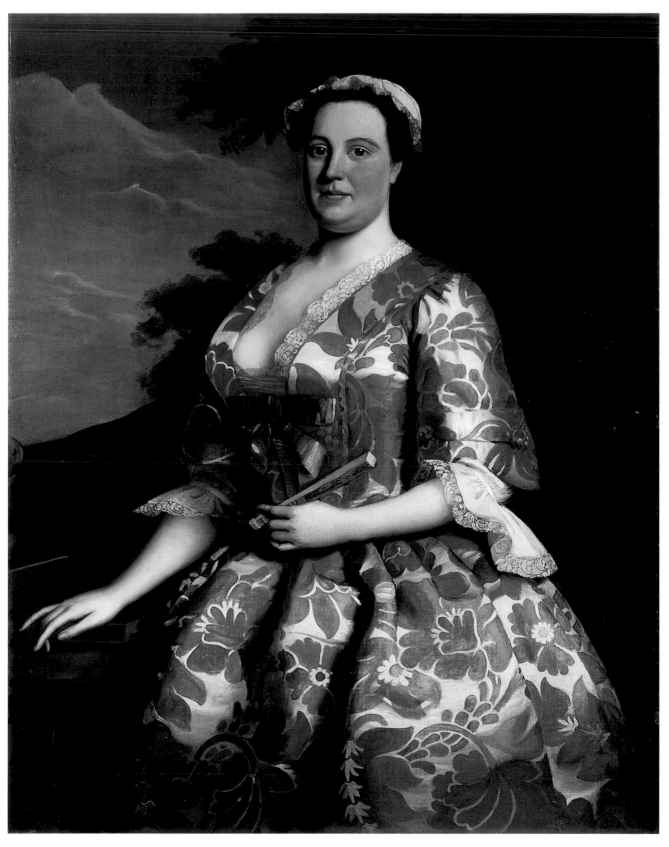

JOHN WOLLASTON (ca. 1710–after 1767)

18. Mrs. Samuel Gouverneur (Experience Johnson) (ca. 1750)

John Wollaston probably arrived in America shortly after the long War of the Austrian Succession had been brought to an end by the Treaty of Aix-la-Chapelle (October 1748) and before his first appearance in colonial records. Since, in the eighteenth century, a war at sea did not end until the warships and privateers had returned to port to learn of the peace, Wollaston could not have left England for America until 1749, by which time news of the peace had traveled and it was reasonably safe to sail the Atlantic. The first record of Wollaston's presence in New York City is in a court case involving two of the great political familes of the colony, the Clintons and the De Lanceys, who were traditional enemies. Governor Clinton wished to prosecute Oliver De Lancey, who had stabbed a man in a drunken brawl and had uttered words of "enormous scurrility" against Clinton, but it was hard to find a lawyer to prosecute a member of the powerful De Lancey family. Wollaston, a newcomer in the town, appeared in court as the governor's witness on July 1, 1749. That date is the unconventional beginning of one of the most prolific careers of any portrait painter in the American colonies.

Wollaston was the son of a lesser portrait painter of the same name and was most likely born about 1710. In London, he had been a moderately successful portraitist and a drapery painter, adding costumes to portraits executed by artists more gifted at depicting faces. In America, however, he was a novelty—a painter from London—and was much sought. Within less than ten years he painted approximately three hundred portraits, more than anyone else before the Revolution but Copley. That a painter whose skill lay in painting textiles rather than faces should enjoy such success implies an intense desire for portraits among the colonial gentry and the acceptance of the portrait more as a symbol of status than as a personal characterization.

Wollaston worked in and about New York City from 1749 to 1752 and then returned briefly to London. He was painting portraits in Annapolis and on the tidewater plantations of Chesapeake Bay in the mid 1750s and made a brief stop at Philadelphia on his way back to England in 1758.

He next went to India as a writer, or clerk, for the East India Company, serving as a magistrate in Calcutta. In 1767 he reappeared in Charleston, South Carolina, where he painted some twenty portraits before returning to England on May 31 of that year. Nothing is known of him thereafter.

The portrait of Mrs. Samuel Gouverneur (Experience Johnson), painted during the artist's first years in America, shows Wollaston at his imperfect best. The subject's erect pose is graceful; her pale blue satin dress, the basket of flowers she holds, and the moonlit landscape in the background are all pleasing. Her face, however, is an empty mask without emotion or individuality. So many of Wollaston's portraits have the fatuous expression and slanted, almond-shaped eyes seen here that these elements were once thought to be his own peculiar invention. But it is now well known that such an approach was used by several English portraitists of the 1740s and was probably first exploited by Thomas Hudson (1701–79). After Wollaston introduced the look to America, it was taken up by a few artists here and can be seen, for example, in young Benjamin West's portrait of Elizabeth Peel (1758, Pennsylvania Academy of the Fine Arts).

Experience Johnson (the traditional identification, which we may assume to be correct) was the daughter of Joseph and Mary Johnson of Newark, New Jersey. In 1750 she married Samuel Gouverneur, and this likeness was probably a marriage portrait. Her husband, a man of means, lived the life of a country gentleman on an estate called Mount Pleasant on the Passaic River north of Newark; he and Experience had eleven children.

Oil on canvas; 49^{15}/$_{16}$ × 40^{1}/$_{8}$ in.
Unsigned.
Provenance: C. K. Johnson, Greenwich, Conn.; H. F. du Pont (1930).
Acc. no. 61.701.
References: Walpole (1782), *Anecdotes of Painting,* 3:252–53; Stokes (1922), *Iconography of Manhattan Island,* 4:616; Groce (1952), "John Wollaston"; Craven (1975), "John Wollaston."

8

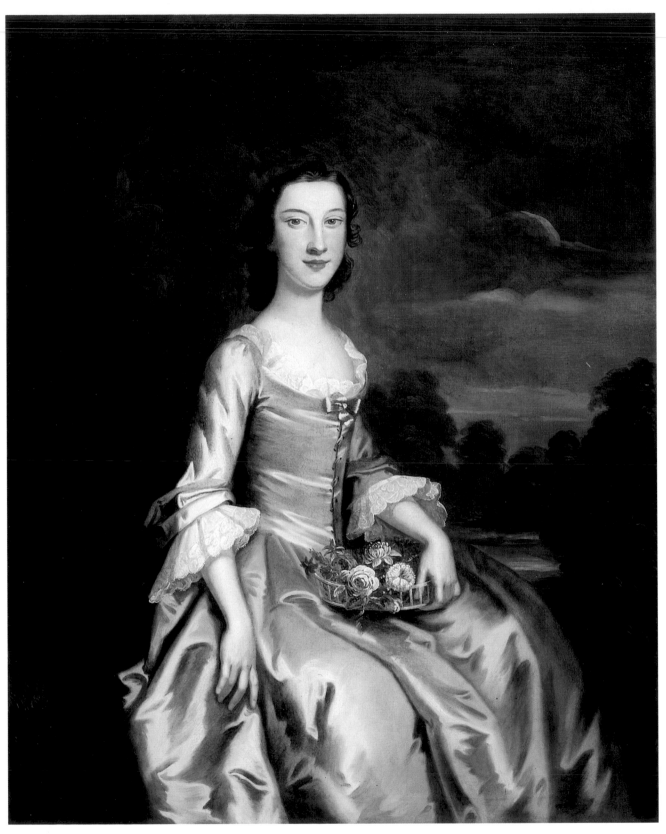

31

JOHN SINGLETON COPLEY (1738–1815)

19. The Gore Children (ca. 1753)

John Singleton Copley painted these four children when he was fifteen or sixteen years old. So important a commission came to him, in part, because at the time more mature painters were few in Boston: John Smibert had stopped painting in the 1740s and died in 1753; Robert Feke disappeared after 1750; and John Greenwood left Boston in 1752 for Surinam. Yet the young Copley's skill also must have helped in attracting the commission: John Gore, a well-to-do merchant, chose Copley to paint his children over Joseph Badger, then forty-five, and Smibert's son, Nathaniel, who was three years Copley's senior.

The picture, somewhat stiff and archaic in style, is the natural production of a young artist at that time, who would have looked back to the stiff poses and rigidly turned heads in his predecessors' work. Copley emulated the best he knew—Smibert and Feke—and the earlier English mezzotint portraits, examples of which his stepfather, Peter Pelham, owned. He at least achieved a clear and well-organized composition, in which the eye is led easily from figure to figure, against a decorative landscape. Better still, the color scheme is fresh, pleasing, and harmonious. Not small qualities.

John and Frances (Pinckney) Gore had fifteen children; the four in the portrait have never been surely identified. In their study of the artist, Barbara Neville Parker and Anne Bolling Wheeler suggested that these may be Frances (b. 1744), John (b. 1745), and Elizabeth (the younger girl); they offer no name for the younger boy (*John Singleton Copley*, p. 86). Because another son, Christopher, born five years later, became a well-known governor of Massachusetts (and a friend of John Trumbull; see no. 51), the group has often been called simply the "Brothers and Sisters of Christopher Gore." It is unfortunate that these four children fell so clearly into anonymity.

Oil on canvas; 41 × 56½ in.
Unsigned.
Provenance: By descent to Mrs. Richard Robins; Katherine R. Robins; Mrs. William E. Groff; Richard Robins.
Acc. no. 59.3408.
References: Perkins (1873), *Life and a List of Some Works of John Singleton Copley;* Bayley (1910), *Life and a List of Some Works of John Singleton Copley;* Boston, Museum of Fine Arts (1938), *John Singleton Copley;* Parker and Wheeler (1938), *John Singleton Copley;* Flexner (1948), *John Singleton Copley;* Prown (1966), *John Singleton Copley in America;* Frankenstein (1970), *World of Copley.*

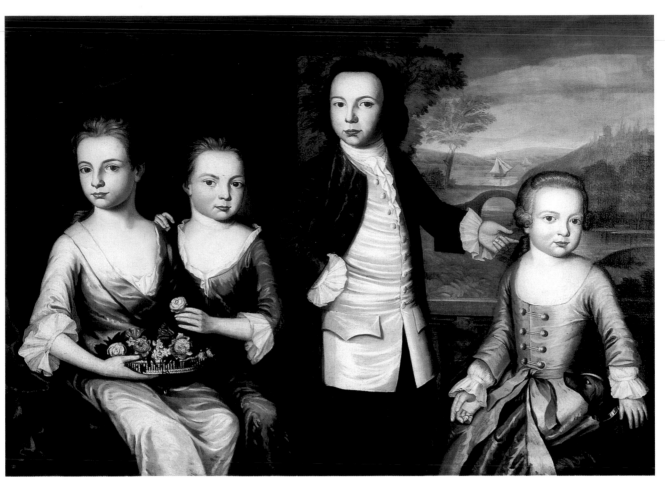

JOSEPH BADGER (1708–65)

20. Benjamin Badger (1758–60)

John Smibert gave up portrait painting after 1745, when his eyesight was failing. Until almost a decade later, when Joseph Blackburn arrived from England and native talent appeared in John Singleton Copley, Bostonians were hard put to gratify their wish for family portraits. One of the few portraitists available was Joseph Badger, who moved from Charlestown, Massachusetts, to Boston in 1733. Presumably, he visited Smibert's Boston gallery and learned what he could from that artist's pictures, but Badger's portraits of adults, are for the most part, mere artisan work by contrast. Trained as a house and sign painter, Badger turned out likenesses dull in color and awkward in drawing. In paintings of children, however, he created the naive, doll-like charm that makes this portrait so engaging.

Whether the Benjamin Badger shown here was the artist's son or grandson is uncertain. A quite similar portrait of a child by Badger in the Metro-politan Museum of Art (acc. no. 29.85) is dated on the back "July 8th 1760." If we assume, as is likely, that the two portraits were painted at about the same time, then common sense suggests that Badger would have been of an age more likely for the child's grandfather than for his father. However, Badger is known to have had a seventh child named Benjamin, who married in 1778 and died in 1835. In view of this information, we are warranted in accepting the traditional identification of the subject as Joseph Badger's son.

Oil on canvas; 30 × 24 in.
Unsigned.
Provenance: Frank Bulkeley Smith, Worcester, Mass.
Acc. no. 56.566.
Reference: Warren (1980), "Badger Family Portraits."

JOHN HESSELIUS (1728–78)

21. Mrs. Richard Young (Rebecca Holdsworth) and Her Granddaughter Rebecca Woodward (ca. 1763)

John Hesselius was born probably in Philadelphia to Gustavus Hesselius, an artist who had emigrated from Sweden in 1711 to Wilmington, Delaware, where his brother was minister of the Swedish congregation. The Swedish colonists who came in the early seventeenth century to the Delaware valley had, by 1711, been subject first to Dutch and then to English rule for half a century, but their churches continued to draw ministers from Sweden and to conduct services in the Swedish tongue.

Gustavus Hesselius settled eventually in Philadelphia, to become the principal painter in that city. His son, however, found a rich market for his own paintings among the wealthy planters of the Chesapeake Bay tidewater, who by the third quarter of the eighteenth century had built for themselves stylish houses in which they wished to hang family portraits. John Hesselius worked in the region for two decades after 1750. In 1763 he married a widow, Mary (Young) Woodward, who owned a plantation, Primrose Hill, near Annapolis. Although he acquired many obligations with his wife's estate, he continued to travel up and down the bay to paint portraits.

It is natural to assume that this likeness of John Hesselius's mother-in-law and her granddaughter, the artist's new stepdaughter, was painted about the time of his marriage. As is witnessed here by his subjects' impassive faces, Hesselius's style of portraiture derived more from Robert Feke and John Wollaston than from his father's less rigid approach. This picture is a dignified and formal little canvas, the brown and beige of the dresses accented by striking highlights and by the whites of ruffles, collars, and caps. There is little depth of characterization, but the fruit that the subjects hold suggests the pleasure of country life on the shores of the great bay.

The inventory of John Hesselius's estate reinforces the impression of pleasant country living. It lists not only the artist's tools one expects but also books, pictures, prints, music, a chamber organ, a guitar, three violins, many pieces of mahogany and walnut furniture, 194 ounces of silver plate, and other items of decorative art that bespeak a leisured and cultivated life. Hesselius died a rich man, able to leave to each of his daughters a legacy of twelve hundred pounds.

Oil on canvas; 23¾ × 19⁹⁄₁₆ in.
Unsigned.
Provenance: Pinkney McLean.
Acc. no. 58.1986.
References: Bolton and Groce (1939), "John Hesselius"; Doud (1963), "John Hesselius," no. 31, p. 91; Doud (1969), "John Hesselius."

WILLIAM JOHNSTON (1732–72)

22. William Verstille (1763–64)

The small state of Connecticut produced so many painters in the century following 1760 that special interest attaches to William Johnston, the first painter known to have been active in the Connecticut colony. Born in Boston to Thomas Johnston, a well-known decorative painter, japanner, and organ builder, William was trained in his father's workshop. He then began his career as a wandering portrait painter, working in Portsmouth, New Hampshire, in 1759–62; New London, Connecticut, in 1762–63; and Hartford and nearby Connecticut towns in 1763–64. He was married in Boston in 1766 and, sometime before 1770, went to Barbados. He died at Bridgetown, Barbados, on August 14/15, 1772.

William Verstille, painted here as a boy, became a miniaturist and portrait painter. He worked in Connecticut, in Philadelphia, in New York City, in Salem, Massachusetts, and in Boston, where he died in 1803.

Oil on canvas; 35⅝ × 28⅜ in.
Unsigned.
Provenance: Ralph W. Thomas, Hartford, Conn.; Dr. Royal W. Pinney, Derby, Conn.
Acc. no. 58.2535.
Reference: Thomas (1955), "William Johnston."

WILLIAM WILLIAMS, SR. (1727–91)

23. William Hall (1766)

24. David Hall (1766)

David Hall, Sr., the father of these two boys, came to America in 1743 to work in Benjamin Franklin's Philadelphia print shop. Franklin, in need of help in his increasingly successful printing, bookselling, and newspaper business, had written to his friend William Strahan in London (July 10, 1743), asking him to recommend "a young man whom you would be glad to see in a better business than that of journeyman printer." Strahan sent to Philadelphia a young Scot, David Hall, who had learned printing and bookselling first in Edinburgh and later under Strahan. Hall proved so satisfactory an assistant that in 1748 Franklin took him into partnership; in 1766, when Franklin was about to leave for London, he sold Hall the business, including the *Pennslyvania Gazette*. In his autobiography, Franklin pays tribute to Hall as his "very able, industrious, and honest Partner." Thus, the young Scot who had come to America to make his way in the world found himself, in 1766, one of the leading citizens of Philadelphia.

In the same year, Hall commissioned artist William Williams, Sr., to paint his children. Williams, born in 1727 to Welsh parents in Bristol, England, worked in Philadelphia, New York, Jamaica, and England and died in a Bristol almshouse in 1791. He had many skills. In the late 1740s he turned up in Philadelphia as a painter and musician. In 1760 he was in Kingston, Jamaica, painting portraits of the planters of that rich sugar island. We learn something of his abilities from the advertisement that he placed in the *Pennslyvania Journal and Weekly Advertiser* (January 13, 1763) upon his return to the American mainland:

WILLIAM WILLIAMS Being lately returned from the West-Indies; desires to acquaint the Publick that he now lives in Loxley's Court, at the Sign of Hogarths Head, his former place of Residence where he intends to carry on his Business viz. Painting in General. Also an Evening School for the Instruction of Polite Youth, in the different branches of Drawing, and to sound the Hautboy, German and common Flutes, by their humble servant: William Williams. [Prime, *Arts and Crafts* (1929), p. 13.]

According to Benjamin West, Williams also did a great deal of decorative painting and giltwork on the ships built at the Penrose shipyards in Philadelphia.

Six years later, another advertisement, in the *New-York Gazette and the Weekly Mercury* (May 8, 1769), shows that Williams had moved from Philadelphia:

WILLIAM WILLIAMS, Painter, at Rembrandt's Head, in Batteaux-street, Undertakes painting in general, viz. History, Portraiture, landskip, sign painting, lettering, gilding, and stewing smalt [preparing a special sign-painting pigment from roasted cobalt ore mixed with molten glass]. N.B. He cleans, repairs, and varnishes, any old pictures of value, and teaches the art of drawing. Those ladies or gentlemen who may be pleased to employ him, may depend on care and dispatch. [Rita Susswein Gottesman, *The Arts and Crafts in New York, 1726–1776: Advertisements and News Items from New York City Newspapers* (New York: Printed for the New-York Historical Society, 1938), p. 7.]

When the American Revolution broke out, Williams returned to England, where West used him as the model for the man wearing a plumed hat in the rear of the central, besieged rowboat, in *The Battle of La Hogue* (1784–85).

The portraits Williams painted of Hall's two sons, William and David, and of his daughter, Deborah (Brooklyn Museum), seem to have been the earliest full-length, life-size portraits painted in Philadelphia. What makes these portraits exceptional, over and above their rarity, is their quality of fantasy. William Hall stands in a palatial, although half-empty, library, while through a marble arch behind him one sees a lighthouse on a sandy shore and ships passing. David Hall stands before a landscape of a castle on a hilltop, high over a valley in which a river winds off into the distance. In the portrait of Deborah Hall, the subject wears a formal gown of rose satin and trims a potted rosebush in a large Italian garden. The imaginary grandeur of these settings owes nothing to the red-brick city of Philadelphia. However, it may be related to a commission Williams had received seven years earlier from David Douglass, the manager of a traveling theatrical company. When Douglass brought his company to Philadelphia in 1759, he built the city's first theater, for which Williams painted a set of stage scenery valued at the great

sum of one hundred pounds. The dreamlike world in which Williams placed the three Hall children no doubt came naturally to the imagination that created scenery for such dramas as the *Tragedy of Tamburlaine* and *Hamlet*.

William Hall
Oil on canvas; 71 × 46 in.
Signed at lower right "Wm. Williams 1766."
Provenance: By descent in the family to Winslow Brewster Ingham and his three sisters, Trenton, N.J.; purchased by H. F. du Pont through Joe Kindig (1940).
Acc. no. 59.1332.

David Hall
Oil on canvas; 70⅞ × 45⅞ in.
Signed at lower left "Wm. Williams 1766."
Provenance: Same as for *William Hall*.
Acc. no. 59.1333.

References: *Pennslyvania Archives,* ser. 3, pp. 659–60; Pollock (1933), *Philadelphia Theatre,* pp. 13–17; Flexner (1944), "William Williams"; Flexner (1947), *First Flowers of Our Wilderness,* pp. 176–83; Smith (1951), "Notes on the Two William Williams'," pp. 375–85; McNamara (1967), "David Douglass," p. 121; Richardson (1972), "William Williams."

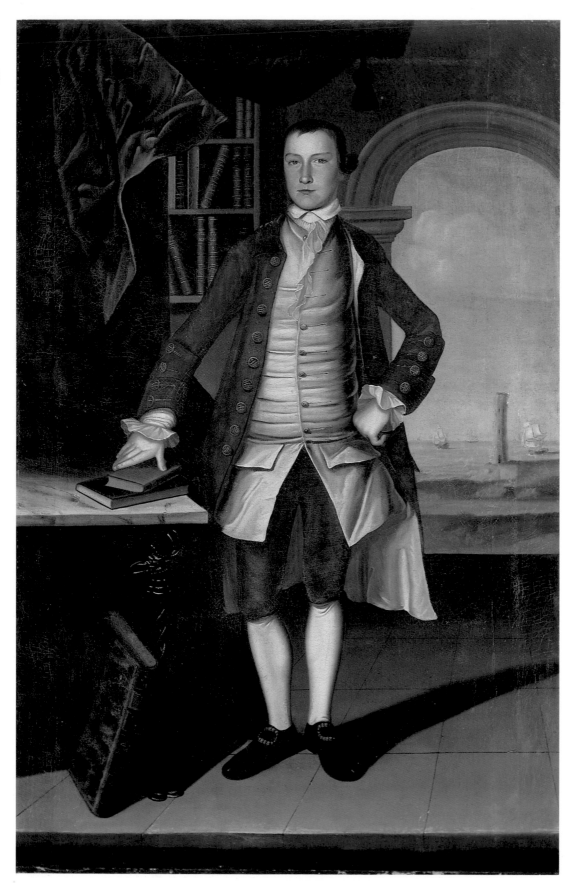

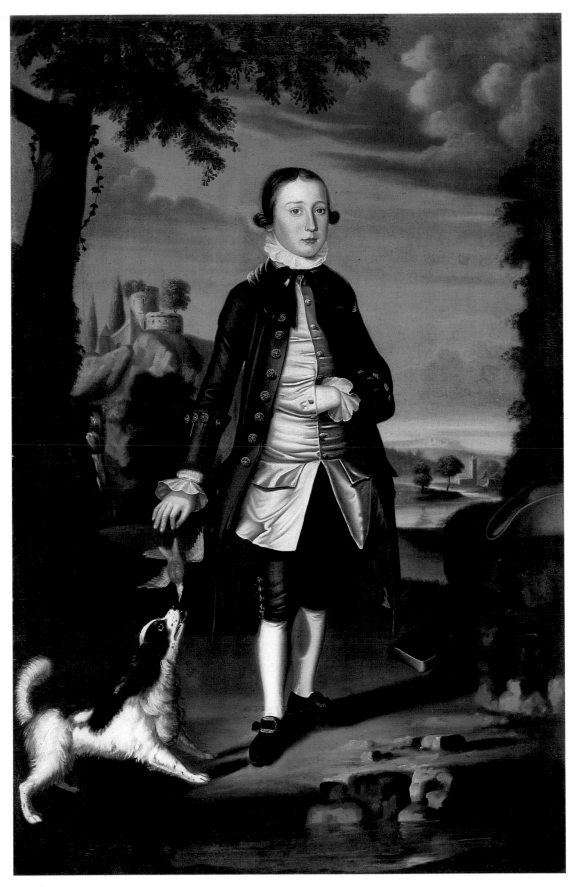

BENJAMIN WEST (1738–1820)

25. A View on the Susquehanna River (1767)

Born near Springfield, Delaware County, Pennsylvania, Benjamin West became by age thirty history painter to King George III and president of the newly founded Royal Academy. West began his career humbly, however, as a portraitist and sign painter in Philadelphia. When merchant William Allen recognized West's talent, he paid for the young artist to study in Italy from 1759 to 1763. West then moved to London, where his large paintings of classical and historical scenes brought him patronage from the aristocracy and ultimately caught the eye of the king.

One of West's most endearing features is that, despite his success in England, he never forgot the land of his birth or lost his fondness for the Philadelphians who had helped him in his youth. American subjects recur in his works; two of his great early successes were paintings of American subjects—*The Death of Wolfe before Quebec,* painted in 1770 for the first earl of Grosvenor, and *William Penn's Treaty with the Indians,* painted in 1771 for Thomas Penn.

The Winterthur landscape, which particularly resembles the stretch of the Susquehanna near Harrisburg, may be the earliest of West's American subjects painted in London. If so, then perhaps his interest in American scenery in 1767 was prompted by the unusually large number of Philadelphians who were visiting London that year. For many Americans, the mid 1760s—the first years after the long war with the French and their Indian allies—were a time of relaxation. Most Philadelphians had relatives and friends in England, and Philadelphians of substance often had important business connections there. With the years of war at sea now ended, Americans felt that it was again safe to journey across the Atlantic. Such people as West's old patron William Allen came to London in part for a holiday, in part to revive long-interrupted business affairs. Benjamin Franklin, who had suffered a bitter defeat in his political campaign against the proprietors of Pennsylvania, transferred to London his campaign to have the Crown take the colony's government away from the Penns. Lt. Gov. James Hamilton of Pennsylvania came to confer with the Penns on how to block Franklin's effort and to argue against certain measures pending before Parliament that would hurt Philadelphia's merchants and overseas trade. Francis Hopkinson,

statesman, poet, musician, and composer, who was then the head of the Customs House at Salem, New Jersey, came to see if he could find the political influence to win a better job. Provost William Smith of the College of Philadelphia came to raise money for his college and for the work of the Society for the Propagation of the Gospel among the Indians and to get a book published. Matthew Pratt of Philadelphia, Abraham Delanoy of New York City, and Charles Willson Peale of Annapolis came to study painting with West.

These Americans did not all like one another, but West was everybody's friend. Hopkinson lived with the Wests part of one winter and had a wonderful time in London; Provost Smith asked West to illustrate the London edition of his book, *An Historical Account of the Expedition against the Ohio Indians in the Year MDCCLXIV under the Command of Henry Bouquet, Esq.* (London, 1766), which had been published in Philadelphia without illustrations. Philadelphians were even depicted in West's art in 1767. During that year he painted one of his finest full-length portraits, *Governor James Hamilton* (Independence National Historical Park), and a half-length likeness, *Mrs. Thomas Hopkinson* (Historical Society of Pennsylvania), which shows the wife of a magistrate and amateur scientist whose work influenced Benjamin Franklin. Pennsylvania must have been much in West's mind.

This landscape is a dusky and dreamlike scene— a wide, shallow river flows over low falls, half-seen groups of men are hunting and fishing, a wild vista is enclosed by blue mountains, and the waters are overhung by great dark trees. According to a list of his work compiled during his lifetime, *A View on the Banks of the River Susquehanna, in America* hung in West's house at Windsor, forming a pair with *A View on the River Thames at Hammersmith* ("A Correct Catalogue of the Works of Benjamin West, Esq.," *Supplement to La Belle Assemblée; or, Bell's Court and Fashionable Magazine* 4 [July 1, 1808]: 13–20). This view may have been our picture.

Oil on canvas; 14 × 17^{15}/$_{16}$ in.
Signed at lower left "B. West. 1767."
Gift of Rita and Daniel Fraad, Scarsdale, N.Y.
Acc. no. 63.47.
Reference: Dillenberger (1977), *Benjamin West,* pp. 201, 208.

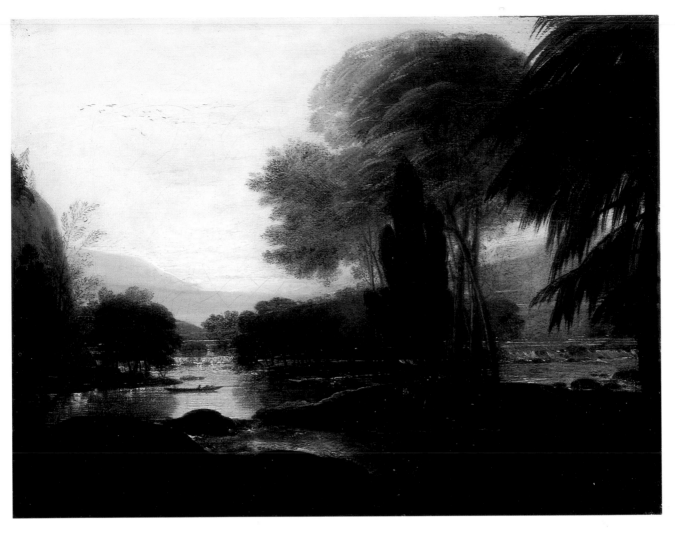

JOHN DURAND (w. 1766–82)

26. Mrs. Benjamin Peck (Hannah Farmer) (1767–70)

John Durand was an itinerant who is recorded first in the 1766 account book of James Beekman of New York City. Beekman noted that he had paid to "Monsieur Duran" the sum of nineteen pounds for portraits of his six children. This entry suggests a French origin for the artist, but certainly—judging from his style—provincial French. Durand was an artist of little formal training, but he had some natural gifts. He worked in New York City from 1766 to 1768, when he probably painted Hannah Peck. He then worked briefly in Connecticut and by 1770 in Virginia, where he painted many portraits. He was still in Virginia in 1782, after which date there is no record of him or his work.

As a painter Durand had little sense of mass or of atmosphere. There is almost no shading in the folds of Mrs. Peck's dress, but the drawing is clear and crisp, the color fresh and decorative. The placement of the subject's languid hands was originally formulated by English portraitist Sir Godfrey Kneller, who used it in his painting of Princess Anne (wife of Prince George of Denmark). A mezzotint of that portrait was published in 1692,

and such American painters as John Wollaston, John Smibert, and Joseph Badger, as well as Durand, sometimes copied the pose in their portraits of women. Here it provides a certain frosty elegance, in spite of the portrait's naiveté. It is from the mingling of such opposite qualities that Durand's work derives its attraction.

Hannah Peck was the wife of New York businessman Benjamin Peck, owner of Peck's Slip on the East River, from which a store front (ca. 1800) now installed at Winterthur was taken. Mrs. Peck's niece, Mrs. Abraham Jarvis, also was painted by Durand (ca. 1770), and her portrait too is in the Winterthur collections.

Oil on canvas; 30¾ × 24⅞ in.
Unsigned.
Provenance: William B. Goodwin,
Hartford, Conn.
Acc. no. 59.2849.
Reference: Belknap (1959), *American Colonial Painting,* pl. 23, no. 181, p. 296; p. 326.

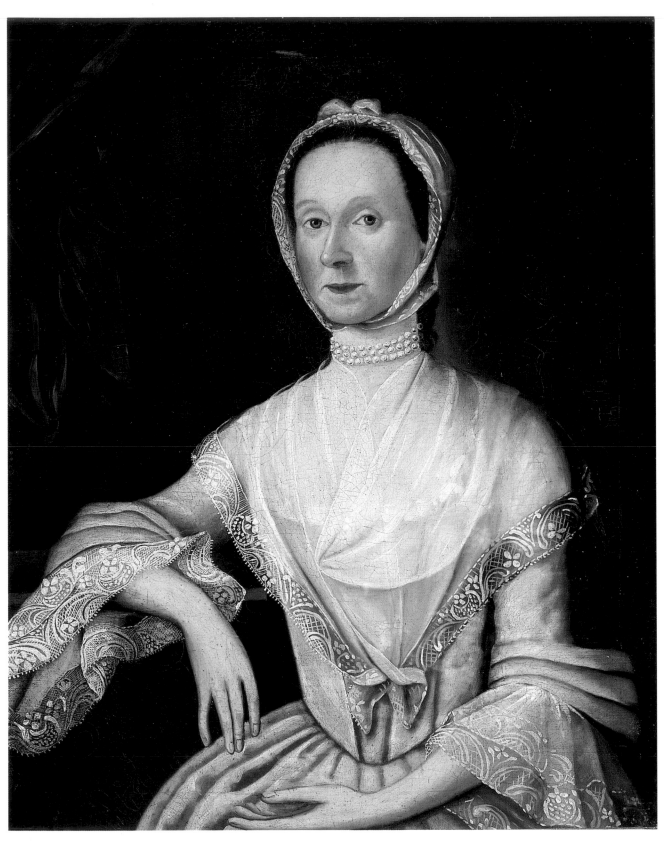

JOHN SINGLETON COPLEY (1738–1815)

27. Self-portrait (1769)

The year of this portrait, 1769, was a landmark in the life of John Singleton Copley. It was the year of his marriage to Susanna Clarke and his purchase of a house and land on Boston's Beacon Hill. Copley had spent the first years of his life in the tobacco shop operated by his widowed mother on the Long Wharf; his mother's second marriage, to Peter Pelham, had introduced him to the wealthier stratum of Boston society. Now, in 1769, his talents and hard work had brought him to the top of the community, both literally and figuratively. No other artist, in that year in the British colonies, could equal him as a portrait painter. Of the other major talents in his generation, Benjamin West was in London, establishing himself as a painter of historical subjects, while Charles Willson Peale had just returned from study in London, pursuing his career in Annapolis.

The young man who looks at us from this self-portrait, clear-eyed and confident, was both fortunate and happy. Copley represented himself wearing a brown waistcoat embroidered in pale gold and a blue-green banyan lined in blue, the lounging garment worn at home by an eighteenth-century gentleman. The portrait's luminous brown and blue color harmony, set off by the frosty white of the powdered wig and linen shirt collar, was a favorite color scheme of the artist. His eyes and mouth are portrayed with equal sensitivity. It is one of his best self-portraits.

By the time Copley rendered both this portrait and the one of his bride (no. 28) in pastel, he had been working in the medium for at least ten years. In 1762 he had written to Swiss pastelist Jean Etienne Liotard, in Geneva, asking him to send "one sett of Crayons of the very best kind such as You can recommend [for] liveliness of colour and Justness of tints" (*Copley-Pelham Letters,* p. 26). That Copley wrote to Liotard, one of the masters of pastel in Europe, is evidence of his serious interest in the medium, which he used in the solid, glowing manner of the eighteenth century. We can agree with Copley's own estimation, written to Benjamin West in 1766, that some of his best work was in pastel, and his was certainly the best use of pastel in colonial America.

Pastel on paper; 23⅛ × 17½ in.
Unsigned.
Provenance: The artist; Elizabeth Copley (Mrs. Gardiner) Greene, his eldest daughter; Mrs. James Sullivan Amory; Harcourt Amory; John Singleton Amory; H. F. du Pont.
Acc. no. 57.1127.
References: Perkins (1873), *Life and a List of Some Works of John Singleton Copley,* p. 47; Bayley (1915), *Life and Works of John Singleton Copley,* p. 84; Bolton (reprint ed., 1970), *American Portrait Draughtsmen in Crayons,* p. 19; Parker and Wheeler (1938), *John Singleton Copley,* p. 219; Prown (1966), *John Singleton Copley in America,* frontispiece, p. 212; Schmiegel (1975), "Pastel Portraits in Winterthur Museum."

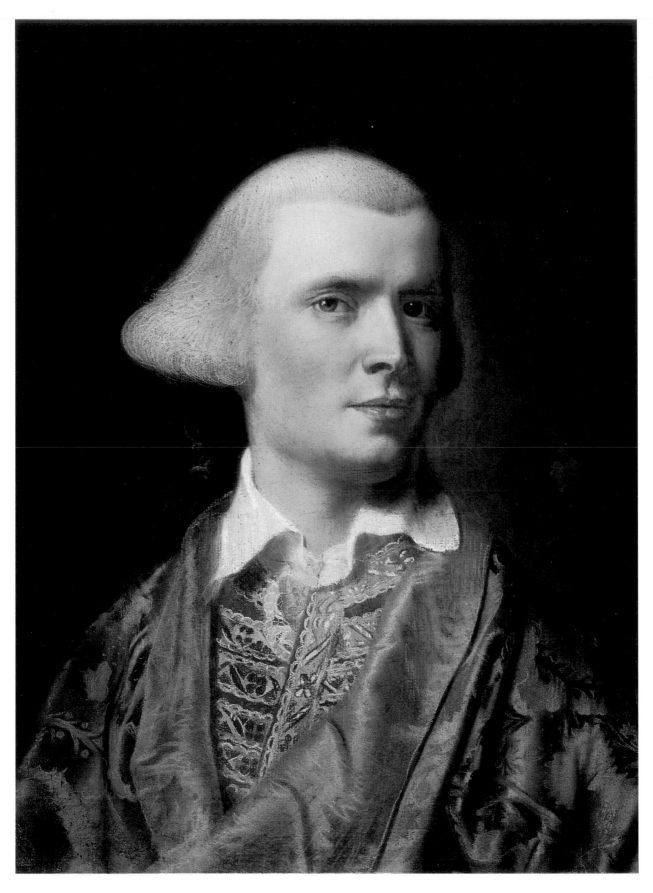

JOHN SINGLETON COPLEY (1738–1815)

28. Mrs. John Singleton Copley (Susanna Clarke) (1769)

Susanna Clarke (1745–1836) married John Singleton Copley on November 16, 1769. This portrait and the self-portrait (no. 27) by Copley show the young couple at the time of their marriage, when she was twenty-four, he thirty-one. Mrs. Copley was a gentle, calm, affectionate woman, who was to contribute to the marriage a stabilizing element which her husband needed. The Copleys had six children, three girls and three boys. Although one son died in infancy, another had a brilliant career in the law, rising to become Lord Lyndhurst, lord chancellor of England.

Copley had married into a family with strong Loyalist sympathies, a connection that brought him personal happiness but political embarrassment as the quarrel between Massachusetts and the English government grew sharper. The bride's father, Richard Clarke, was a prominent merchant and the agent in Boston for the East India Company; much of the tea thrown into Boston harbor on December 16, 1773, had been consigned to him. Subsequently driven from their homes, the men of the Clarke family were forced to take refuge in Castle William, a fortress in the harbor garrisoned by British troops; from there they went to Canada and to London.

Copley left America for Italy in 1774. The following year Susanna Copley sailed to join her husband in London, in the interval between the fighting at Lexington and Concord and the Battle of Bunker Hill. She took with her three children, leaving behind the youngest boy, who was thought too delicate to survive the sea voyage. She spent the remainder of her life in London and survived her husband by twenty-one years.

Pastel on paper; 23⅛ × 17¼ in.
Unsigned.
Provenance: The artist; Elizabeth Copley (Mrs. Gardiner) Greene, his eldest daughter; Mrs. James Sullivan Amory; Harcourt Amory; John Singleton Amory; H. F. du Pont.
Acc. no. 57.1128.
References: Bayley (1915), *Life and Works of John Singleton Copley,* p. 85; Boston, Museum of Fine Arts (1938), *John Singleton Copley,* no. 21, p. 21; Parker and Wheeler (1938), *John Singleton Copley,* pp. 219–20; Prown (1966), *John Singleton Copley in America,* pp. 61, 212; Schmiegel (1975), "Pastel Portraits in Winterthur Museum."

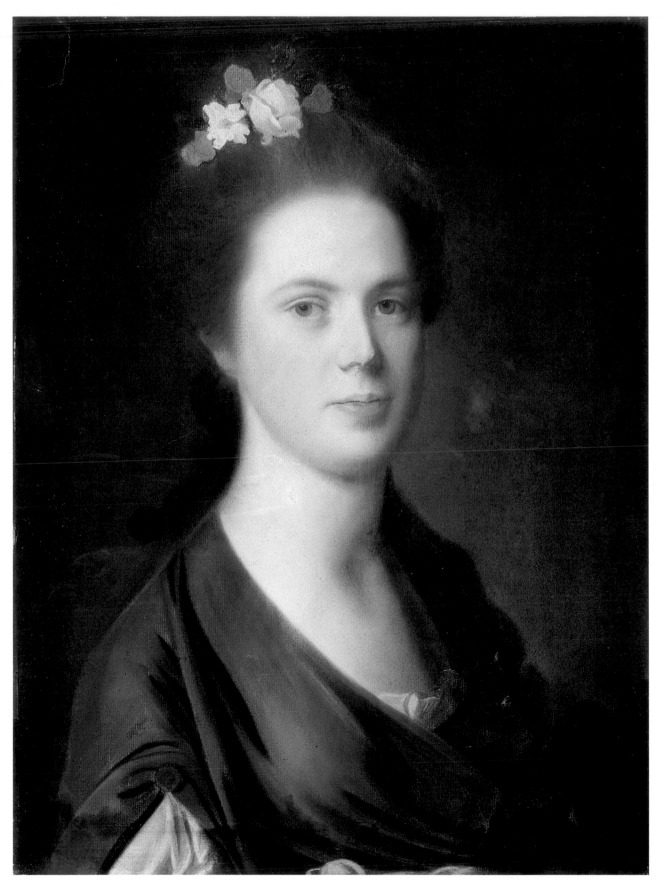

MATTHEW PRATT (1734–1805)

29. Hugh McCulloch (ca. 1770–73)

Matthew Pratt is chiefly known for a single picture, *The American School* (1765), which shows a group of young art students in the studio of Benjamin West. The Metropolitan Museum of Art acquired the picture in 1897, and since then it has been considered an important document of early American painting.

Pratt played a part also in Benjamin West's personal life. Before leaving Philadelphia for Italy in 1760, West had become engaged to Betsy Shewell. After several years in Italy, West arrived in London, where opportunities opened for him in such an encouraging way that his friends told him it would be unwise to leave. Therefore, instead of returning to Philadelphia to be married, he wrote asking his fiancée to come to London. On June 24, 1764, Miss Shewell sailed from Philadelphia accompanied by John West, the artist's father, and Matthew Pratt, a relative of the Shewell family. A few weeks after their arrival, West and Miss Shewell were married in St. Martin's-in-the-Fields; Pratt gave away the bride. His portraits of the newly married pair, painted in 1764, were given in 1892 by the great-granddaughter of the artist to the Pennsylvania Academy of the Fine Arts.

Aside from his connection with West, Pratt has remained little known despite the quality of his paintings. This portrait of Hugh McCulloch, for example, is a dignified, rich-toned canvas. The old gentleman is dressed in black, upon which a white neckband and white cuffs are the only accent. He sits in a green upholstered chair, leaning his elbow on a table covered in green and on which rest two books and a pewter inkwell holding two quill pens. One can imagine what a striking portrait Copley or Peale would have made of this, but in Pratt's work everything is muted. The mood of the sitter, the dusky tone, and the soft light are almost too quiet to catch the eye; yet when examined carefully, it is recognized as a picture worthy of attention. The quiet manner characteristic of Pratt's portraits has perhaps in our century worked against his popularity.

Hugh McCulloch was a Philadelphia merchant whose death, at the age of eighty-eight, was recorded in Zachariah Poulson's *American Daily Advertiser* of September 1, 1807. Pratt also painted McCulloch's wife, Christiana (Rhode Island School of Design), and son, James (Princeton Univeristy Art Museum). Their three lives seem to have been as quiet as their portraits.

Oil on canvas; 50⅛ × 40 1/16 in.
Unsigned.
Provenance: By descent in the family to James Hugh McCulloch; the portrait of Hugh McCulloch as well as those of Christiana and James were purchased by Vose Galleries (ca. 1930–35); H. F. du Pont.
Acc. no. 59.1485.
Reference: Burroughs (1952), "Three Portraits by Matthew Pratt."

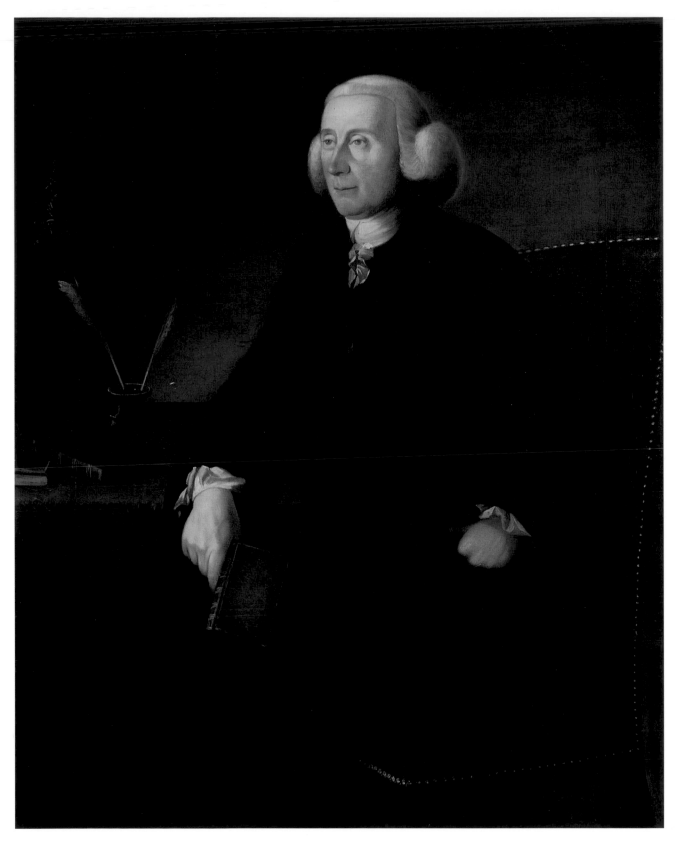

CHARLES WILLSON PEALE (1741–1827)

30. The Edward Lloyd Family (1771)

Charles Willson Peale was for many years the leading portrait painter in the middle states. Before the Revolution, he painted the owners of great plantations in Maryland; during the war, he painted the leaders and founders of the new nation; afterward, he lived to paint Andrew Jackson, Henry Clay, and John Quincy Adams—statesmen in a republic from which memories of colonial days were fast fading. In the portraits of the Edward Lloyd family and Richard Bennett Lloyd (no. 31), Winterthur has two outstanding pictures from Peale's early career in Maryland: perhaps no others give a more striking impression of the self-confidence of the planters on Maryland's Eastern Shore before the Revolution and of the elegance of their lives. To those who know Peale's work only by the restrained neoclassic style of a later period, the glowing colors and rich textures of these portraits will be a surprise.

Peale mentioned the work in a letter to his friend Edmund Jenings in London (July 18, 1771): "All this spring and summer I had intended to go to Philadelphia and have retouched your piece of Mr. Dickinson, but was prevailed on to do some pieces for Mr. Lloyd" (quoted in Sellers, *Portraits and Miniatures,* p. 128). The pieces were two miniatures, the portrait of the Edward Lloyd family, and the portrait of Edward's brother, Richard Bennett Lloyd. The pictures record one of the greatest families of Maryland, the Lloyds of Talbot County, in Peale's most sumptuous style.

Edward Lloyd (1744–96), the fourth of that name, resided at Wye House in Talbot County. The imposing structure seen in the background of this portrait, however, is not a picture of his actual home; it was most likely copied from a design in Isaac Ware's *Complete Body of Architecture* (1756) and was intended simply to suggest Lloyd's resources and awareness of fashion. He lived at Wye House in great luxury for a colonial American. In the years after this portrait was painted, he would sur-round his house with wheat fields (he was one of the largest wheat growers in America) and a deer park, and he would build the finest library in colonial Maryland, including books of travel, fiction, and French literature inherited after his brother Richard's death in 1787. Moreover, Lloyd worked hard at his many public responsibilities. He was a burgess of Talbot County; a member of the Committee of Correspondence for Talbot County, of the Council of Safety, and of the Executive Council of Maryland (1777–79); a state senator for the Eastern Shore; and a delegate to the Continental Congress (1783–84) and to the Constitutional Convention (1787). Four years before Peale's portrait, Lloyd had married Elizabeth Tayloe of Mount Airy (Richmond County, Virginia) on November 19, 1767. Their first child, Anne, who is shown here with her parents, inherited the picture, which remained in possession of her descendants until it was acquired by H. F. du Pont.

In Peale's handwritten list of portraits painted in Maryland between 1770 and 1775 (American Philosophical Society, Peale Papers), this picture appears as "3 Mr Loyd a conversation 36.15.0" (quoted in Sellers, *Portraits and Miniatures,* p. 21).

Oil on canvas; 48 × 57½ in.
Signed at right center "C: W: Peale pinx. 1771."
Provenance: By descent in the family to Elizabeth Lloyd Lowndes; H. F. du Pont.
Acc. no. 64.124. (A replica of slightly smaller size was made in 1965 for Wye House.)
References: Johnston (1912), "Lloyd Family," pp. 428–29; Sellers (1952), *Portraits and Miniatures by Charles Willson Peale,* no. 486, p. 128, and pl. 32; Sellers (1969), *Charles Willson Peale with Patron and Populace,* p. 69; Sellers (1969), *Charles Willson Peale,* p. 78; Wolf (1969), "Library of Edward Lloyd"; Schmiegel (1977), "Encouragement Exceeding Expectation."

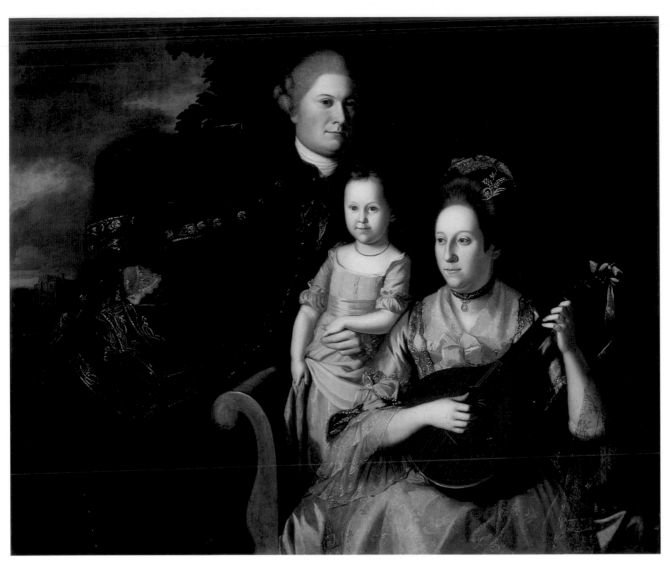

CHARLES WILLSON PEALE (1741–1827)

31. Richard Bennett Lloyd (1771)

Peale almost certainly painted Richard Bennett Lloyd (1750–87) in 1771, while he was also at work on a family group for Edward Lloyd, Richard's elder brother (no. 30). Although Richard Lloyd's portrait is less elaborate than *The Edward Lloyd Family,* it, too, is a splendid example of Peale's style immediately after his return from studying in London. The pose, for example, is one dear to the English painters whom Peale admired: Lloyd, an elegant young man of twenty-one, leans easily against a pedestal before a dark tree, which is a bold contrast to his scarlet suit with gold buttons and his white powdered wig. Behind him, the view of a river and distant waterfall is painted in Peale's pearly atmospheric style. Like the mansion in the background of Edward's portrait, the waterfall here is a symbol, rather than a real feature, of the Lloyd lands on Maryland's Eastern Shore.

The elegance that Peale saw in this young man was joined to ambition. In 1773 Richard Lloyd, visiting England, purchased a commission in the Coldstream Guards. He then had Benjamin West paint a portrait of him in uniform, standing before the Horse Guards Whitehall, as a memento to be sent home to his family; it still hangs in Wye House. In 1775 he married Johanna Leigh, from the Isle of Wight, and had her marriage portrait painted by Sir Joshua Reynolds. Reynolds's splendid full-length portrait, which shows her standing in a woodland grove and carving her husband's

initials, *RBL,* on the bark of a tree, is now at Waddesdon, England. Either because he had married or because the situation between England and the colonies was growing increasingly tense, Lloyd resigned from the army in 1775 with the rank of captain, but he did not return to America. He and his wife lived in England until 1777, when they moved to France and became friends of Benjamin Franklin. In 1780 they returned briefly to England before sailing to America. Lloyd's having remained abroad during the Revolution made him unpopular at home, where he was considered a Tory by many in contrast to his brother Edward, "the Patriot." However, Richard's ownership of prints showing such men as Franklin, Gouverneur Morris, and Baron von Steuben and his purchase of a copy of Peale's *George Washington at the Battle of Princeton* (1779) imply that his political sympathies came closer to his older brother's than is often realized.

Oil on canvas; 48 × 36⅛ in.
Unsigned.
Provenance: American Art Association, Anderson Galleries (1931); H. F. du Pont.
Acc. no. 62.590.
References: Sellers (1952), *Portraits and Miniatures by Charles Willson Peale,* no. 486, p. 128; pl. 32; no. 490, p. 129; pl. 25; Schmiegel (1977), "Encouragement Exceeding Expectation."

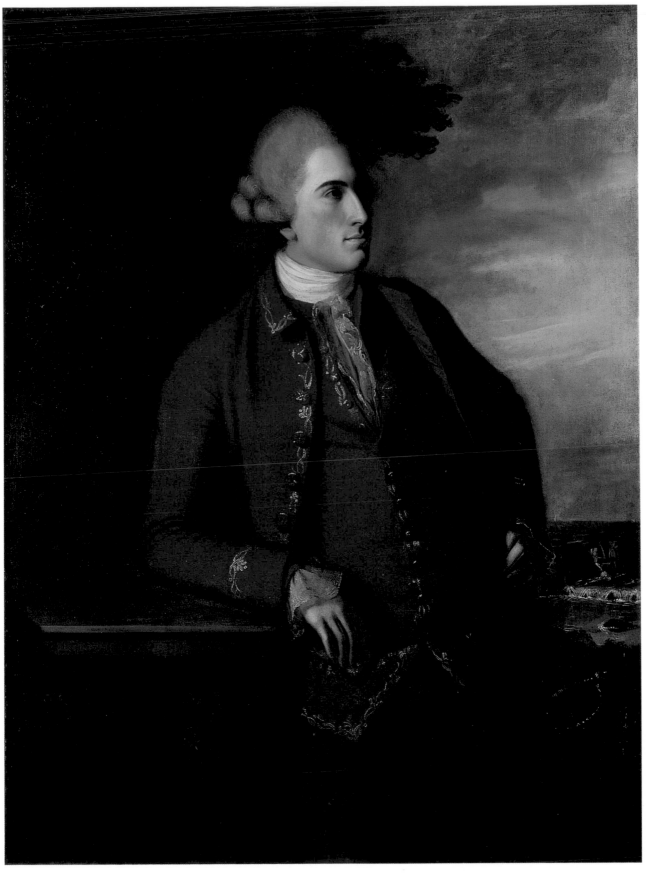

JOHN SINGLETON COPLEY (1738–1815)

32. Mrs. Roger Morris (Mary Philipse) (1771)

The dark-haired woman who looks from this picture with an expression of slightly amused intelligence was born Mary Philipse in 1730 of an old Dutch landed family seated at Philipse Manor on the Hudson River. The house where she was born and where her brother Frederick Philipse lived in great state still stands in Yonkers as one of the few surviving eighteenth-century houses of the great Dutch landholders. Mary Philipse was a singular personality. Cooper is said to have modeled the heroine of his early novel *The Spy* (1821) upon her. When Gen. Edward Braddock arrived in New York in 1754 at the beginning of the French and Indian Wars, his young staff officers gathered about this charming young colonial heiress. George Washington himself found her fascinating.

She married instead Roger Morris (1727–94), a young English officer from Yorkshire. Morris, an able soldier, served in the Hudson valley campaigns, was wounded fighting under Wolfe at Quebec, fought for Murray at Sillerey, and commanded one of the columns of Murray's force in the reduction of Montreal. When Morris resigned from the army in 1764, he built a house on Harlem Heights to which his family moved from their house on Wall Street. Their new house overlooked the Harlem River and had an extensive view of New York and Long Island; now known as the Roger Morris–Jumel Mansion, at West 160th Street and Edgecombe Avenue, the house is the most celebrated pre-Revolutionary building within the limits of New York City.

Twice yearly Mary Morris visited the tenants on the 51,000 acres upriver that were her inheritance; her husband served the public as a member of the Provincial Council. When the Revolution broke out, Morris was unwilling to fight for either side, and so he and his family went to England. He returned to America in 1777, the same year that the Morris house served as Washington's headquarters for the Battle of Harlem Heights (November 16, 1777). Also in 1777, the legislature of New York State passed an act of attainder against fifty-nine Loyalists, including Colonel and Mrs. Morris,

confiscating their lands. At the end of the war, Morris left America with his family and returned to his native Yorkshire. He and his wife received some compensation from the British government for their confiscated American estates. Their two daughters married well in England, and their two sons served with distinction in the British navy. Mary Morris outlived her husband and died at the age of ninety-six in 1825.

The portrait is a remarkable example of Copley's work during his six-month stay in New York City in 1771. He had been invited to New York by Capt. Stephen Kemble, an American-born officer of the Sixtieth Regiment of Foot (the Royal Americans) and brother-in-law of Gen. Thomas Gage, commanding officer of the British forces in America. In New York City the artist and his young wife (they had been married only eighteen months) were a great success. "We experiance such a Disposition in a great many People to render us happy as we did not expect," he wrote home (*Copley-Pelham Letters,* p. 136). They were feted, dined, sought after; Copley, by his own statement, painted thirty-seven portraits, a phenomenal production for so painstaking a painter. He worked in this New York period with both great intensity and great simplicity. Mrs. Morris, for example, could hardly have been represented more straightforwardly. Alive with character and intelligence, she radiates the force of her personality as seen by an expert recorder of human character.

Oil on canvas; 30 × 24½ in.
Signed at lower left "COPLEY."
Provenance: Amherst Morris; John Hay Whitney; Lawrence Fleischman.
Acc. no. 64.23.
References: Massachusetts Historical Society (1914), *Copley-Pelham Letters;* Richardson (1965), "Copley's Portrait of Mrs. Roger Morris: I"; Simmons (1965), "Copley's Portrait of Mrs. Roger Morris: II"; Prown (1966), *John Singleton Copley in America,* pp. 81, 223.

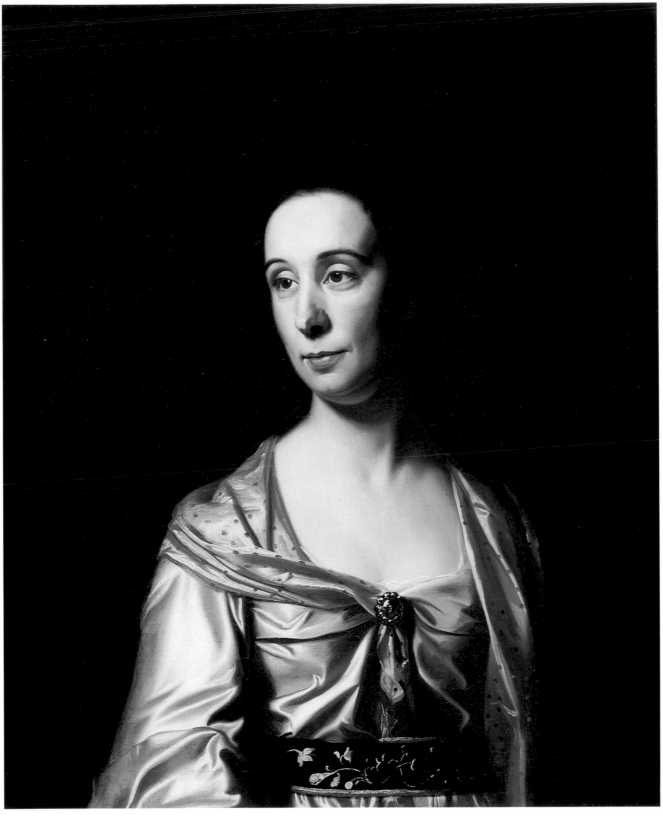

WILLIAM WILLIAMS, JR. (w. 1767–75)

33. A Gentleman and Lady in a Landscape (1775)

Two painters and one pastelist named William Williams worked in eighteenth-century America, and another (to whom portait no. 67 was once attributed) painted in the English provinces. The earliest of the name was the painter of the self-portrait (no. 39) and of the Hall children (nos. 23, 24). His son, also called William Williams, is known through a small number of pictures painted in the 1760s and 1770s, such as the piece shown here. It is signed and dated "Wm Williams Pinxt. 1775" in a feeble cursive hand quite unlike the signature of the senior Williams.

The son weakly imitated his father's style; this picture is perhaps his best work. A view of buildings and water in the background, the foreground framed by foliage and rock, the figures looking in various directions—all the elements of his father's conversation pieces are present, but in a confused and less convincing form. The lady and gentleman stand uncertainly on feet too small to support their bodies. They appear to be deciding on a direction in which to walk. And indeed might they wonder where and how to move in a land-scape so crowded with rocks, cliffs, waterfalls, streams, a water mill, a castle, a church, an over-hanging tree. One possible cause for this unnatural confusion is that the picture represents not an out-door scene but a stage set with actors. Portraits of performers in their most successful roles were not unusual in the late eighteenth century; Charles Willson Peale, for instance, painted actress Nancy Hallam in her costume for Imogen in Shakespeare's *Cymbeline,* with an ominous cave and shepherds behind her (1771, Colonial Williamsburg). Although the subjects remain unknown, Williams's painting too has the charm and other worldliness of a theatrical production.

Oil on canvas; 33³⁄₁₆ × 39⅛ in.
Signed at lower left "Wm Williams Pinxt. 1775."
Provenance: Francis P. Garvan; Donald D. Macmillan.
Acc. no. 58.1732.
Reference: Richardson (1972), "William Williams," pp. 21–22.

HENRY BENBRIDGE (1743–1812)

34. Captain John Purves and His Wife (Anne Pritchard) (ca. 1775)

Henry Benbridge, a Philadelphian from a well-to-do family, was the first American-born artist of means. Coming into his inheritance in 1764, he was able to go at once to Italy to study painting. Although he did not create the same sensation as Benjamin West had shortly before in Rome and Florence, he did cause a stir of another kind in London. At the time, Gen. Pascal Paoli was fighting in Corsica to defend the island's independence from the French. Commissioned by James Boswell, who was known for his book on Corsica (1768), Benbridge made his way to the island, found and sketched Paoli, and sent a full-length portrait of him to London for the exhibition at the Free Society of Artists in May 1769. The Corsican struggle for independence had made Paoli a hero of the cult of liberty that was rising throughout Europe, and all London, including the royal family, went to see the picture. The portrait was displayed with a contribution box beside it to aid Corsican refugees. Thus, when Benbridge came to London later in 1769, he already had a reputation there from this picture. His Philadelphian friends in the city, notably Benjamin Franklin and the Reverend Thomas Coombs (whose portraits he painted), thought his future in London promising and advised him to remain, but Benbridge chose to return to Philadelphia in 1770. He then went on to Charleston, South Carolina, a thriving city without a portrait painter since the death in 1774 of Jeremiah Theus.

Benbridge was most talented at painting heads, to which he gave great force of character. His full-length portraits, however, are often awkwardly drawn, especially in the lower halves of the figures. The weakness fortunately is not evident in this vigorously painted double portrait of John Purves and his wife.

Purves was born in Scotland in 1746. He came to South Carolina in 1770, settled in the backcountry near present-day Edgefield, and soon became an active figure in the Revolution. He was a member of the first congress of the province, which met in January and June of 1775; in June, he was commissioned as captain of a ranger company of the Third South Carolina Regiment. Exactly one year later, Purves fought at Sullivan's Island, where Sir Henry Clinton's first attempt to take Charleston was defeated. When the South Carolina regiments were made part of the Continental army, Purves appears to have remained with the local militia, and he ended the war as lieutenant colonel of the Lower Ninety-six Militia Regiment. After the war, he served in the South Carolina legislature and became a large landholder in his adopted state. He died in 1792.

Eliza Anne Pritchard, who married Purves in February 1775, was a war bride. Here she leans against her husband's shoulder, looking rather anxiously at his face. He wears the uniform of the Third South Carolina Regiment at the start of the Revolution—blue coat with red facings, silver buttons, and a single silver epaulet. The flat collar of his coat also dates the portrait at the beginning of the war, confirming a family tradition that this is a marriage portrait.

Oil on canvas; 39½ × 50 in.
Unsigned.
Provenance: By descent in the family to Eliza McKellar; H. F. du Pont.
Acc. no. 60.582.
References: Rutledge (1948), "Henry Benbridge"; Rutledge (1949), *Artists of Charleston*, pp. 122–23; Stewart (1971), *Henry Benbridge*, no. 48, p. 51.

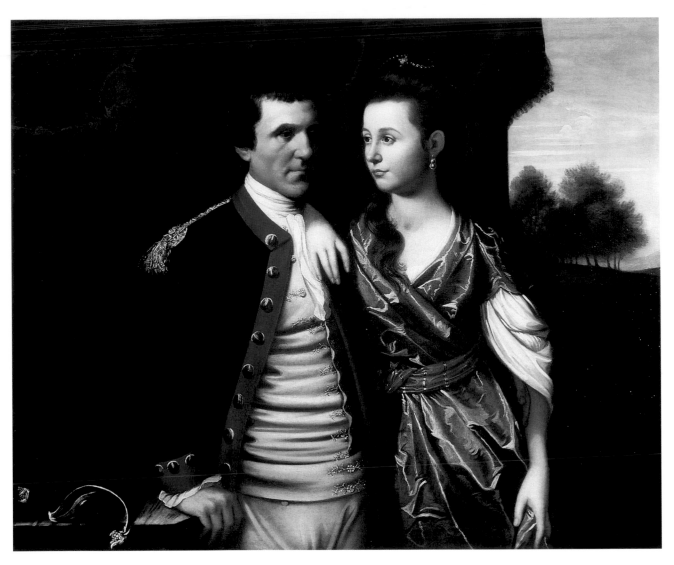

PART THREE

The American School from 1776

CHARLES WILLSON PEALE (1741–1827)

35. Mrs. Benjamin Rush (Julia Stockton) (1776)

Julia Stockton was born on March 2, 1759, at Morven, an estate in Princeton, New Jersey. Her father, Richard Stockton, a much-respected figure in New Jersey affairs, was a lawyer, a trustee of the College of New Jersey (Princeton), and a cultivated man whose library has been accounted one of the best in the colonies. Her mother, Annis Boudinot Stockton, was a poet of some celebrity. Julia was their eldest daughter and married the brilliant but contentious Benjamin Rush, a Philadelphia physician, on January 11, 1776. He was fourteen years her senior.

Peale began the portrait on June 28, 1776, and the sittings continued until the end of July. The number of sittings seems to imply that the artist took unusual care to make the portrait a success, but it may indicate instead the many events that could have distracted Peale or his subject, living in Philadelphia during a crucial session of the Continental Congress. Julia Rush's father and new husband were both members of the Congress; they both signed the Declaration of Independence and were engrossed in the preparations for war. Before Mrs. Rush had been married a year, she saw her husband and the artist march off with John Cadwalader's Pennsylvania brigade to fight at Trenton and Princeton. From April 1777 to February 1778 Rush served in the army as surgeon general (later physician general) for the Middle Department. He attended the wounded of the battles of Trenton, Princeton, and Germantown and the sick at Valley Forge. Yet, although Peale painted Julia Rush in time of war, he shows the young bride as an expert in the arts of peace—fingering her guitar, a faraway look in her eyes, with books spread on the table beside her and a fragrant flower in the bosom of her dress.

In his edition of Benjamin Rush's autobiography, George W. Corner wrote, "The memory of Julia Stockton Rush . . . lives almost exclusively in these pages of her adoring husband. Married before seventeen, and the mother of thirteen children, nine of whom she raised to maturity in a time of war, pestilence, and great economic stress, she could have had little time for anything but the care of her family. It is evident between the lines as well as in BR's direct tributes to her, that she was a sensible, calm woman upon whom he depended for solace and stabilizing advice. Her deeply pious religious diary has been preserved (privately owned)." Her husband said of her: "To me she was always a sincere and honest friend. Had I yielded to her advice upon many occasions, I should have had known less distress from various causes in my journey thro' life" (Rush, *Autobiography,* pp. 115n, 166). She outlived her husband by thirty-five years, dying in Philadelphia on July 7, 1848.

The painting, which was completed in July 1776, shows elements both of Peale's early Maryland style and of the neoclassic manner that he developed during and after the war. Its formality, its spacious composition, and its tone of ease and elegance recall the artist's years in Maryland, when memories of London were fresh in his mind; but its sober coloring—pale blue, rust, olive green—is already subordinate to the clear, precise drawing of his neoclassic style.

Oil on canvas; 49½ × 39¼ in.
Signed at lower left "C W Peale / pinx 1776."
Provenance: By descent in the family to Mrs. T. Charlton Henry of Philadelphia, who bequeathed it and the companion portrait, *Dr. Benjamin Rush,* to Winterthur Museum.
Gift of Mrs. T. Charlton Henry, Philadelphia, Pa. Acc. no. 60.392.
References: Rush (1948), *Autobiography;* Sellers (1952), *Portraits and Miniatures by Charles Willson Peale,* no. 760, pp. 187–88; pl. 89.

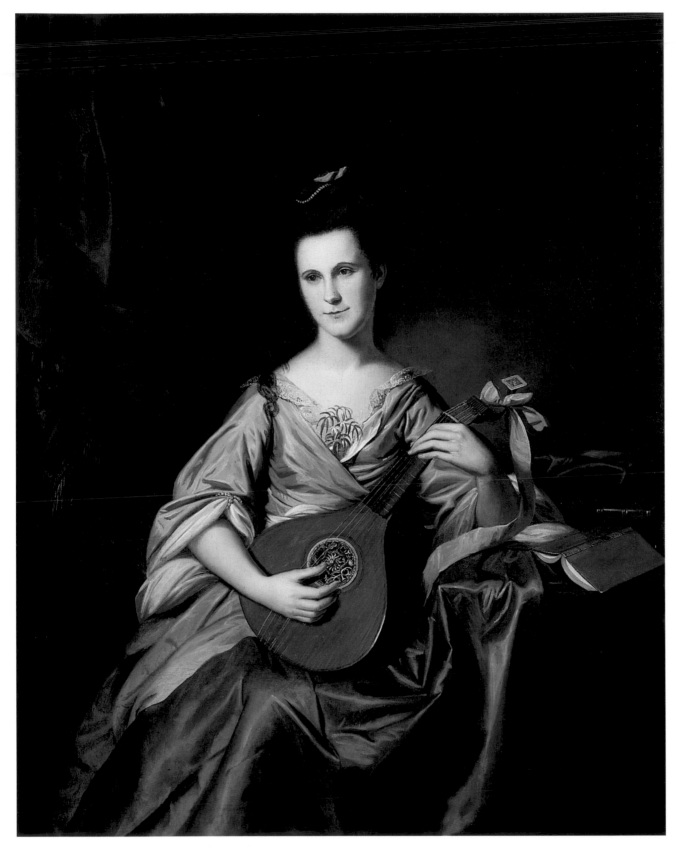

HENRY BENBRIDGE (1743–1812)

36. Major Benjamin Huger (after 1779)

This portrait, a memorial to a South Carolina officer killed during the Revolution, shows the deceased leaning against an obelisk on which is inscribed: "Sacred to the memory of Maior B. Huger; who fell in the cause of liberty before the lines of Charleston Iune. 1779." Major Huger's death was part of a disorganized attempt to defend the city. The British, having failed to capture Charleston from the sea in 1776, made a second attempt by land in 1779. Taking advantage of the absence of the region's American force, which was 150 miles up the Savannah River in inland Georgia, Gen. Augustine Prevost suddenly crossed the river from lower Georgia to move by land upon Charleston with 2,000 men. No one in the city had anticipated a land attack; Charleston Neck was almost wholly undefended. Edward Rutledge (later governor of South Carolina) and General Moultrie raced toward the city, bringing what militia forces they could gather. A hasty line of defense was built, behind which the militia, with a stiffening of 250 continentals and Pulaski's legion, waited for the British attack. On the night when Prevost's army arrived, the defenders, expecting an immediate attack, stood to arms all night, with tar barrels burning before the lines to give light. A false alarm led to a general discharge of cannon and musketry. As David Ramsay wrote in his history of South Carolina:

By this unfortunate mistake major Benjamin Huger, a brave officer, an able statesman, and a highly distinguished citizen, was killed by his countrymen. He was without the lines on duty with a party, twelve of whom were either killed or wounded. [*The History of South-Carolina, from Its First Settlement in 1670, to the Year 1808,* 2 vols. (Charleston: David Longworth, 1809), 1:308.]

Perhaps the futility and sadness of such a loss led to this memorial portrait. The major stands by his own tomb, with a fanciful citadel behind him. His military career is further signified by his dress; he wears a blue uniform coat with red facings, a buff waistcoat, and trousers. The epaulets are gold, and his coat has the turnover collar that came into fashion sometime after the portrait of Captain Purves was painted (no. 34). The head must have been copied from an earlier likeness, possibly a miniature by Benbridge. The subject's stance, however, is typical of English military portrait engravings of the time.

Oil on canvas; 29⅛ × 24 in.
Unsigned.
Inscribed: "SACRED TO THE MEMORY / OF / MAIOR B. HUGER; / WHO FELL / IN THE CAUSE OF LIBERTY / BEFORE THE LINES OF CHARLESTON / IUNE. 1779."
Provenance: Elise Wiggall Simons; Averell Ross du Pont.
Gift of Averell Ross du Pont and Molly Laird Downs.
Acc. no. 71.278.
Reference: Stewart (1971), *Henry Benbridge,* no. 156, p. 86.

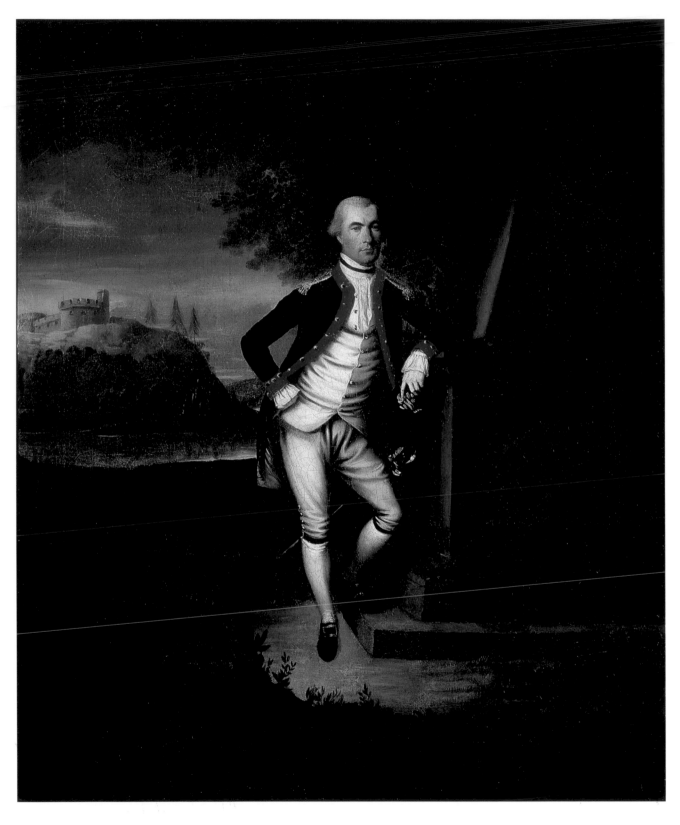

CHARLES WILLSON PEALE (1741–1827)

37. Dr. Benjamin Rush (1783 or 1786)

Although Charles Willson Peale completed his portrait of the just-married Julia Rush (no. 35) in July 1776, he was unable to begin working immediately on a portrait of her husband, Dr. Benjamin Rush. During the summer of 1776, Peale joined the Pennsylvania militia and soon marched to Trenton as an officer of Coxe's Philadelphia Regiment. The following autumn, Rush himself marched off as a doctor to Cadwalader's brigade of Pennsylvania militia. Thus, it is doubtful that Peale could have even begun Rush's portrait amid the excitement and confusion of 1776. The painting is signed and dated in two places, one with the year 1786 and the other with 1783. Study of Peale's papers has not helped in ascertaining the correct date, but in either case the painting was not completed until long after Peale had finished its companion.

One is at first surprised by Peale's gently contemplative image of Dr. Rush. Can this be that brilliant but abrasive man, so full of energy and so intolerant of opposition that he was continually involved in controversy? While an army doctor, Rush had denounced his superior in the medical service, Dr. William Shippen, Jr., as incompetent, a move that only prompted Congress to vote its confidence in Shippen. In 1778 he wrote a rash letter to Gov. Patrick Henry of Virginia, in which he denounced Washington's generalship and called for Gage or Conway to replace him. Another army doctor wrote to a colleague, "*Rush* has quarrel'd himself out of all public Posts" (Barnabas Binney to Solomon Drowne, August 31, 1778, in "Notes and Queries," *Pennsylvania Magazine of History and Biography* 3 [1879]: 467). The letters written in 1783, printed in Lyman H. Butterfield's admirable edition (*Letters of Benjamin Rush,* 2 vols. [Princeton: Princeton University Press, 1951]), bristle with characteristic anger, as Rush denounces the Congress for having been frightened out of Philadelphia by the mutiny of unpaid Pennsylvania troops and heaps scorn upon those who opposed his plan to establish a Presbyterian college at Carlisle, to be named after his friend John Dickinson.

Yet there was another side to Rush, shown not only in his deeply affectionate letters to his wife but also in his many idealistic and humanitarian activities: He was active in movements against slavery, alcohol, and capital punishment; he was a member of the American Philosophical Society; he was an immensely popular teacher in the University of Pennsylvania's medical school; and he helped Richard Allen found the first African Methodist Episcopal Church, the famous Mother Bethel. Engraver Moritz Furst's medallic portrait of Rush (1808), which shows so well the beaky nose and belligerent profile, is also inscribed with Rush's motto, Read-Think-Observe.

Peale's portrait shows us this philosophic Rush, the writer of *Thoughts upon Female Education* (1787), an important statement in its day, and the pioneering study *Medical Inquiries and Observations upon the Diseases of the Mind* (1812). The books on the table and in the bookcase represent the great figures of medicine on whose work Rush based his own career: Dutch physician Hermann Boerhaave, Hippocrates, and William Cullen, who had been Rush's teacher in Edinburgh. Rush based his own theory of disease on Cullen's work. Thomas Jefferson once told Rush, "[I] read with delight everything that comes from your pen" (review of Dagobert D. Runes, ed., *The Selected Writings of Benjamin Rush,* in *Pennsylvania Magazine of History and Biography* 72 [January 1948]: 87). This is the man whom Peale shows sitting quietly in his study, wearing a loose morning robe, or banyan, pausing in thought after writing on the paper before him, "Sec. 29. We come now gentlemen to investigate the cause of earthquakes."

Oil on canvas; 50¼ × 40 in.
Signed at left center "C W Peale / pinx: 1783" and at lower left "C W Peale / pinx: 1786."
Provenance: By descent in the family to Mrs. T. Charlton Henry of Philadelphia, who bequeathed it and the companion portrait, *Mrs. Benjamin Rush,* to Winterthur Museum.
Gift of Mrs. T. Charlton Henry, Philadelphia, Pa. Acc. no. 59.160.

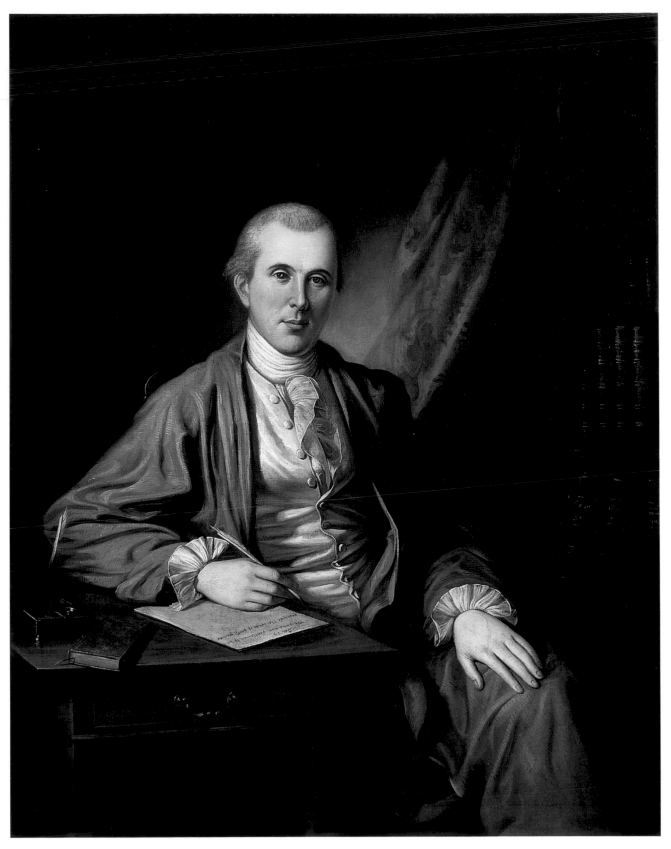

BENJAMIN WEST (1738–1820)

38. American Commissioners of the Preliminary Peace Negotiations with Great Britain (1783–84)

Four of the men depicted here—from the left, John Jay, John Adams, Benjamin Franklin, and Henry Laurens—formed the American commission that, accompanied by secretary William Temple Franklin (seated at right), negotiated the preliminary articles of peace with Great Britain. Signed on November 30, 1782, the preliminary articles paved the way for the treaty of peace, which was signed almost a year later by a different commission. The former acknowledged the independence of the United States from Britain, but the treaty, a general settlement among Great Britain, France, Spain, and the Netherlands, was needed to bring the de facto Anglo-American settlement into effect. Samuel Flagg Bemis, historian of the diplomacy of the Revolution, said of the men painted here:

Their action was the first decisive step to loose a new nation from Europe's bonds and Europe's distresses, so that those people after them might have freedom to expand, and to develop a new continent, to rise to surpassing power, and to do this during that century and a half which was to follow before the industrial and scientific revolutions of our own times united the nations of six continents in the embrace of a dynamic civilization and its political perils, placing them far closer to each other than the six great European powers stood in the days of Catherine II, Frederick the Great, Kaunitz, Florida Blanca, George III, and the Comte de Vergennes. The greatest victory in the annals of American diplomacy was won at the outset by Franklin, Jay, and Adams. [*The Diplomacy of the American Revolution* (2d ed.; Bloomington: Indiana University Press, 1957), p. 256. Bemis omits Laurens because he took part in the negotiations reluctantly and only at the last moment.]

Apparently, Benjamin West painted the group as the first of a contemplated "set of pictures containing the great events which have affected the revolution of America" (Historical Society of Pennsylvania, West to Charles Willson Peale, August 4, 1783). West later resigned his project to John Trumbull, but in the winter of 1783/84, following the signing of the treaty and the king's speech at the opening of Parliament acknowledging the independence of England's former colonies, the work was very much in West's mind. Adams and Jay were in London that winter and posed for West. Laurens's rather enigmatic likeness was also painted

from life. West painted William Temple Franklin, Benjamin Franklin's grandson, while William was visiting London in August 1784. But Benjamin Franklin's portrait is a triumph of West's artistic construction. Franklin was in Paris while West was working on the painting, and his health did not allow him to travel. West had last seen Franklin in 1775, eight years before. Consequently, West borrowed a bust of Franklin by Caffieri and a copy by Joseph Wright of Duplessis's portrait. A drawing by West of the Caffieri bust (American Philosophical Society) shows that West was trying hard to capture the shape and structure of the great head that, together with the dark costume, makes Franklin the dominant figure of the group.

West never completed the picture. One evening in 1817 he told John Quincy Adams that he left the group unfinished because British plenipotentiary Richard Oswald had refused to sit for his portrait. Adams wrote in his diary:

The most striking likeness in the picture is that of Mr. Jay. Those of Dr. Franklin, and his grandson, W. T., who was Secretary to the American Commission, are also excellent. Mr. Laurens and my father, though less perfect resemblances, are yet very good.

Mr. Oswald, the British Plenipotentiary, was an ugly looking man, blind of one eye, and he died without leaving any picture of him extant. This Mr. West alleged as the cause which prevented him from finishing the picture many years ago. Caleb Whitefoord, the Secretary of the British Commission, is also dead, but his portrait exists, from which a likeness may be taken. As I very strongly expressed my regret that this picture should be left unfinished, Mr. West said he thought he could finish it, and I must not be surprised if some day or other it should be received at Washington. I understand his intention to be to make a present of it to Congress. [*Memoirs of John Quincy Adams,* ed. Charles Francis Adams, 12 vols. (Philadelphia: Lippincott, 1874–77), 3:559.]
Yet the picture remained unfinished. After West's death it was purchased at the sale of his effects (Christie's, London) by Joseph Strutt, of Derby, England, in whose family it remained until 1916, when purchased by J. Pierpont Morgan. H. F. du Pont acquired it from Morgan in 1944.

Oil on canvas; 28⅜ × 36⁵⁄₁₆ in.
Unsigned.
Provenance: Joseph Strutt, Derby, England;

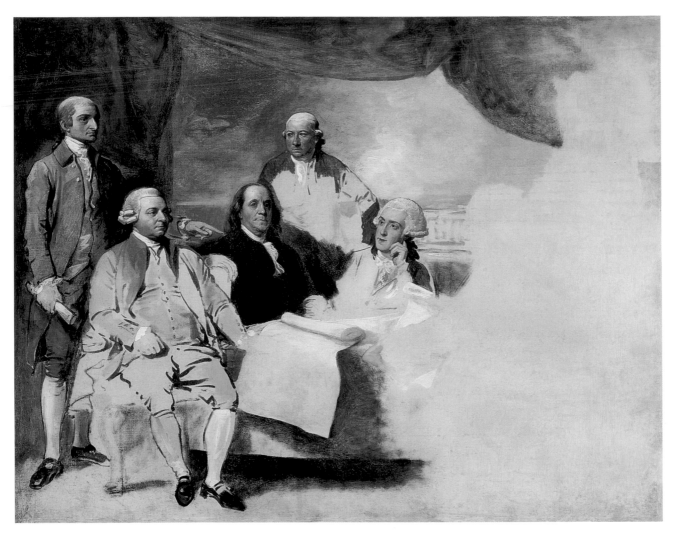

Edward Strutt, Lord Belper, his nephew; Henry Strutt, Lord Belper, his son; Algernon Henry Strutt, Lord Belper, his son; J. P. Morgan, New York; H. F. du Pont.
Acc. no. 57.856.
References: Alberts (1978), *Benjamin West,* pp. 15–35; Bowen (1892), *Centennial Celebration,* pp. 426, 481–82, 495; *Brooklyn Museum Quarterly* 4 (April 1917): 81; Marks (1974), "Benjamin West and the American Revolution"; Monaghan (1935), *John Jay,* p. 170; New York, Metropolitan Museum of Art (1936), *Franklin and His Circle,* no. 100, pp. 62, 64 (pl.); *Bulletin of the Metropolitan Museum of Art* 31 (May 1936): 101; Philadelphia Museum of Art (1938), *Benjamin West,* no. 35, pp. 38–39 and pl. 35.

WILLIAM WILLIAMS, SR. (1727–91)

39. Self-portrait (ca. 1788–90)

This portrait depicts William Williams, the artist who painted the sons of printer David Hall (nos. 23, 24). A palette is in his hand, and a chalk drawing of a landscape is pinned to the wall behind him. His velvet cap (worn for warmth on a shaved head when a wig was not worn) and loose banyan tell us he was an eighteenth-century gentleman. The sharp, observant face is that of a man of parts yet not of polish or of worldly success: it seems the face of a man who has seen more of the rough than of the smooth in life.

Williams worked at everything from painting stage scenery to giving flute lessons, living both in his native England and in towns throughout the American colonies. The final act in his life occurred in Bristol. A man named Thomas Eagles was walking home one evening when a beggar approached him. As told later by John Eagles, Thomas Eagles's son, the beggar said, "Sir, I have been looking about for a gentleman to whom I might with confidence address myself, and tell my wants. I think I have found him in you." After a pause, he continued, "I am alone in the world, have lost my wife and children, my two sons were killed at Bunker's Hill. I have nothing to live for. I want a place to die in. I ask for a pass to St. Peter's Hospital. I think you can obtain it for me." Although he was rough in appearance, his speech showed him to be no ordinary beggar, and Eagles questioned him further, saying, "You have certainly seen better days." "I have," replied the beggar, "I have been a painter—but am now old and alone, and only want where to end my life." (Quoted in Dickason, *William Williams,* pp. 5–6.)

Eagles arranged for the old man to enter the Merchants' and Sailors' Almshouse. He continued his interest in the artist, having him frequently in his own house and seeing that he enjoyed some extra comforts. When Williams died he left his effects—including this self-portrait and some books and papers—to Eagles.

Among Williams's papers was an extraordinarily picturesque narrative in manuscript. Passed on by Thomas Eagles to his son John, the manuscript was published at London in 1815 under the title *The Journal of Llewellin Penrose, a Seaman* (4 vols. [London: John Murray]). At that date, ninety-six years after *Robinson Crusoe* had been published, adventure stories were still very rare. *Llewellin Penrose* enjoyed a success sufficient to produce in 1817 a pirated German translation, but taken as Williams's autobiography by subsequent art historians, it has produced only disastrous confusion. Interestingly, X-ray photographs of the portrait reveal over-painting: the area that now shows the artist's palette and his hands at work painting originally showed the subject with a book and depicted him writing. Perhaps Williams had first wished to be remembered as a writer and on second thought deemed more memorable his career as a painter.

Oil on canvas; 30⅛ × 25⅛ in.
Unsigned.
Provenance: Thomas Eagles; John Eagles; Emma Jane Graham-Clarke; Leonard John Graham-Clarke; John Eagles Henry Graham-Clarke; H. F. du Pont.
Acc. no. 64.2202.
References: Dickason (1970), "West on Williams"; Dickason (1970), *William Williams.*

EDWARD SAVAGE (1761–1817)

40. The Washington Family (ca. 1789–90)

The Washington Family has a secure place among illustrations of American history less by reason of its excellence than by the fact that it exists at all. There is no other contemporary picture of General Washington and his family in a domestic setting at Mount Vernon. A stipple engraving of the picture, published in 1798, was popular instantly and was reproduced until it became part of our national imagery.

The painting shows a hero in retirement. The general, wearing the blue-and-buff uniform of commander of the army of the Revolution, sits at his ease on a terrace. He faces Mrs. Washington across the table on which is spread a map of the future capital of Washington, D.C. She points with her fan to some feature of the map, suggesting that they are in the midst of a pleasant discussion. Her two grandchildren, who grew up at Mount Vernon, stand beside them: the general's arm rests on the shoulder of George Washington Parke Custis, while Eleanor Parke Custis stands to her grandmother's right, helping her spread the map. Billy Lee, who was Washington's body servant throughout the war, stands behind Mrs. Washington. In the background is the noble prospect of the Potomac River as seen from Mount Vernon.

Referring to the portrait, a newspaper spoke of the general's "serene commanding aspect of a venerable man, whose presence alone calms the tempest" (*New York Morning Chronicle,* November 18, 1802). Such a characterization fitted into the mythology that began to grow around Washington immediately after his death. All that the newspaper writer could find to say about the image of Martha Washington was, "We cannot sufficiently admire the drapery of Mrs. Washington; it is inexpressibly graceful." Unfortunately, as was often done in portraying older women at the time (see no. 44), she is represented in a singularly unflattering bonnet.

Little is known of Edward Savage's early career. Born in Princeton, Massachusetts, he was painting in Boston by about 1785 and several years later was working in New York. In 1791 he traveled to London, where he engraved and published copies of his portraits, including one of George Washington

(1790, Harvard University). In 1794 he returned to Boston and there married Sarah Seaver (1765–1861). He spent most of the remainder of his life in Philadelphia (1795–1801), New York (1801–11), and Boston (1812–17). He was not a gifted artist, nor was he, so far as one may judge, an agreeable man. Other artists who knew him as a colleague or a teacher had nothing good to say of him or of his abilities. Yet he gave us an image that has been part of our national memory for two hundred years.

The picture exists in three forms:

1. Savage's small version, 18 by 24 inches, on panel. The eighteenth-century engraver worked from this small replica, which was approximately the same size as his copperplate. This version passed to Savage's son, Edward, Jr., of Springfield, Massachusetts. From him it passed to Theodore H. Bell of Springfield, in whose family it remained until sold to Charles D. Childs of Boston, who sold it in 1951 to Henry Francis du Pont.

2. A stipple engraving of the group, which Savage published in Philadelphia and London in 1798.

3. A large canvas (7 feet by 9 feet 3 inches) with life-size figures, now in the National Gallery of Art, Washington, D.C. Savage exhibited this painting with other canvases and curiosities in a museum he ran in partnership with another showman, David Bowen. The museum existed under various names, first in Philadelphia, then in New York, and then in Boston. In 1890 its proprietor, Moses Kimball, sold *The Washington Family* to Samuel P. Avery, Jr., from whom it passed to William F. Havemeyer, to Thomas P. Clarke, and to Andrew W. Mellon, who gave it to the National Gallery.

Oil on wood panel; 18⅛ × 24⅛ in.
Unsigned.
Provenance: The artist; the artist's son, Edward Savage, Jr.; Theodore H. Bell; the Bell family; Childs Gallery; H. F. du Pont.
Acc. no. 61.708.
Reference: Dresser (1952), "Edward Savage," pp. 199–204.

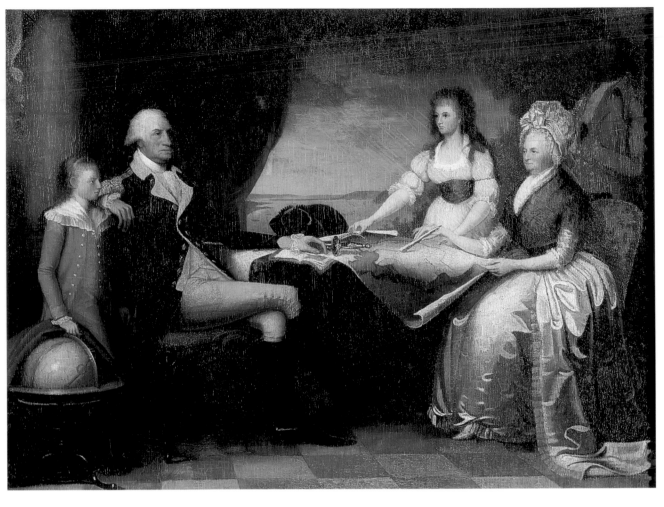

JOHN TRUMBULL (1756–1843)

41. Washington at Verplanck's Point (1790)

George Washington Parke Custis, a grandson of Martha Washington by her first marriage, offers a charming account of life at Mount Vernon during his childhood in his *Recollections of Washington*. What he writes of *Washington at Verplanck's Point,* which hung during those years in the New Room, does credit to its painter, John Trumbull:

The figure of Washington, as delineated by Colonel Trumbull, is the most perfect extant. So is the costume, the uniform of the staff in the war for Independence, being the ancient *whig colors,* blue and buff— a very splendid performance throughout, and the objection to the face as being too florid, not a correct one. He was both fair and florid. [*Recollections and Private Memoirs of Washington.* With *A Memoir of the Author by His Daughter* and notes by Benson J. Lossing (New York: Derby & Jackson, 1860), pp. 519–20.]

Trumbull, with no formal artistic training behind him, had gone to London in 1783 to study for six years under Benjamin West. In 1785 he began a series of historical paintings representing decisive events of the War of Independence, on which his fame now rests. In the autumn of 1789, he returned to America, bringing with him three finished studies and a number of unfinished pictures in which the portrait heads had to be added. Three of these unfinished pictures, showing victories of the Continental army, required the likeness of Washington. After visiting his family in Connecticut, the artist went to New York City, where the first federal government of the United States was being organized. He showed his pictures to General Washington, who was clearly impressed; between February 10 and July 13, 1790, he gave Trumbull no fewer than fourteen sittings. On March 1, Washington noted in his diary, "exercised on horseback this afternoon, attended by Mr. John Trumbull, who wanted to see me mounted" (*The Diaries of George Washington, 1748–1799,* ed. John C. Fitzpatrick, 4 vols. [Boston and New York: Houghton Mifflin Co., 1925], 4:93). Thomas Jefferson once described Washington as "easy, erect, and noble; the best horseman of his age, and the most graceful figure that could be seen on horseback" (*The Writings of Thomas Jefferson,* collected and ed. Paul Leicester Ford, 10 vols. [New York and London: G. P. Putnam's Sons, 1892–99], 9:448–49). Jefferson's assessment is not contradicted by Trumbull's three pictures that show Washington on horseback: *The Capture of the Hessians at Trenton* (1786–99), *The Death of General Mercer at the Battle of Princeton* (1787–94), and *The Surrender of Lord Cornwallis at Yorktown* (1787–97).

When the sittings for the preceding pictures had concluded, Trumbull painted the present portrait as a gift for Mrs. Washington. In the process, to quote George Custis again:

the painter had *standings* as well as sittings—the white charger, fully caparisoned, having been led out and held by a groom, while the chief was placed by the artist by the side of the horse, the right arm resting on the saddle. In this novel mode the relative positions of the man and horse were sketched out and afterwards transferred to the canvas. [*Recollections of Washington,* pp. 519–20.]

Probably no portrait of Washington was prepared for by more thorough acquaintance. The artist's father had been wartime governor of Connecticut and a strong supporter and trusted friend of the general; the painter himself had been one of Washington's aides-de-camp during the siege of Boston. Trumbull knew his subject as his former commander and as a family friend of long standing. Surely something entered from this relationship into his perception of Washington's character.

In 1790 Trumbull perceived a man who was slowly and carefully putting together an experiment in government, superimposing upon thirteen hesitant, jealous, and restless states a federal government. There were many officials of the new government to be chosen that spring; an army and a diplomatic service to be created; a national census to be taken so that the states would have their due representation in the Congress; a patent office to be established to encourage manufactures; and the enormous and intractable war debts of the old government to be somehow financed. The frontiers of the nation were still uncertain. Peace with England had given the United States title to the country south of the Great Lakes and as far west as the Mississippi River, but the British still held military posts in the northwest, and the Spanish and the Creek Indian Confederacy threatened control of the southern portion. The spring of 1790 was a time of problems and perplexities for the man who had been made president largely because he was

the only leader that all Americans would accept. As one studies Washington's face, one becomes aware of the traits that Trumbull knew—Washington's firmness, sense of duty, and tendency toward troubled reflection.

Trumbull had been a soldier in the War of Independence (he used his military title of colonel all his life). As a background for the figure of Washington, he chose a climactic, albeit nearly forgotten, event of the war. After the surrender of British forces in the South at Yorktown in the autumn of 1781, Washington at once brought the American army north to resume watch upon the main British force holding New York City. The French expeditionary force, which had supported the Americans at Yorktown, stayed the winter in Virginia, marching northward the following summer, in 1782. That autumn, the allied armies met again at the King's Ferry crossing of the Hudson River. This crossing, from Stony Point on the west bank to Verplanck's Point on the east bank, had been bitterly fought over during the war. Rochambeau described the meeting of the armies in his *Mémoires:*

The general, wishing to show his respect for France and his gratitude for its generous acts, had us pass between two ranks of his troops, clothed, equipped, and armed for the first time since the revolution, partly in materials and arms brought from France, partly from English stores taken with the army of Cornwallis and which the French army had generously given over to the American army. General Washington had his drums beat the French march during this entire review, and the two armies rejoined each other with the liveliest signs of mutual pleasure. [Translated from *Mémoires militaires, historiques et politiques de Rochambeau, ancien Maréchal de France, et Grand Officier de la Légion d'Honneur* (Paris: Chez Fain, 1809), 1:309.]

These few words provide an eloquent description of the scene in the background of Trumbull's painting—the Americans drawn up in two long ranks as the French march between them from the ferry landing to Washington's headquarters.

Oil on canvas; 30 × 20⅛ in.
Signed at lower right "J. Trumbull / 1790."
Provenance: Mrs. Washington; Elizabeth Parke Custis Law, her granddaughter; Edmund Law Rodgers; Mrs. Wilfred P. Mustard; Edmund L. R. Smith.
Acc. no. 64.2201.
References: Johnston (1882), *Portraits of Washington,* p. 71; Bowen (1892), *Centennial Celebration,* no. 38, facing p. 2, and p. 144; Morgan and Fielding (1931), *Life Portraits of Washington,* no. 4, p. 165; Sizer (1953), *Autobiography of John Trumbull,* pp. 165–66 n. 11, 326; Sizer (1967), *Works of Trumbull,* p. 82; Richardson (1967), "Washington by Trumbull"; Jaffe (1975), *John Trumbull,* pl. 9, facing p. 186, and pp. 314–15.

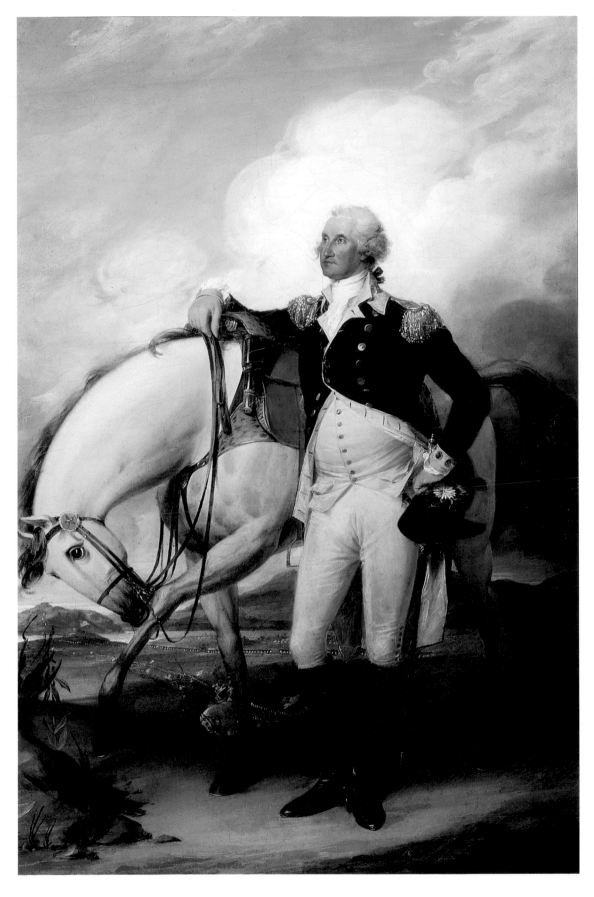

CHARLES WILLSON PEALE (1741–1827)

42. Mrs. Robert Milligan (Sarah Cantwell Jones) and Her Daughter Catherine Mary (1790–91)

This young mother was born Sarah Cantwell Jones in Newcastle, Delaware. About 1789 she married Robert Milligan, owner of a plantation in Maryland on the Sassafras River, and the following year gave birth to Catherine Mary. The Sassafras, one of the uppermost and prettiest rivers of the Eastern Shore, carried in the eighteenth century numerous travelers who were sailing between the plantations along its banks and the Delaware towns of Newcastle and Odessa, as well as the growing city of Philadelphia. Peale made several expeditions to paint portraits in this part of Maryland. On August 8, 1790, he arrived at the Milligan plantation, to which he had been invited so that he might paint Mrs. Milligan and Catherine Mary, her firstborn. At Sarah Milligan's insistence, Peale painted a separate portrait of her husband at the same time.

An irrepressible inventor of many fields, Peale saw much room for improvement in the tools of his trade. In the years after the Revolution, he explored the degreasing of paper, the preparation of canvas with soap, and the concoction of red pigments from cochineal. About 1790, he was experimenting with turpith mineral, a mercuric salt used as a yellow colorant. He tried the pigment in the Milligan portraits, probably in depicting flesh, but within a year it had darkened. Peale therefore returned on September 19, 1791, to repaint the damaged areas with a more trustworthy material.

The portrait of Sarah and Catherine Mary Milligan demonstrates the approach to depicting mother and daughter that Peale began to follow in the 1790s. His earlier attempts were generally more complicated; for example, in *Mrs. John Dickinson and Her Daughter Sally* (1773, Historical Society of Pennsylvania), the child sits beside the mother on a tall stone pedestal carved with a classical relief. Here, however, the canvas includes little more than the sitters. The mother holds the standing child in her lap, and the only object visible is the silver whistle, hung with bells and tipped with coral for teething, that Catherine Mary holds and that suggests her parents' affluence.

Catherine Mary grew up to marry American statesman and diplomat Louis McLane, the son of the famous Col. Allan McLane of Wilmington, Delaware, a daring leader of light cavalry in the War of Independence. Peale painted Colonel McLane about 1818 for the collection of portraits of great men in Peale's Philadelphia museum.

Oil on canvas; 24 × 22¾ in.
Signed at left "C. W Peale / painted 1791."
Bequest of Katharine A. Batchelder,
Beverly, Mass. (1977).
Acc. no. 77.157.
References: Stoner et al. (1979), "Portrait of C. W. Peale Restored by C. Volknar."

SAMUEL JENNINGS (ca. 1755–ca. 1834)

43. Liberty Displaying the Arts and Sciences (1792)

Allegory and symbolism appear rarely in American art. They seem not to be native to our prevailing forms of thought, except when there arises some special urge to give symbolic shape to our ideals. Such an urge was strongly felt at the beginning of the Republic, when symbols like the Great Seal, Columbia as the Genius of America, and the Goddess of Liberty were created to represent a new nation and its government. The painting *Liberty Displaying the Arts and Sciences* is one allegory from this period.

Little is known of its painter, Samuel Jennings. He appears to have been born and trained in Philadelphia, where, on January 8, 1787, he advertised himself in the *Pennsylvania Packet* as a painter of miniatures and teacher of drawing. By 1789, however, he was in London, and he spent the remainder of his life there. He exhibited portraits and classical and religious subjects at the Royal Academy, the British Institution, and the Associated Artists until 1834. While Jennings's ties to Philadelphia were still fresh, he heard that the Library Company of Philadelphia was building an elegant library on Fifth Street. Through his father, who was then secretary of Green Tree Insurance Company, he offered to paint a "history" to place over the mantel of the new library's principal room. He suggested that the subject be either Clio, the muse of history; Calliope, the muse of harmony; or Minerva, the goddess of wisdom. The directors of the Library Company were pleased with Jennings's overall plan but, instead of Jennings's ideas, requested as a subject

Liberty (with her Cap and proper Insignia) displaying the arts by some of the most striking Symbols of Painting, Architecture, Mechanics, Astronomy &ca., whilst She appears in the attitude of placing on the top of a Pedestal, a pile of Books, lettered with, *Agriculture, Commerce, Philosophy & Catalogue of Philadelphia Library.*

In addition, because many of the directors were active in the Philadelphia movement against slavery, they asked for

A Broken Chain under her feet, and in the distant back Ground a Groupe of Negroes sitting on the

Earth, or in some attitude expressive of Ease & Joy. [Quoted in Smith, "*Liberty Displaying the Arts and Sciences,*" p. 89.]

This kind of additive composition, strange to us who are accustomed by the camera to images of a single instant, involved looking at one item after another and adding them mentally into a total complex of ideas. Jennings illustrated all the ideas suggested by the directors and added a few of his own, such as a bust of English reformer Henry Thornton, a terrestrial globe, a columned portico, and a distant landscape with ships under sail. The original work, somewhat stiff but decorative and pleasing to the eye, has ornamented the rooms of the Library Company of Philadelphia since 1792.

While he was fulfilling his commission for the Library Company, Jennings planned a popular version of the same subject. In the June 11, 1792, Pennsylvania *General Advertiser,* he advertised a stipple engraving, fifteen by eighteen inches, at twenty-five shillings, to be delivered to subscribers in the following year. The print was never issued, perhaps because the world was sliding rapidly into a general war between revolutionary France and the conservative European monarchies. However, Jennings did paint this small version for the engraver to work from; it is signed and dated 1792. Showing the business instinct that was to carry the artist through forty-five years of activity in the London art world, he added one detail: beside the figure of Liberty is a shield painted in the British colors. To the British public, the figure would thus read as Britannia presiding over the English abolition movement, while to the American eye, she was American Liberty.

Oil on canvas; 15 × 18 in.
Signed at lower right ". . . Jennings / . . . 1792."
Acc. no. 58.120.2.
References: Dunlap (1834), *Rise of the Arts of Design,* 1:435, 2:471; Scharf and Westcott (1884), *History of Philadelphia,* 2:1045; Prime (1932), *Arts and Crafts,* p. 16; Smith (1949), "Philadelphia Allegory"; Smith (1965), "*Liberty Displaying the Arts and Sciences.*"

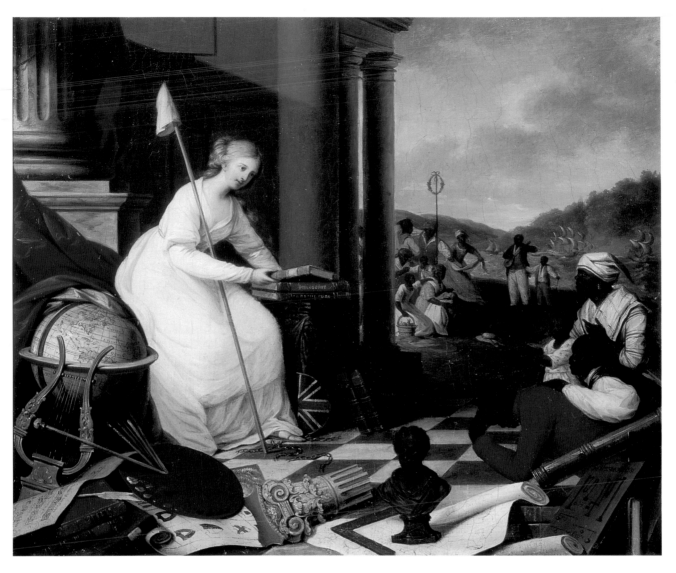

JAMES EARL (1761–96)

44. Mrs. William Mills (Rebecca Pritchard) and Her Daughter Eliza Shrewsbury (1794–96)

At the end of the eighteenth century, Charleston, South Carolina, was rich, elegant, yet so small that everyone knew everyone else. Life in Charleston was a complex mesh of relationships. The mother in this double portrait by James Earl, for example, was the sister of Mrs. Purves, painted twenty years earlier by Benbridge (no. 34). Born Rebecca Pritchard, she married Edward Shrewsbury of Charleston and had one child, Eliza, who sits here beside her. Edward Shrewsbury died in 1793, and two years later his widow married William Mills of Charleston. The woman we see here is certainly not in mourning, so we must assume that Earl, who arrived in Charleston in 1794, painted Rebecca after her second marriage. William Mills was fortunate to have an excellent portrait painter arrive in town to paint his handsome new wife and new stepdaughter.

James Earl, born in Paxton, Massachusetts, was the younger brother of Ralph Earl (1751–1801), a New England portraitist who studied under Benjamin West in London. Like his brother, James went to England as a young man, studied painting in London, exhibited at the Royal Academy, and returned to America as a skillful portrait painter. He chose Charleston as the place to practice his art and found there ample patronage for his talents. During this time, he painted the double portrait *Elizabeth Fales Paine and Her Aunt* (Rhode Island School of Design), whose composition differs from the present example's primarily in that the younger subject is seated in a side chair next to the sofa.

Earl was cut down by yellow fever only two years after his arrival. The *South Carolina State Gazette* (August 20, 1796) said of him:

This gentleman has resided for nearly two years in this city, in which time he has exhibited so many specimens of his art as to enable us to speak with decision of his talents. To an uncommon facility of hitting of the likeness, may be added a peculiarity in his execution of drapery, and, which ever has been esteemed in his art the NE PLUS ULTRA, of giving life to the eye, and expression of every feature.

He was a Royal Academician in London, where he resided ten years and where his wife and children are; and his name appeared equally prominent with the other American geniuses of the present time, Copley, West, Trumbull, Savage.

As a man, he must be regretted as possessing a suavity of disposition, benevolence, and good humor. As a husband, a father, we attempt not to reach his merits! [Quoted in Rutledge, p. 124.]

Beautiful drapery, animation of expression, vivid life in the eyes, suavity of tone—the artist shows all such qualities in this portrait. James Earl had every gift except time.

Oil on canvas; 40¹⁄₁₆ × 50³⁄₁₆ in.
Unsigned.
Provenance: Cordelia Eason.
Acc. no. 60.554.
Reference: Rutledge (1949), *Artists of Charleston*, p. 124.

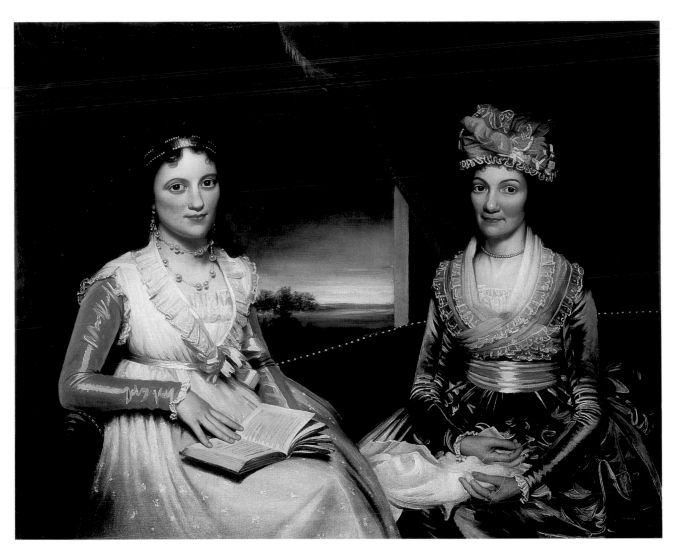

FREDERICK KEMMELMEYER (w. 1788–1803)

45. General George Washington Reviewing the Western Army at Fort Cumberland, the 18th of October 1794 (after 1794)

During Washington's first term as president, one of the great problems facing the new government was the ruin of the country's commercial credit. In the revolutionary war, each state had borrowed heavily from merchants and bankers in Europe, incurring debts that they either could not or would not pay after the war. The solution offered by Alexander Hamilton, Washington's secretary of the treasury, was to have the new federal government of 1789 assume these debts. He persuaded Congress to accept his plan by striking a bargain with Jefferson and Madison through which, if the debts were assumed, the capital of the new union would be located in a southern state rather than in Philadelphia. A federal tax on whiskey would in turn provide the money for the new capital. But it was not clear whether the tax could be collected from the countless farmers who then made whiskey in their own stills (especially on the frontier, where distilling was the best use of any grain that could not be hauled to distant markets).

For a time the government collected the tax, and all went well. But any dispute over the tax required farmers on Pennsylvania's western frontier to make a long journey across the mountains to appear in court in Philadelphia. In 1794, during Washington's second term, organized opposition to the whiskey tax broke out among the farmers. The commissioners sent by Washington to investigate found the region in chaos and the authority of the federal government seriously undermined. The situation seemed a repetition of that of 1786, when Shays's Rebellion in western Massachusetts convinced Washington that the government of the confederated states lacked the power to maintain internal peace. He therefore considered it imperative that the new government prove its ability to keep order during this crisis.

Because the nation's small regular army, under Gen. Anthony Wayne, was far off in the Ohio wilderness fighting an Indian war, Washington called out the militias of Virginia, Maryland, Pennsylvania, and New Jersey. The men responded cheerfully and marched west to Fort Cumberland, Virginia, where Washington reviewed them. The whiskey rebels were overawed by the show of force, and the rebellion was subdued without a shot being fired. This result gave proof to Washington that the New Republic was going to succeed. He wrote to Edmund Pendleton:

The spirit with which the militia turned out in support of the constitution and laws of our country, at the same time that it does them immortal honor, is the most conclusive refutation that could have been given to the assertions of Lord Sheffield and the predictions of others of his cast that without the protection of Great Britain we should be unable to govern ourselves; and would soon be involved in anarchy and confusion. [Worthington Chauncey Ford, ed., *Writings of George Washington* (New York: G. P. Putnam's Sons, 1892), 13: 33–34.]

Some of the triumph felt by Washington is preserved in the bright, cheerful image painted by Frederick Kemmelmeyer, a naive painter active in Maryland from about 1788 to 1803. He is said to have been present at Fort Cumberland and to have seen Washington's review, which he painted several times. However, a very similar, although technically more advanced, portrayal of the scene has been attributed to Charles Willson Peale's youngest brother, James (Metropolitan Museum of Art). Perhaps, then, Kemmelmeyer derived his own versions from Peale's. Although each example has its own variations, they all show the same enthusiasm.

Winterthur also owns Kemmelmeyer's *General Weyne Obtains a Complete Victory over the Miami Indians, August 20th, 1794* (ca. 1800), whose composition, although depicting a battle rather than a review, is somewhat similar to the present example.

Oil on paper backed with linen; 18⅛ × 23⅛ in.
Signed at lower left "F. Kemmelmeyer. Pinxit."
Inscribed: "GENERAL GEORGE WASHINGTON. / Reviewing the Western army at Fort Cumberland the 18th of Octobr 1794."
Provenance: Robert Fridenberg.
Acc. no. 58.2780.
References: Johnston (1882), *Portraits of Washington*, p. 142; Morgan and Fielding (1931), *Life Portraits of Washington*, no. 2, p. 199; Gardner and Feld (1965), *American Paintings*, pp. 67–70.

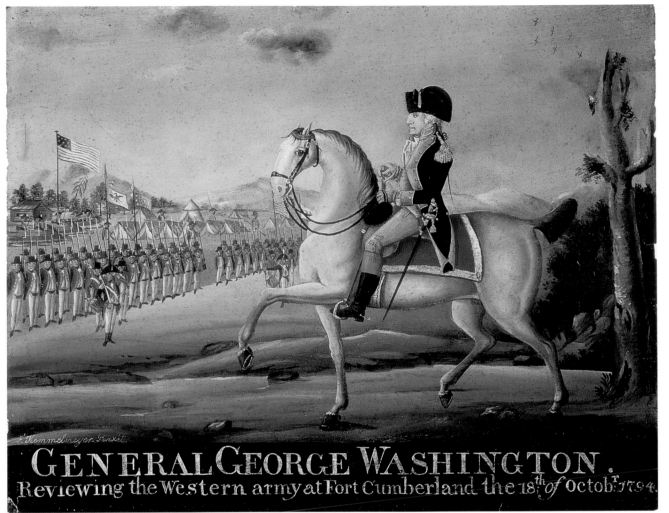

[Artist unknown]

46. Perry Hall, the Home of Harry Dorsey Gough (ca. 1795)

To live in a pleasant country house, exchanging the noise and dirt of the city for the occupations of a gentleman farmer, was a powerful ideal in the eighteenth century. Spreading from Great Britain to the North American provinces, it affected the American colonies profoundly. The popularity of the ideal in this country is witnessed by the sale of English engraved "Views of Gentleman's Seats," advertised from the middle 1740s by printsellers such as William Bradford in Philadelphia. In the 1790s a number of English engravers and painters migrated to America and began portraying American country houses.

Once situated near today's U.S. Route 1, Perry Hall was one of the largest houses of the time in Maryland. Its owner, Harry Dorsey Gough (1745–1808), was a Baltimore merchant who had inherited a large fortune in England. In 1774 he purchased a country house that later became the central portion of Perry Hall, located about twelve miles from Baltimore on the south side of the falls of the Gunpowder River. It was a large stone house with a fine prospect (although the absence of large trees is striking); Gough added to it the two wings seen in this view. One wing contained an elaborate marble-lined bathhouse with a pool, a hot room, and a steam room in the Roman fashion; the other wing contained a room large enough to be used, after Mrs. Gough was converted to Methodism, as a chapel, seating seventy-five. In 1782/83 John Rawlins was paid £394.10.11 for ornamenting and plastering the ceilings; as an outgrowth of this work, General Washington engaged Rawlins to do the ceiling and frieze in the New Room at Mount Vernon.

Horses and horse racing were then as now part of the life of a gentleman farmer in Maryland, and Gough had at least one famous racehorse. However, Mrs. Gough's conversion to Methodism changed the tone of life at Perry Hall, and her husband turned from horse racing to the study of advanced methods of farming. In 1786 Gough became the first president of the Society for the Encouragement and Improvement of Agriculture in Maryland. His imported English cattle and broad-tailed Persian sheep were famous. One hears of Gough's animals also in General Washington's correspondence; he thought Gough's prices very high. Sheep graze in the foreground of the view of the house, and a building at the right in the middleground appears to be a sheepfold.

Gough evidently became as active a Methodist as his wife. In December 1784 Perry Hall was used for a meeting between Francis Asbury, the only Wesleyan missionary who stayed in America during the Revolution, and Thomas Coke, who had just arrived from England with a new group of missionaries. During their ten days at Perry Hall, the men planned the Christmas Conference, at which the American Methodist Episcopal Church would be organized, and ordained Francis Asbury as its first superintendent.

Several of the figures in the foreground of *Perry Hall* have been identified. The two ladies are Mrs. Gough and her daughter, Mrs. James Carroll; they are talking with Mr. Carroll; Mr. Gough is on horseback; and two grandchildren are with their nurse. Gough died in 1808, leaving Perry Hall to his wife for her life, then to his grandson, Harry Dorsey Gough Carroll (1795–1866). In 1824 fire destroyed the east wing and part of the main building. The surviving portion was rebuilt in a simpler style.

Oil on canvas; 38½ × 51¾ in.
Unsigned.
Provenance: By descent in the family to Prudence Gough Carroll (Mrs. James Winn); Mary Winn; Mrs. Arthur B. Keating (until March 1939).
Acc. no. 57.670.
References: Pleasants (1954), "Francis Guy"; Colwill (1981), *Francis Guy,* p. 111.

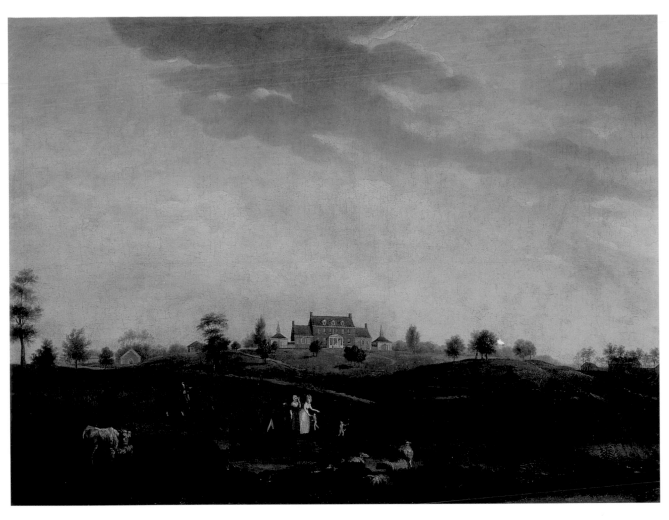

GILBERT STUART (1755–1828)

47. George Washington (1795–96)

Although Gilbert Stuart was born and raised in Rhode Island, it was in England that he won a reputation for brilliant success as a portraitist who practiced the flattering, decorative London style of painting. When Stuart returned to America in late 1792 or early 1793 after eighteen years abroad, his notoriety made it almost inevitable that he should seek to paint the most renowned American of his day—George Washington. The artist spent some months first in New York City, establishing himself in America with a series of admirable portraits. In 1795 he went to Philadelphia, where, in September, he painted his first portrait of Washington. Known as the Vaughan portrait, it shows the right side of Washington's head, while the so-called Athenaeum portrait shows the left. Samuel Vaughan, whose name is attached to the portrait because he bought the original life study from Stuart, was an English merchant in the American trade and a great admirer of Washington. The handsome fireplace in the New Room at Mount Vernon was his gift, a mark of his admiration for the leader of America.

The Vaughan portrait of Washington created a sensation when Stuart placed it on exhibition in the State House, Philadelphia. Orders for repetitions showered the artist. In 1923 Mantle Fielding listed fourteen copies from Stuart's own hand (Fielding, *Gilbert Stuart's Portraits of George Washington* [Philadelphia: Privately printed, n.d.], p. 113); subsequent students have added others. The first version from life is possibly that which was given by Andrew Mellon to the National Gallery of Art, Washington, D.C. The second in Fielding's list, painted for Col. George Gibbs of New York City, is in the Metropolitan Museum of Art. The third is the present example, executed for William Bingham of Philadelphia, a senator in the new federal government and a strong supporter of Washington.

The Vaughan likeness is considered Stuart's best version, yet the artist was dissatisfied with it. In the following year he asked Washington for another opportunity to paint him and so created the Athenaeum portrait. The Winterthur portrait, a Vaughan type, shows us a personality of great dignity and force. In all the Vaughan-type portraits Washington has an impenetrable quality, a formidable presence; there is none of the benign air that has made the Athenaeum portrait so popular.

That impenetrable quality has sometimes been attributed to Stuart's confusion in the presence of Washington. The artist's daughter Jane later said that her father, normally the most entertaining of men and always able to enliven a sitting, found himself tongue-tied and overwhelmed in Washington's presence. Another explanation is that Washington, having lost his teeth, was wearing a new set of false teeth so ill-fitting and uncomfortable as to enforce a severe, unsmiling silence. Whatever truth may be in these interpretations, they leave out of consideration that the portrait was painted at a moment of disappointment and bitter unhappiness in Washington's life.

On his sixty-third birthday, in February 1795, Washington was depressed by his deafness, loss of teeth, and general debility. Further, he had for some six years been away from his beloved Mount Vernon, having reentered public life to help to preserve the union of thirteen independent states. He feared the union was about to break up and in its dissolution be an easy victim to the great powers of Europe. Largely on his initiative, a convention had been called at Philadelphia to seek "a more perfect union," and he had taken the responsibility of being president of the new government that emerged. Although Disraeli once observed that "men are governed either by force, or by habit," in 1795 the young federal government, having neither, rested solely on the confidence of its citizens in Washington.

At this moment an episode, personally distressing to the president, worsened the situation. Washington's only long-standing Virginia friend still in the cabinet was the secretary of state, Edmund Randolph, a man of graceful manners upon whom Washington relied to keep in touch with the French minister, Joseph Fauchet, during the current debate on a treaty between the two countries. In August 1795 a storm broke around Randolph. A British frigate, *Cerberus,* had stopped the French packet *Jenn Bart* in midocean. A splash was heard as something was thrown overboard from the French ship. A British sailor, leaping into the sea, retrieved a bundle of papers that included a dispatch from Fauchet to his government, in which he hinted that "several thousand dollars" paid to the always impecunious Randolph could influence the American decision. When the dispatch was translated and

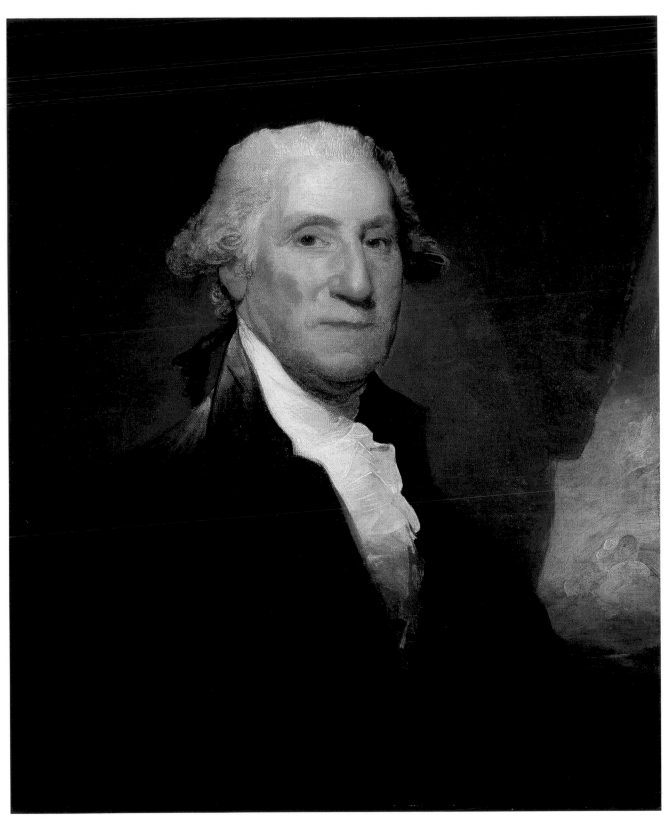

made known in Philadelphia, Randolph was forced to resign, and Washington lost his last old friend in the government. The treaty was ratified.

An ability that Washington exhibited at times of great stress was to withdraw into stoical silence. He would do his duty at whatever cost and keep his own counsel. "No art or address could draw him from an opinion which he thought prudent to conceal," observed Aaron Bancroft, an early biographer of the general who served with him in the Revolution. Is this what we see in Stuart's portrait, painted just a few days after Randolph's resignation—an impenetrable reserve, marking a personality of great power and dignity?

Oil on canvas; 28¾ × 23½ in.
Unsigned.
Provenance: William Bingham; James Kitchen; Dr. James Kitchen; Charles Henry Hart; Marsden J. Perry; Arthur Meeker; James Cox Brady.
Acc. no. 57.857.
References: Hart (1902), "Stuart's George Washington," p. 509; Park (1926), *Gilbert Stuart,* no. 3; 2:847; Morgan and Fielding (1931), *Life Portraits of Washington,* pp. 251–52, no. 3; Eisen (1932), *Portraits of Washington,* 1:201, pl. 16.

GILBERT STUART (1755–1828)

48. Mrs. Perez Morton (Sarah Wentworth Apthorp) (ca. 1802–3)

> Let not the CRITIC, with disdainful eye
> In the weak verse condemn *the novel plan;*
> But own that VIRTUE bears in *ev'ry sky*
> Tho wayward frailty is the lot of man.
>
> Dear as ourselves, to hold each faithful friend,
> To tread the path, which INNATE LIGHT inspires,
> To guard our country's *rites,* her soil defend,
> Is all that NATURE, all that HEAV'N requires.

With this epilogue, Sarah Morton closed her poem *Ouâbi; or, The Virtues of Nature, an Indian Tale* (Boston, 1790), a work that made her famous. It was highly, even extravagantly, praised. Republished in London, the plot of *Ouâbi* was borrowed for an English play, and one of the author's admirers even named Morton the American Sappho.

Sarah Morton was well born, charming, rich, and talented. She must have fascinated Gilbert Stuart when she and her husband visited Philadelphia from Boston in 1802, for he painted her three times. A half-length portrait shows her seated in an armchair, a pose that Stuart frequently employed. The portrait at Winterthur, however, is more complex. Mrs. Morton is characterized here as an author (seated before pen and paper), as a figure of elegance (fastening a pearl bracelet on her wrist), and as a friend and admirer of the late Washington (owning a copy of Houdon's bust of the first president). The third portrait, most unusual in Stuart's work, shows her with lifted arms adjusting a lace mantilla about her chestnut hair. Left unfinished, and one of Stuart's most fascinating sketches, it was kept by the artist in his studio until his death.

Sarah Morton's beauty was of the type that embodied the neoclassical ideal—an oval face with clear-cut features, a small mouth, and large dark eyes. She had talent as well as beauty, although—judging from the little attention *Ouâbi* receives today—perhaps not so much talent as her friends and admirers supposed.

Ouâbi is a tale of nature's noblemen in the American forest. The plot involves a heroic chief of the Illinois Indians, Ouâbi, two Indian girls, Azâkia and Zisma, and a white youth, Celario, who falls in love with Azâkia. Ouâbi dies fighting the Hurons, Azâkia and Celario are united, and Zisma is left alone. Neither the poem's plot nor its sentiment moves modern readers.

Oil on panel; 29½ × 24 in.
Unsigned.
Provenance: The subject's granddaughter, Griselda Eastwick Cunningham, wife of the Rev. Joseph Hart Clinch; Rev. Joseph Hart Clinch; Mary Josephine Clinch; Mary Griselda Gray of Halifax, Nova Scotia; Una Gray; John Hay Whitney.
Acc. no. 63.77.
References: *Port Folio* (1803); Mason (1879), *Gilbert Stuart,* pp. 225–28; Park (1926), *Gilbert Stuart,* no. 563, 2:537–38; Whitley (1932), *Gilbert Stuart,* pp. 118–20; Mount (1964), *Gilbert Stuart,* pp. 242–48, 256–66.

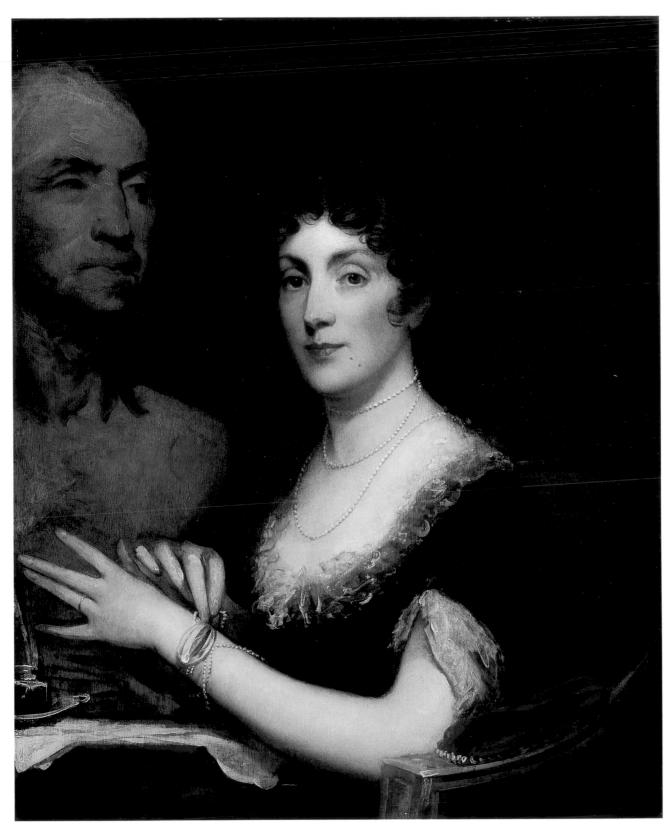

JAMES PEALE (1749–1831)

49. Washington at the Battle of Princeton (1804)

James Peale, a younger brother of Charles Willson Peale, was first trained as a cabinetmaker on the Eastern Shore of Maryland and became a frame-maker and painter by the early 1770s. After seeing fierce action in the Revolution, during which both James and Charles fought on the American side, he joined Charles in Philadelphia as a studio assistant and painter in his own right. By 1786 he was so competent as a miniaturist that Charles resigned the field to him. The brothers remained close collaborators. James had a part in the Peale workshop's copying of portraits of Washington and other historic subjects, but how large a part is difficult to determine. His original works are a little stiffer and less atmospheric than his elder brother's; his range of subjects, however, is wide, including both life-size and miniature portraits, conversation pieces, landscapes, narratives, and still lifes. Despite his versatility, working in less than life size, as here, was always congenial to him.

During the Revolution, James had served as an officer in Smallwood's Maryland regiment, one of the more famous fighting units of the Continental army. The regiment suffered heavy losses at the Battle of Long Island; by the end of the retreat from New York to the Delaware River, it had been reduced from 1,000 men to 5 officers and 158 enlisted men. What was left of the regiment nonetheless fought in Mercer's brigade, which marched in advance at Princeton and was overrun in the first sharp collision of the armies. James Peale knew, if anyone did, how savage that action was.

Yet when he painted this picture twenty-seven years after the battle and five years after Washington's death, he chose to paint his hero as a symbol of victory and calm, as a man above the storms felt by ordinary people. In the background, at the left, is Princeton University's Nassau Hall; at the right, General Mercer lies wounded, and the American and British lines face and fire at each other. But Washington, on his fine chestnut mount, halts, calm and triumphant. It is Washington as the people of his country wished to remember him, not as a soldier might have seen him on a cold, furious morning in New Jersey long before.

Oil on canvas; 36 × 27 in.
Signed at lower right "I. Peale / 1804."
Provenance: Said to have been given by Rembrandt Peale to the grandfather of Frank Mears of Philadelphia; Frank Mears; H. F. du Pont (1930).
Acc. no. 59.1391.
Reference: Egbert (1952), "General Mercer at the Battle of Princeton."

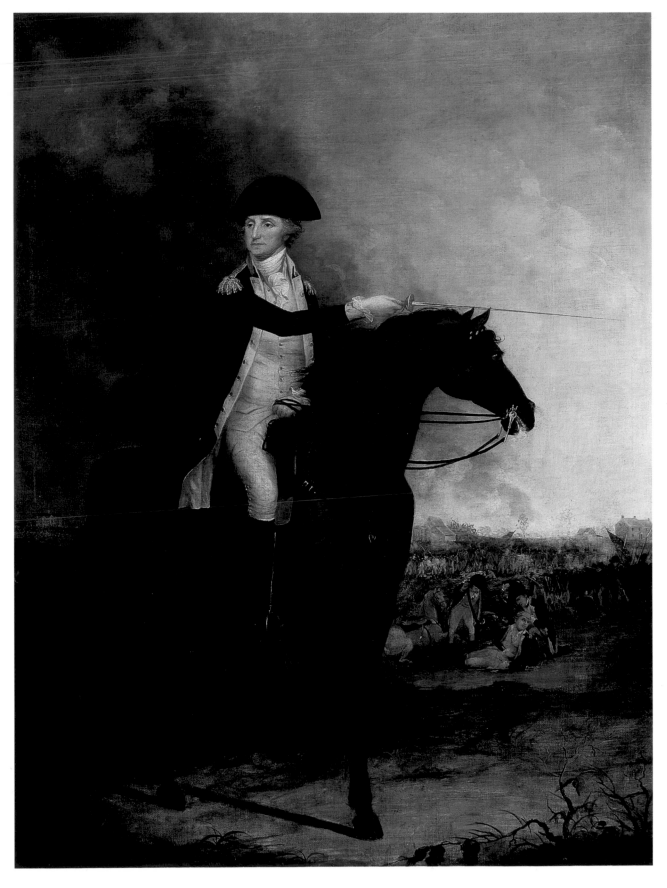

CHARLES BALTHAZAR JULIEN FEVRET DE SAINT-MÉMIN (1770–1852)

50. An Osage Warrior (ca. 1804)

Charles Saint-Mémin came to portraiture by an unusual route. Born in Dijon, France, to a family of the lesser French nobility, he was educated for the army. When the French Revolution came, he joined, in 1790, the "Army of the Princes" as a lieutenant colonel. When that army was disbanded, he moved on to Switzerland. In 1793 he and his father traveled by way of Holland, England, Canada, and the United States to reach the plantations owned by his mother in Santo Domingo. But while in New York City they learned of an insurrection on the island and abandoned hope of settling there. The artist's mother and sister joined them in New York; for a time he and his father cultivated a vegetable garden. Then John R. Livingston introduced the young Saint-Mémin to a public library, where he learned engraving from instructions in an encyclopedia. His first engravings were landscapes, but in 1796 he began the far more lucrative practice of portraiture.

Saint-Mémin was the first portraitist in America to use the physionotrance, a device invented in France some years earlier to enable an artist to copy mechanically the exact profile of a sitter. Saint-Mémin used the device to create portraits on tinted paper; he then finished his portraits in black and white pastel. In addition, by means of a pantograph, he reduced each image onto a small copper disk and engraved the likeness. He charged thirty-three dollars for the drawing, the plate, and a dozen engravings. These likenesses, quickly made and very decorative, proved extremely popular, and Saint-Mémin was able to employ at least two assistants. He worked in New York (1796–98); then in Burlington, New Jersey (where his mother had started a school), and Philadelphia; in Washington, Baltimore, Annapolis, and Richmond (1804–8); and in Charleston (1809). In 1810 Saint-Mémin returned to France. He was back in New York in 1812, remaining there until 1814, when he left once again for France. In 1817 he became director of the museum at Dijon, a position that he held until his death in 1852.

While he was in Washington, a delegation from the Indian tribes of the Missouri River came to the capital at the invitation of President Jefferson. Meriwether Lewis, who accompanied them, commissioned a series of portraits of the Indians from Saint-Mémin; eight of these portraits are in the New-York Historical Society. The Indians were a great curiosity to a young English diplomat in Washington, Sir Augustus John Foster, then secretary to the British minister. He joined the delegation on a tour of Philadelphia, reporting afterward:

The Ozage Chief would never sit when he saw a lady without a chair. They were particularly observant not to commit the slightest impropriety and their manners were perhaps more gentlemanlike than those of . . . their civilized superiors. [Wollon, "Foster and 'The Wild Natives of the Woods,'" p. 208.]

Foster acquired five Saint-Mémin watercolor portraits of the Indians, each half the size of life. These portraits descended in his family until they were sold in London in 1926. Purchased by Luke Vincent Lockwood, they were sold in New York with his collection in 1954, when this example came to Winterthur.

The unidentified Osage warrior shown here wears ceremonial dress: a band of black cloth around his chest, a black scarf around his throat, a crest of red feathers on the back of his head, bright red tone on his body and face, and other colors above his ear. A trade-silver band, engraved with the Seal of the United States, encircles his arm.

When one considers that the physionotrace could give only a profile in single outline, the remainder of the portrait being completed in crayon by Saint-Mémin with remarkable assurance, delicacy, and elegance, one must agree with Theodore Bolton's judgment that Saint-Mémin was "the greatest early American black crayon portrait draughtsman" (*American Portrait Draughtsmen in Crayons*, p. 64).

Watercolor on paper; 7½ × 6¾ in.
Signed at lower left "St. Memin fecit."
Provenance: Sir Augustus John Foster; Lady Foster, London (1926); Luke Vincent Lockwood, New York (1954).
Acc. no. 54.19.3.
References: Bolton, *American Portrait Draughtsmen in Crayons*, pp. 62–70; Lockwood (1928), "St. Memin Indian Portraits"; Norfleet (1942), *Saint-Mémin in Virginia*, p. 36; Wollon (1952), "Foster and 'The Wild Natives of the Woods'" (see esp. pl. 6); Ewers (1966), "'Chiefs from the Missouri'"; Foley and Rice (1979), "Visiting the President" (see also cover illustration).

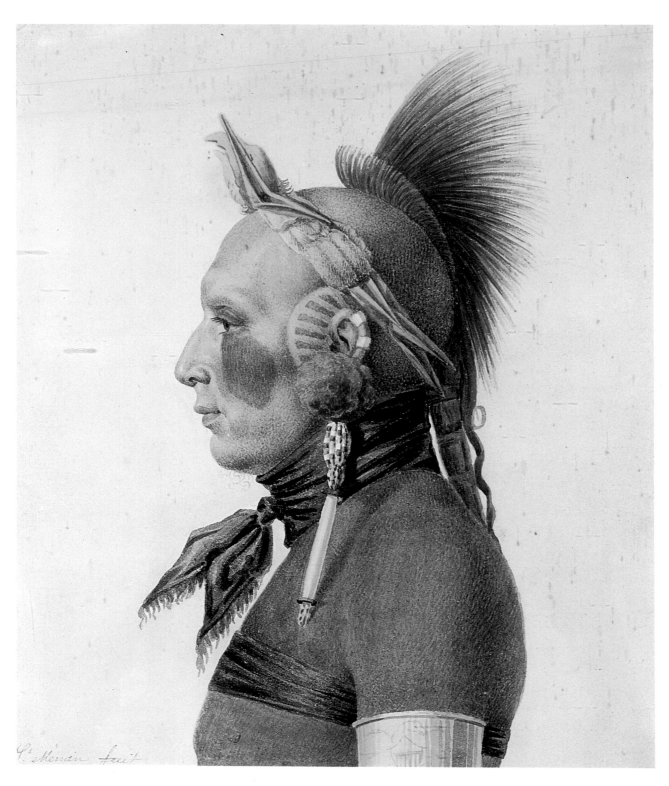

St Memin fecit

JOHN TRUMBULL (1756–1843)

51. Mrs. John Trumbull (Sarah Hope Harvey) (ca. 1805)

Soldier, diplomat, and painter, John Trumbull was a portraitist of great gifts, as this likeness of his wife demonstrates. At the time of their marriage, he was forty-four years of age, his bride twenty-six. He had for a time forsaken painting for diplomacy; sent to London in 1794 as secretary to John Jay, who was negotiating a treaty with Great Britain, Trumbull had stayed on as a commissioner to settle claims arising from the treaty. His marriage six years later to an Englishwoman, Sarah Hope Harvey, came as a complete surprise to his friends.

An atmosphere of mystery has always enveloped the identity and early life of the bride. Theodore Sizer, the leading student of Trumbull, told the story of their marriage:

A little drama took place before the ancient Parish Church of St. Mary, Hendon (seven miles from London), on a Monday, the first day of October 1800. A small group of puzzled men and women had just attended the unexplained marriage of the handsome, middle-aged Colonel John Trumbull and his strikingly beautiful bride of twenty-six. They were, one and all, seeking an answer to the question: why had the proud, painter-turned-diplomat, a socially conscious member of one of the first families of Connecticut, suddenly, almost secretly, married an obscure, uneducated English girl? The group was composed of the Rev. Ralph Woseley, the Church of England priest who had just performed the wedding service; Elizabeth Halbrook, an official witness, presumably a friend of the bride; and two of the artist's old Harvard friends, Christopher Gore [brother of the children shown in no. 19], later governor of Massachusetts and United States senator (another witness), and Rufus King, American Minister to Great Britain. The inquisitive wedding guests stood aside as the coach rumbled up to carry off the newly married pair. Rufus King, who had given the bride away, acting as spokesman, turned to Trumbull and inquired who the lady might be. The Colonel's curt reply was simply: "Mrs. Trumbull, sir." [Sizer, *Works of Trumbull,* p. 157.]

Although Trumbull may have fallen in love with no more than a pretty face, he nonetheless remained a devoted and affectionate husband until Sarah Trumbull died in 1824. He painted her portrait often—for the last time upon her deathbed—and her oval face with its neoclassic features, as regular as a head by Canova, appears frequently in his subject pictures.

Students of Trumbull's work disagree on the dating of this portrait. Theodore Sizer (in "Sarah Trumbull") placed it earliest among the many likenesses of Mrs. Trumbull, because her comb closely resembles one seen in another of John Trumbull's portraits, dated 1800. But in 1975 Irma Jaffe argued that Winterthur's example could not have been painted before 1803; for Trumbull's packing list of that year mentions just one portrait of his wife, almost certainly the portrait of her with a spaniel (ca. 1802, Yale University Art Gallery). As a result, both Jaffe and Oswaldo Rodriguez Roque (in Helen Cooper, ed., *John Trumbull*) believe Winterthur's likeness to have been painted after the Trumbulls sailed to America in 1804, Rodriguez Roque dating it circa 1805 and Jaffe placing it a few years later.

Oil on canvas; 25 1/16 × 29 15/16 in.
Unsigned.
Provenance: Jeremiah Wadsworth; Catherine Wadsworth Terry; George Brinley II; Charles A. Brinley; Mary Frothingham Brinley (Mrs. John Wallingford Muir).
Acc. no. 60.150. (A replica of a later date is in Yale University Art Gallery [no. 1929.1].)
References: Dunlap (1834), *Rise of the Arts of Design,* 1:340–93; Sizer (1953), *Autobiography of John Trumbull,* pp. 350–65; Sizer (1965), "Sarah Trumbull"; Sizer (1967), *Works of Trumbull,* p. 73; Jaffe (1975), *John Trumbull,* pp. 191–93, 312 (Jaffe considered another picture the wedding portrait); Cooper (1982), *John Trumbull,* cat. no. 118.

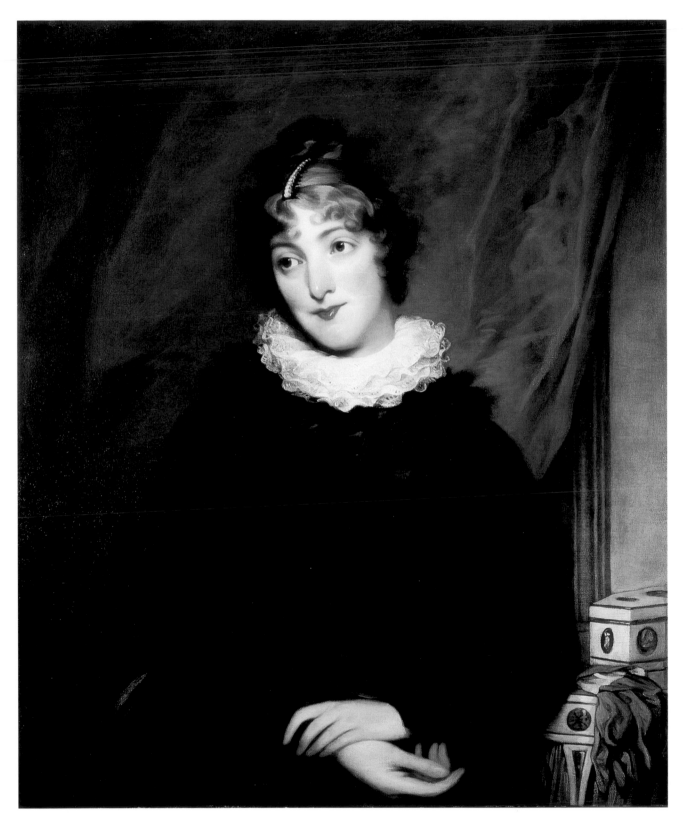

JAMES PEALE (1749–1831)

52. Henry Whiteley (1807)

This attractive miniature was the gift of Henry Whiteley to his bride and cousin, Catherine Whiteley, at the time of their marriage. Their monogram, *HCW*, is cut out over braided hair on the reverse of the case. One sometimes sees such marriage miniatures in old portraits, worn by a woman as a pin on the bosom of her dress or in a bracelet of seed pearls on her wrist. This miniature, in its original case, was set to be worn as a locket.

After James resigned from Smallwood's regiment of the Maryland line in 1779, for reasons of health, he worked toward becoming the miniaturist of the Peale family shop, living in his brother Charles's household until his own marriage in 1782. Years later, when James's age and failing eye-

sight had made painting miniatures difficult, he resigned such portraiture to his daughters Anna and Sarah, but he continued to paint still lifes and landscapes into his eighties. This portrait, of his best quality, is a relatively late example of Peale's miniatures. It descended in the Whiteley-Kirkwood family until its last owner gave it to Winterthur.

Watercolor on ivory (oval miniature);
$2\frac{3}{16} \times 2\frac{1}{4}$ in.
Signed at lower right "IP / 1807."
Provenance: By descent in the family to Mrs. Katherine Kirkwood Scott.
Gift of Mrs. Katherine Kirkwood Scott.
Acc. no. 76.108.

REMBRANDT PEALE (1778–1860)

53. Mrs. Ferdinand Bauduy (Victorine Elizabeth du Pont) (1813)

"She is well-informed, gentle, and attractive," wrote Victorine du Pont's father, Irénée, to his own father in Paris, but she was not destined for a happy life. Rembrandt Peale painted this portrait of her in 1813, the year of her marriage to Ferdinand Bauduy. Her husband was the son of Pierre Bauduy, a partner in the du Pont powder mill, who was in constant disagreement with Irénée over management of the business. Because of the couple's youth and the opposition of their parents, the marriage had been postponed, and Ferdinand had gone to France for two years. In the November after his return, they were married, but their happiness lasted only eleven weeks. Ferdinand Bauduy contracted pneumonia in January 1814 and died at his father-in-law's home on January 22.

The death of her young husband overwhelmed Victorine with grief. She fell into a prolonged depression, from which only chance rescued her. Her father went one Sunday to visit a neighbor, John Siddall, an Englishman who operated a cotton mill on the Brandywine downstream from the du Pont mill. He was surprised to find the Siddalls' dining room full of children. They were attending what was then called a Sunday school; in the days before free public education, children of the poor were often taught reading, writing, and arithmetic by charitably minded people on Sundays, the only nonworking day of the week. Irénée du Pont, interested and impressed, took his daughter to see the school on the following Sunday. The possibility of rescuing children from illiteracy aroused something in Victorine, and the next week saw her teaching in the Siddall school. In 1817, with her father's help, she founded her own school for the children of du Pont workers. She never remarried; the school became the great interest of her life.

Rembrandt Peale, the prize student and second surviving son of Charles Willson Peale, was a precociously gifted yet erratic artist. He spent most of his early career painting portraits and assisting in his father's forays into natural history. In 1802 he brought to London the skeleton of one of the mastodons his father had excavated, and there he studied under Benjamin West until returning to America in 1803. Probably his best work, however, dates not to his time with West but to the decade following his two visits to Paris, in 1808 and 1809/10. Exposed to the paintings of Jacques Louis David (1748–1825) and other French neoclassicists, Rembrandt finally made full use of his formidable skills. His subsequent portraits of men are direct, incisive in characterization, and strong. His portraits of young women, such as Victorine du Pont Bauduy or her sister Eleuthera du Pont Smith (also at Winterthur), show equal care but are less striking, especially in contrast to Thomas Sully's *Mrs. Benjamin Tevis* (no. 58).

By the late 1820s, Rembrandt's energies were increasingly diverted to lithography and to the marketing of his definitive, so-called Port Hole portraits of Washington, which show the general through an oval window. He concentrated less and less on his other work, and his portraiture, once the most insightful in the United States, suffered as a result.

Oil on canvas; 28½ × 23⅛ in.
Unsigned.
Acc. no. 61.709.
Reference: Johnson (1980), "Victorine du Pont."

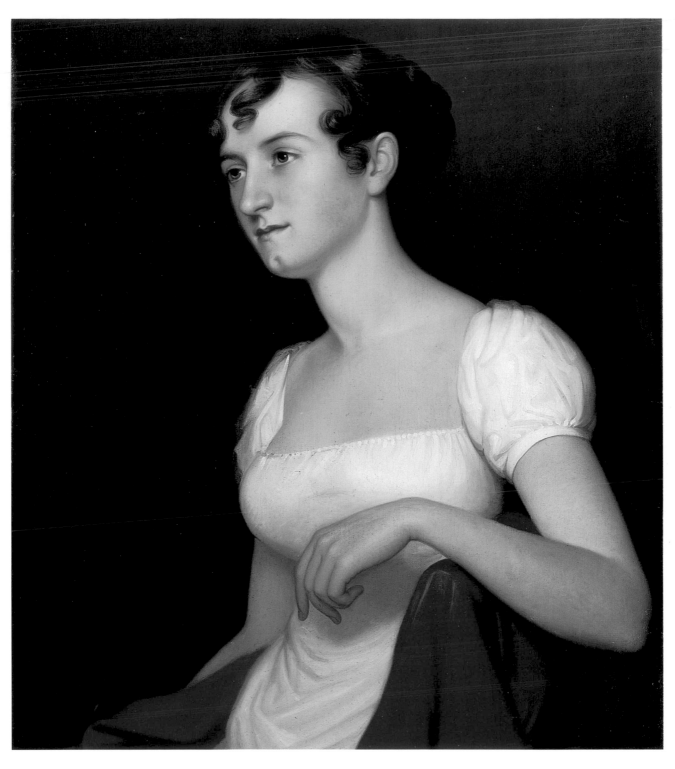

JOHN LEWIS KRIMMEL (1786–1821)

54. Quilting Frolic (1813)

Artist-historian William Dunlap, in his *History of the Rise and Progress of the Arts of Design in the United States* (1834), gives an attractive picture of John Lewis Krimmel as a talented, independent, good-humored, and blunt-spoken individual. Krimmel had every asset except a long life; he was drowned in a bathing accident at the age of thirty-two.

Krimmel was born in Ebingen, Württemberg, and trained as an artist in Germany. Coming to Philadelphia by way of England in 1810, he began by painting portraits. But the work of Sir David Wilkie (1785–1841), an English painter known for historical and genre scenes, opened Krimmel's eyes to the depiction of humorous tableaux from every-day life, a subject that peculiarly suited his temperament. For ten years Krimmel produced pictures of the daily lives and customs of his adopted countrymen. The *Quilting Frolic* of 1813, which was exhibited at the Pennsylvania Academy of the Fine Arts, is a perfect example.

Like many genre paintings, the scene is set as if on a stage, across which actors are arranged. The guests, several young men and women who seem already exhilarated, burst in at the door. They are followed by a fiddler and a man playing what appears to be an accordion. But the confusion of household utensils and scraps, among which a cat is playing, was apparently to be cleared away before anyone arrived. A young woman at the left is cutting a completed quilt off its frame, while at the heavily laden table stands an older woman slicing bread. A black servant—perhaps a slave—has brought in a tray loaded with cups, saucers, a teapot, and a pitcher; another servant is on her knees cleaning up scraps of sewing materials from the floor. Two other people are more-or-less detached actors: a bent old man sits smoking by the fireplace, quietly watching the scene, and by the table a greedy little boy stuffs his pockets with cake. The atmosphere is of cheerful, disorderly domesticity.

To our eyes Krimmel's figures appear stiff and somewhat wooden. But nothing like the humorous genre scenes he painted had appeared before in the United States. His premature death cut short a promising aristic career.

Oil on canvas; 16⅞ × 22⅜ in.
Signed on the reverse of the canvas "J. L. KRIMMEL PINX / PHILA. 1813."
Acc. no. 53.178.2.
References: *Third Annual Exhibition of the Columbian Society and the Pennsylvania Academy* (1813), no. 120, p. 21; Williams (1973), *Mirror to the American Past,* p. 43; Stebbins (1976), *American Drawings and Watercolors,* pp. 83–84; Harding (forthcoming), *J. L. Krimmel.*

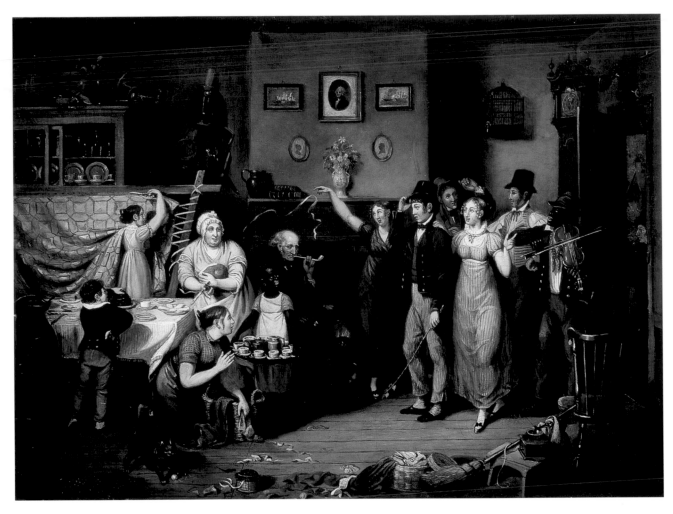

JOHN LEWIS KRIMMEL (1786–1821)

55. Election Day in Philadelphia (1815)

Elections in Krimmel's Philadelphia were rough, tumultuous, and noisy. The Federalist party was fast losing voters manipulated by big-city bosses. The Democratic party, meanwhile, was split into factions. And the pro-British and pro-French passions aroused throughout the nation by the Napoleonic Wars cast a pall of bitterness over all political activity. The tumultuous scene painted by Krimmel is probably a sanitized version of actuality.

The variegated crowd is skillfully composed. According to William Dunlap, many of the well-drawn and well-colored figures depict prominent Philadelphia politicians of the day. In 1815, elections were held at the State House, with the votes handed in through the windows. The State House clock shows the hour to be 5:40. A carriage is stopped on Chestnut Street to discharge an elderly voter. A little beyond, an election float in the shape of a longboat approaches, its crew shouting about some forgotten issue.

One of Krimmel's best friends, engraver Alexander Lawson, urged him to paint his favorite subjects immediately, without waiting to have pictures commissioned. Nevertheless, Krimmel took the time to make a great many preliminary studies and sketches; the Winterthur collection includes seven books of these preparatory works. The present picture may have been one of Krimmel's few commissions, which Lawson either ordered or purchased to engrave. His friends thought it the artist's best work. Lawson never completed the engraving, and after his death the picture disappeared from sight. The composition remained known, however, through a beautiful and complete watercolor version of 1816 which James L. Claghorn gave to the Historical Society of Pennsylvania in 1873. In 1887 Lawson's daughter Mary gave the unfinished copperplate to the Pennsylvania Academy of the Fine Arts, and several reprints have been taken from it. The original painting finally reappeared in 1959 and was bought by H. F. du Pont for Winterthur. Krimmel's *Election Day in Philadelphia* and his *Procession of the Victuallers* of 1820 (in a private Philadelphia collection) are the two most important views of American civic life that we have from the early Republic.

Oil on canvas; $16\frac{3}{8} \times 25\frac{5}{8}$ in.
Signed at lower left "I. L. Krimmel Pinxit. 1815."
Provenance: Alexander Lawson; Daniel Farr (1959); H. F. du Pont.
Acc. no. 59.131.
References: Dickson (1968), *Arts of the Young Republic,* p. 73; Wainwright (1974), *Paintings at the Historical Society of Pennsylvania,* p. 298; Stebbins (1976), *American Drawings and Watercolors,* p. 84.

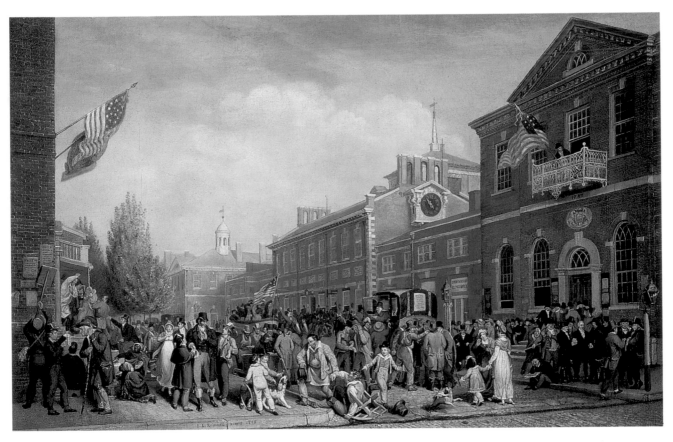

THOMAS SULLY (1783–1872)

56. Dr. David Hosack (1815)

Born in Horncastle, Lincolnshire (England), Thomas Sully emigrated to Charleston, South Carolina, with his parents in 1792. His brother Lawrence and brother-in-law Jean Belzons gave him his earliest lessons in painting, and in 1801 the young man set up on his own as a portraitist in Virginia. He married his brother's widow in 1805 and moved to New York City, where he lived for two years before moving to Hartford, then to Boston, and, in 1808, to Philadelphia. Sully resided in Philadelphia for the rest of his long life, except for a year in London (1809/10), when he studied under Benjamin West and was influenced by the elegant portraiture of Sir Thomas Lawrence (1769–1830), and a later visit to London to paint Queen Victoria (1838). In his own day and ever since, he has been considered one of Philadephia's foremost portraitists.

Dr. David Hosack—physician, scientist, writer, and leading citizen of New York City—is the subject of this effective male portrait, showing the man at ease yet magnetic, as if intent upon a discussion of interest. He holds a volume of Hermann Boerhaave, and on his table are works of the other three pillars of American medicine at that time, William Cullen, Thomas Sydenham, and Hippocrates. Many of these authors are represented also in Charles Willson Peale's portrait of Hosack's old teacher, Dr. Benjamin Rush (see no. 37), a bust of whom can be dimly seen in the background of this painting.

The son of a Scottish artillery officer who had served at the capture of Louisbourg in 1758, Hosack was educated at Princeton (1789), took his medical degree at Philadelphia (1791), and, after study in England and Scotland, settled in New York City in 1794. He rose quickly to the top of his profession, becoming a professor of materia medica and botany at Columbia College and, in 1797, the partner of Dr. Samuel Bard, dean of the medical faculty at Columbia. Since the materia medica was chiefly botanical at that time, it is not surprising that Hosack was a founder of the Elgin Botanical Garden (where Rockefeller Center now stands) and a president of the Horticultural Society. He advanced the knowledge of his profession with his three-volume *Essays on Various Subjects of Medical Science* (1824, 1830) and by a journal, *The American Medical and Philosophical Register* (1810–14), which he edited with his friend and pupil, Dr. John W. Francis. He also helped found Bellevue Hospital.

Hosack was a leading figure in New York's cultural life as well. He wrote biographical memoirs of Dr. Hugh Williamson, DeWitt Clinton, and Dr. Caspar Wistar, and he was a president of the New-York Historical Society. He and Philip Hone were considered by many to be the New Yorkers most hospitable to visiting strangers and givers of the most pleasant entertainments.

Following Alexander Hamilton's duel with Aaron Burr on July 11, 1804, Hosack, the attending physician, did what he could for the wounded Hamilton. A letter to Hosack from Burr, written on the day after, came down in the family with the portrait:

Mr. Burr's respectful compliments—He requests Dr. Hosack to inform him of the present state of Genl. H. and of the hopes which are entertained of his recovery.

Mr. Burr begs to know at what hour of the day the Dr. may most probably be found at home, that he may repeat his inquiries—He would take it very kind if the Dr. would take the trouble of calling on him as he returns from Mrs Bayards.

Thursday July 12

The portrait descended to J. Hampton Barnes of Philadelphia, who gave it to Winterthur in honor of the friendship of more than fifty years between Mr. and Mrs. du Pont and his parents, Mr. and Mrs. John Hampton Barnes. The Burr letter and a volume of Boerhaave were donated with the portrait.

Oil on canvas; 36 × 27⅝ in.
Unsigned.
Provenance: By descent in the family to J. Hampton Barnes, Jr.
Gift of J. Hampton Barnes, Jr. (1977).
Acc. no. 77.170.
References: Historical Society of Pennsylvania, Sully's register of paintings (painting begun August 8, 1815); Herring and Longacre (1835), *National Portrait Gallery*, 2:no. 57; Biddle and Fielding (1921), *Thomas Sully*, no. 815, p. 178; Robbins (1964), *David Hosack: Citizen of New York;* Washington, D.C., National Portrait Gallery (1969), *Gallery of Distinguished Americans,* p. 39.

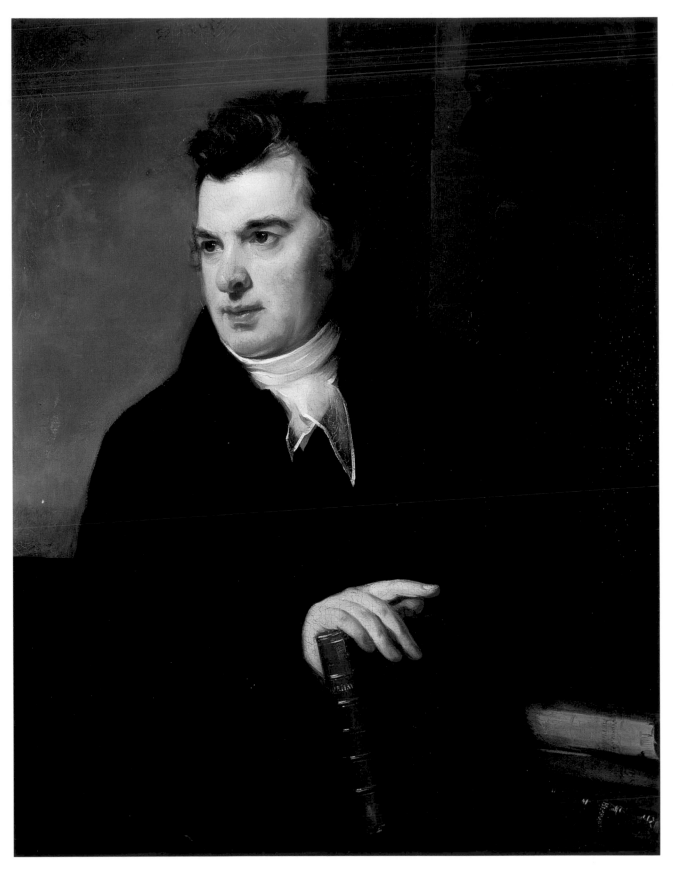

THOMAS SULLY (1783–1872)

57. Benjamin Tevis (1822)

58. Mrs. Benjamin Tevis (Mary M. Hunter) (1827)

Readers of William Dunlap's life of Thomas Sully know that the artist inspired affection in all kinds of people, from the most sophisticated to the simplest. Dunlap wrote of a "wish to make others happy" as characteristic of Sully. This trait is reflected in his work, which always portrays his sitters as attractive, agreeable people.

Of Mr. and Mrs. Tevis we know little except that they lived in Philadelphia. Mr. Tevis was an auctioneer (the retail shop had not yet appeared, and auctions mediated between importer and consumer) and was so successful that he retired from business at the time of his marriage, in 1824, to Mary Hunter. The couple settled in a house at 393 Mulberry Street (Race Street). We know from Sully's register that the artist painted Tevis between January 23 and March 1, 1822, and that Tevis paid Sully one hundred dollars for the portrait. For Mrs. Tevis's portrait in 1827, he paid Sully seventy-five dollars.

The Tevis portraits are among Sully's finest: luminous, rich in chiaroscuro, and graceful in composition. Contemporaries often remarked on Sully's excellence in painting eyes and the luster of hair. The portraits give evidence of these abilities as well as the amiable and decorative nature of Sully's best work.

Mr. Tevis
Oil on canvas; 30 × 25 in.
Signed below center "TS, 1822."
Provenance: Sir Joseph Plunkett, London; the Misses Plunkett, Stockholm; Charles D. Morgan (cousin of Lady Plunkett) and Mrs. Morgan, Paris; Richard H. Morgan, Paris (1975).
Acc. no. 75.115.1.

Mrs. Tevis
Oil on canvas; 30 × 25 in.
Signed at lower left "TS 1827."
Provenance: Same as for *Mr. Tevis.*
Acc. no. 75.115.2.
References: Historical Society of Pennsylvania, Sully's register of paintings (*Benjamin Tevis* begun January 23, 1822; *Mrs. Benjamin Tevis* begun September 17, 1827); Dunlap (1834), *Rise of the Arts of Design,* 2:101–41; Biddle and Fielding (1921), *Thomas Sully,* nos. 1774, 1775, p. 295.

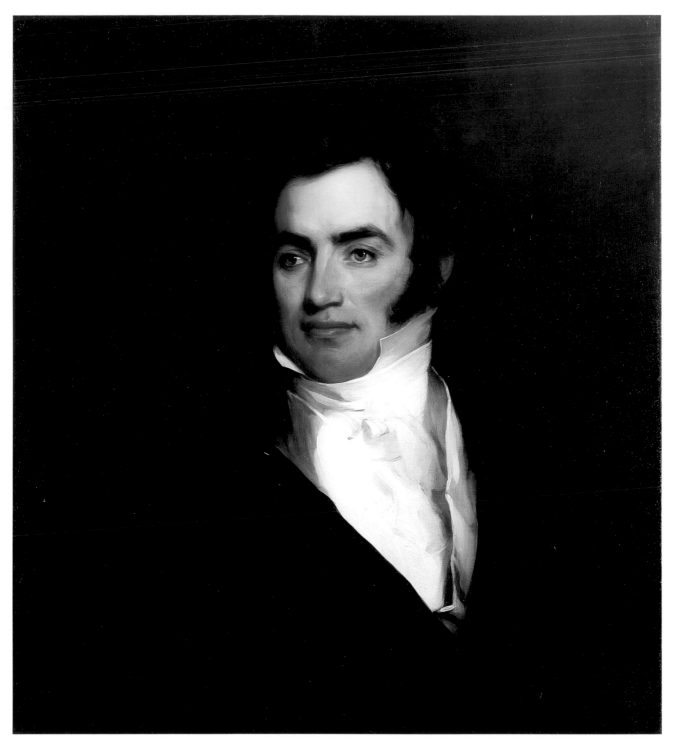

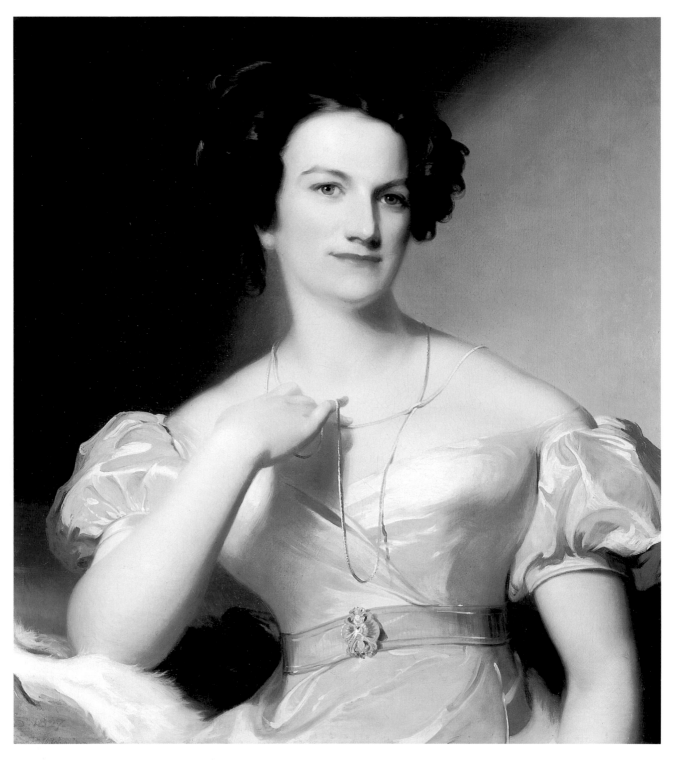

JAMES PEALE (1749–1831)

59. Still Life with Vegetables and Squash Blossoms (1828)

In the first quarter of the nineteenth century, James Peale, past his prime and losing his eyesight, gradually abandoned miniature painting to his daughters Anna and Sarah. Accompanied by his nephew Raphaelle, the eldest son of Charles Willson Peale, James turned his attention to the painting of still lifes, becoming the first American painter to specialize in that field.

What prompted this pioneering work of James and Raphaelle Peale remains unknown. Still-life painting had not been popular during the eighteenth century; indeed, the Peales' still lifes are mostly reminiscent of seventeenth-century Dutch examples. Such paintings are known to have decorated the homes of Dutch settlers in New York and even Philadelphia throughout the eighteenth century, and they could easily have inspired James and his nephew to revive the neglected form.

James painted still lifes up to his death in 1831. This example, in a soft, rich, atmospheric style, is a very late work. Inscribed on the back of the canvas, "Painted by James Peale in the 79th year of his age 1828," it is almost identical to an example signed by Peale and inscribed "Philad., 1826, aged 76" that was sold at Sotheby Parke Bernet in 1984. Works like these helped raise still-life painting to

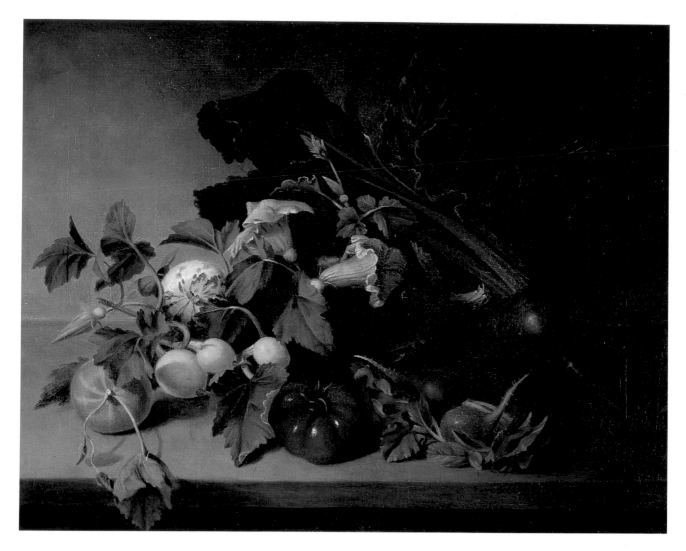

59

prominence in nineteenth-century America among not only professional painters but also cultivated young women, whose amateur still lifes on velvet are sometimes exact copies of a Peale original.

Oil on canvas; 19¹³⁄₁₆ × 25⅜ in.
Signed on back of canvas "Painted by James Peale / in the 79th year of his age 1828."

Provenance: By descent in the family to the artist's great-grandson, Clifton Peale, of Philadelphia.
Acc. no. 57.625.
References: Baur (1940), "Peales and American Still Life"; Sotheby Parke Bernet, New York, January 26, 27, 1984, lot no. 358.

EDWARD HICKS (1780–1849)

60. The Peaceable Kingdom (1830–32)

Edward Hicks came from a notable Quaker family. Elias Hicks, whose powerful preaching split the Society of Friends into Hicksite and Orthodox branches in 1827, was a cousin. Another cousin, Thomas Hicks, was a portrait painter in New York City; his full-length portrait of Gov. Hamilton Fish in the Museum of the City of New York is a measure of his admirable gifts. Edward Hicks, however, grew up in the farm country of Bucks County, Pennsylvania. During his apprenticeship to a coach painter, he learned the ancient crafts of decorative patterning, of bright, flat coloring, and of lettering and gold leafing. From 1818 until his death in 1849 he lived in Newtown, one of the earliest Quaker settlements in Pennsylvania and the Bucks County seat. Like his cousin Elias, Edward was an earnest Quaker preacher, traveling widely from meeting to meeting. But his livelihood came from painting coaches, tavern signs, furniture, fire buckets, and other things that people liked to enliven with bright decoration.

Hicks's religious fervor led him to preach in pictures as well as by the spoken word. For the source of his compositions he adapted quite unself-consciously images from illustrated Bibles, from engravings in magazines, or from popular prints. In the artisan's world as Hicks knew it, a desire for originality, in the modern sense of the word, played no part. An artisan accepted as given the desires of his customers and sought excellence in meeting those desires, not in imagining original works. The silversmith or cabinetmaker was usually not an inventor of new forms; he readily accepted the designs dictated by others for his teapot or side chair. In a similar way, Hicks relied on printed sources to develop such pictures as *The Falls of Niagara, Penn's Treaty with the Indians, Wash-*

ington at the Crossing of the Delaware, Noah's Ark, and *The Peaceable Kingdom.*

He found his model for the last of these paintings in an English illustration by Richard Westall for the prophecy of the reign of the Messiah in the Book of Isaiah (11:6–7): "The wolf also shall dwell with the lamb, and the leopard shall lie down with the kid; and the calf and the young lion and the fatling together; and a little child shall lead them. / And the cow and the bear shall feed; their young ones shall lie down together; and the lion shall eat straw like the ox." Sometimes Hicks added to the Peaceable Kingdom as described in the prophecy a little scene of Penn's Treaty with the Indians.

Hicks painted so many Peaceable Kingdoms that no one knows exactly how many examples there may once have been—at least forty exist today. Each one shows variations. The Winterthur example is one of the nine so-called Peaceable Kingdoms with Quakers Bearing Banners, whose left-hand compositions are based on a poem by Hicks's friend Samuel Johnson (1763–1843). The "Banner Kingdoms" use the religious and historical imagery set forth in Johnson's poem in order to link Elias Hicks (seen in the foreground holding a handkerchief and wearing riding boots) with the roots of Quakerism, Protestantism, and ultimately Christianity. Standing beside Hicks are several sympathetic preachers, possibly accompanied by one of Edward Hicks's heroes, George Washington, who has been suggested as the man holding the word *earth* (Mather, p. 39). Behind the crowd, to the right of the tree, stand three key figures of early Quakerism: (*left to right*) Robert Barclay (1648–90), who defended Quaker theology in his *Apology* (1676); William Penn (1644–1718); and George Fox (1624–91), founder of Quakerism,

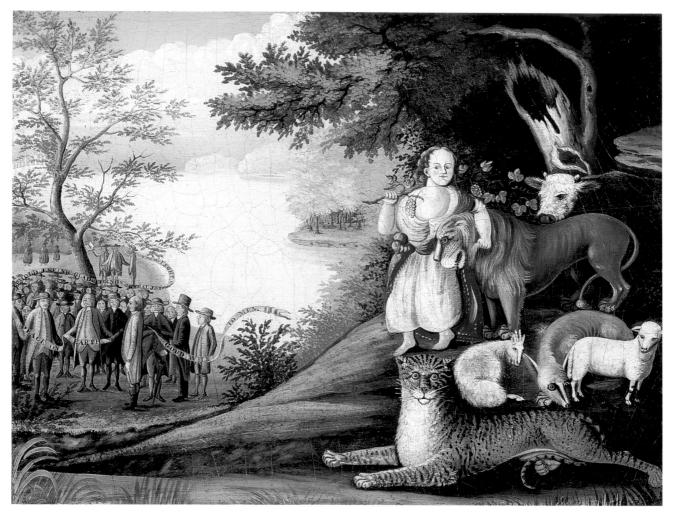

whose motto Mind the Light curves nearby. To the left of the tree are three Protestant reformers, possibly Martin Luther, Ulrich Zwingli, and John Calvin. Finally, atop the hill partially hidden by the tree, shine several rays of light representing Christ and his apostles, which in other versions form the source of the banner.

Winterthur's example is the only Banner Kingdom in which a tree rises from the Quakers' midst. This addition may have been intended to underline the message of the other symbols, identifying Hicksite Quakerism as the contemporary outgrowth of Fox's preachings, Protestant reform, and early Christianity.

Oil on canvas; 17⅝ × 23⅝ in.
Unsigned.
Inscribed "mind the LIGHT / BEHOLD I BRING GLAD TIDINGS OF GREAT JOY / PEACE ON EARTH / GOOD WILL TO MEN."
Acc. no. 61.501.
References: Bye (1936), "Edward Hicks"; Ford (1960), *Edward Hicks;* Tolles (1961), "Primitive Painter as Poet"; Ayres (1976), "Edward Hicks and His Sources"; Mather (1983), *Edward Hicks.*

NICOLINO V. CALYO (1799–1884)

61. Harlem, the Country House of Dr. Edmondson, Baltimore (1834)

Born in Italy in 1799 and trained at the Naples Academy, Nicolino Calyo immigrated to the United States early in the 1830s. He went to Baltimore first (1834–35); then lived briefly in Philadelphia, and finally moved to New York City, where he appears in directories for 1838–55. Although he made various excursions to Philadelphia, Charleston, and Richmond, he resided in New York City until his death, in 1884.

Calyo's picture of Dr. Edmondson's house, located on what were then the western outskirts of Baltimore, is dated by a receipted bill of 1834. The painting is executed in gouache, or opaque watercolor, and is the only example of this technique in the Winterthur collections. Used for miniatures since the sixteenth century, gouache became particularly popular in the eighteenth century among French, Swiss, and Italian watercolorists. Calyo has used it here to portray a yellow-painted house at the right and a range of greenhouses on the left. On the lawn in the foreground, a servant brings a tray of iced drinks to a group of three gentlemen; another gentleman converses with two ladies. In the distance, one sees Baltimore and its harbor, where both steam and sailing vessels are visible. The artist must have won Edmundson's admiration with this example of the exact drawing, delicacy of tone, and spacious composition that give charm to his work.

Thomas Edmondson (1808–56), the son of a prosperous Baltimore merchant, was educated at St. Mary's College and studied medicine at the University of Maryland, but he never practiced. Instead, in his native city he lived the life of a gentleman of leisure. He formed a large library and a collection of some two hundred pictures by American artists; he devoted himself to horticulture and to music. He is said to have owned fifteen violins, including two Stradivarii and one Guarnerius, and eight cellos.

After Edmondson's death, his collections were deposited in the Maryland Historical Society and later dispersed in a series of public sales, although many of his best pictures were kept by the family. This example, which descended through the family, brings to the Winterthur collections an image of the cultivated society of Maryland in Jacksonian America.

The green lawn of the Edmondson house was given to the city to become Harlem Square. The gentle eminence on which the house stood is now bounded by Edmondson, Harlem, and Fulton avenues and Mount Street.

Gouache on paper; 16¾ × 29⅞ in.
Unsigned.
Provenance: By descent in the family to the Misses Hough of Baltimore.
Acc. no. 68.60.
References: Baltimore, Museum of Art (1941), *Century of Baltimore Collecting,* p. 31; Baltimore, Museum of Art (1945), *Two Hundred and Fifty Years of Painting in Maryland,* no. 109, p. 48; Baltimore, Museum of Art (1984), *Baltimore Antiques Show, 1984,* pp. 68–69.

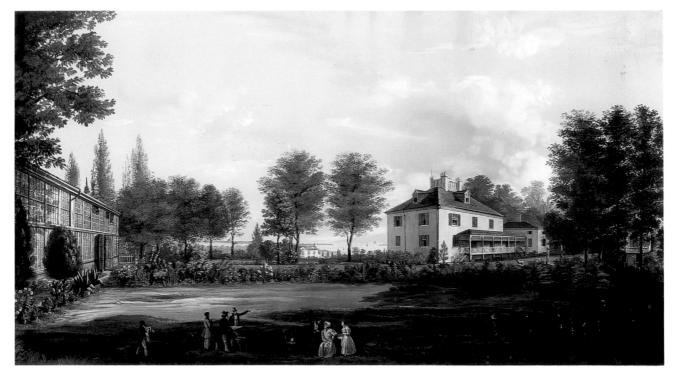

61

THOMAS BIRCH (1779–1851)

62. Winter Scene (1838)

William Russell Birch and his son Thomas worked in the centuries-old topographical tradition, which produced landscapes, marines, and cityscapes with a precision originally achieved for military reconnaissance (see nos. 64, 65, 66). Working together as William Birch and Son, they produced a portfolio of engravings called *Views of Philadelphia* (1800). It was unprecedented in American art at the time and has hardly been equaled since. Thomas went on to become famous for his paintings of naval battles of the War of 1812 and for his marine and snow scenes.

Beginning some years earlier than romantic landscapists Asher B. Durand, Thomas Cole, and others of the generation of 1825, Birch painted the realistic, inhabited landscape. In his work, our everyday activities form part of life on the land, just as ships form part of the life of the ocean, in weather both stormy and fair. Although the prints of Currier and Ives later popularized the snowy landscapes perfected in America by Birch, the delicacy of his line, the aerial depth of his skies, and the gentle poetry of his idylls of winter life remain unrivaled in the nineteenth century.

Oil on canvas; 19¾ × 29¾ in.
Signed at lower right "Thos Birch. 1838."
Gift of Charles K. Davis (1956).
Acc. no. 56.46.29.

PART FOUR

Foreign Works with American Subjects

WILLIAM VERELST (d. after 1756)

63. Audience Given by the Trustees of Georgia to a Delegation of Creek Indians (1734–35)

The earliest settlements on our Atlantic coast—in Virginia, on the Delaware and Hudson rivers, at Plymouth, and on Massachusetts Bay—were promoted and financed by companies of English, Dutch, and Swedish merchant adventurers whose aim was to find in North America such wealth as Spain had drawn from South America. The hoped-for profits were not forthcoming, however, and one by one the chartered companies gave up, leaving the support of their colonies to the Crown.

This portrait group records the Georgia Company, the last and most unusual of the English promoters. Georgia, the final colony to be founded before the Revolution, was the product of a humanitarian impulse rather than a business venture. In England, John Viscount Percival, who became the first earl of Egmont, and soldier-philanthropist James Oglethorpe both served on a parliamentary committee to investigate the condition of debtors' prisons. Horrified by the scandalous conditions they discovered, they sponsored a bill of reform, passed by Parliament in 1729, which brought about the release of a great number of debtors. To help these unfortunates to reestablish themselves, Egmont and Oglethorpe took the lead in founding a new colony in America to be a refuge for the poor and unfortunate. The colony, on the Savannah River, would at the same time serve as a military buffer against the Spaniards, who then sought the whole coast up to and including Charleston, and against the powerful, dangerous Creek Indian nation.

The Georgia project elicited an outpouring of humanitarian feeling: clergy, nobles, gentry, and anonymous supporters contributed; the king gave six hundred pounds; Parliament made a land grant. Slavery and the manufacture of rum were to be prohibited in the new colony; land was to be equally divided; and the manufacture of silk was to be established. Oglethorpe himself led the first detachment of colonists, in 1733, to the site of the future city of Savannah. There, on the bluffs above the river, he met a trader named John Musgrove and his Indian wife, Mary, a Creek woman of strong personality and great influence among her nation. With their help Oglethorpe negotiated a treaty with Tomochichi, chief of the Yamacraws (a detached group of Creeks living along the lower Savannah River), by which the lower lands south of the Savannah, where no Creeks lived, were opened to the settlers.

When Oglethorpe returned to England in 1734 to report to the trustees, he took with him the Yamacraw chieftain, a group of his people, and the trader Musgrove as interpreter. The scene is depicted here. The trustees are meeting in the headquarters of the Georgia Company in the Palace Court, Old Palace Yard, Westminster. Oglethorpe and the Creek Indians stand facing the Common Council (or executive committee) of the trustees.

William Verelst belonged to one of those transplanted families of artists whom the English think of as Dutch and the Dutch think of as English and who are, in consequence, ignored by both. William was the first of the family to be born in England; his nephew Harry, whom he raised, rose in the East India Company to govern Bengal and to be one of Lord Clive's right-hand men.

A variety of causes—mismanaged land, a Spanish war, and the dynamics of human nature—brought the Georgia Company's idealistic program to an end. After twenty years the Crown assumed responsibility for the colony. At this point, Anthony Ashley, the fourth earl of Shaftesbury, who had been a trustee during most of the company's existence, exerted himself to see that the settlers' rights were protected. In gratitude for his efforts, the trustees presented this painting to him. It remained in his family until about 1930, when it was purchased by H. F. du Pont.

Oil on canvas; 48½ × 60⅜ in.
Unsigned.
Inscribed on frame "WILLIAM VERELST / ALL PORTRAITS / Gift of Trustees to 4th Earl of Shaftesbury"; cartouches with names of sitters and description of scene.
Provenance: Trustees of Georgia; by descent in the family of the earl of Shaftesbury; H. F. du Pont.
Acc. no. 56.567.

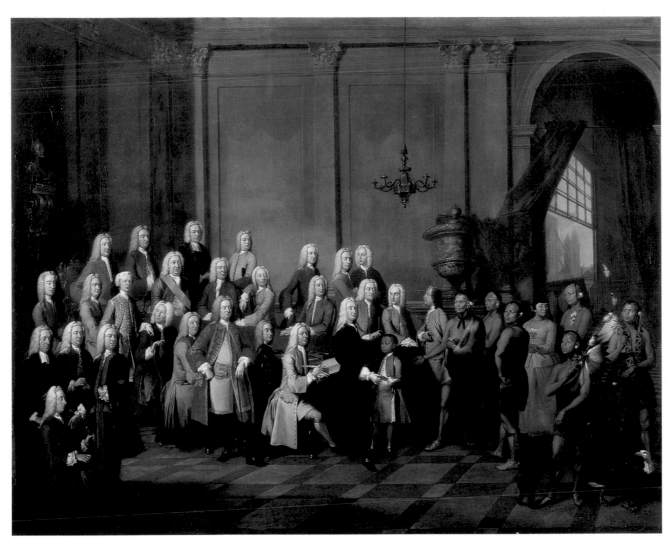

THOMAS DAVIES (ca. 1737–1812)

64. A South View of the New Fortress at Crown Point (1759)

65. A View near Flushing on Long Island (1765)

66. A View of the Attack against Fort Washington (1776)

The physical changes in North America in the last two centuries have been so many and so rapid that it is difficult to visualize the land as our ancestors saw it. We owe most of our ideas about the appearance of North America in the eighteenth century to the British army's use of skilled mapmakers, surveyors, and artists in its operations, whose pictures and maps provide an almost photographic record of the colonial landscape.

The post of drawing master was established at the Royal Military Academy (founded 1741 at Woolwich, England) to train future officers of artillery in drawing and watercolor; after the Royal Engineers were founded, they also studied at Woolwich. In 1768, with the office of chief drawing master held by Peter Sanby, a brilliant topographic artist, the training was of the highest quality. But before Sanby, an obscure artist named Gamaliel Massiot had held the post. Thomas Davies, a pupil of Massiot, a soldier by profession, and only an amateur artist, painted these views. Nonetheless, an album of more than fifty of Davies's watercolor drawings, which in 1953 came up for sale at Christie's from the library of the earl of Derby, forms an exceptionally interesting record of what he saw, during peace and war, in North America between 1756 and 1789. Many sheets from the album ended up in the National Gallery of Canada, Ottawa, and in the Royal Ontario Museum, Toronto; some sheets went to the New-York Historical Society. Three sheets are owned by Winterthur.

Davies first came to North America in 1757 as a second lieutenant of artillery. Arriving in the midst of the French and Indian Wars, he took part in the unsuccessful attack against Louisbourg and advanced with Maj. Gen. Jeffrey Amherst up the Champlain waterway in 1759. Davies's *View of Crown Point* records the great fortress constructed by Amherst's army to replace the French fort there.

After the capture of Montreal in 1760, Davies was sent to explore the new western territories that had come under British control; he mapped and surveyed in the summer seasons, returning to headquarters at New York City in winter. His *View near Flushing*—of a country retreat then favored by New Yorkers—belongs to one of these year-end visits.

In 1767 Davies's unit returned to England, to remain there until 1773. In 1774 he served in Gen. Thomas Gage's army, which then was occupying Boston. He fought in Sir William Howe's army to capture New York City, presumably taking part in the Battle of Long Island (August 27) and certainly seeing action at White Plains (October 28). He commanded a battery in the attack upon Fort Washington and made two watercolors of that action. One, which General Amherst owned, is now in the I. N. Phelps Stokes Collection of the New York Public Library; the other, slightly larger, is the present example. On July 19, 1779, Davies was made aide-de-camp to General Amherst and returned with him to England. In 1786 he was sent to the West Indies, and, in 1788/89, he served in the garrison at Quebec, making his last tour of duty in North America.

Davies was a man of ability. He rose to the rank of lieutenant general in the army. He exhibited watercolors at the Royal Academy. He excelled even in ornithology, becoming in 1781 a Fellow of the Royal Society and an organizer of the Linnaean Society.

Crown Point
Watercolor on paper; 14¾ × 21 1/16 in.
Signed, dated, and inscribed at bottom margin "A South View of the New Fortress at Crown Point, with the Camp, Comman[d]ed by Major General Amherst in the Year 1759 / Drawn on the Spot by Thos: Davies Capt: Lieut: of the Royal Artillery [Key to the letters: *left:*] *A* the New Fort. *B* Ruins of the Old Fort / *C* Light Infantry of the Army Fort / *D* Granadier Fort / *E* Gages Light Infantry Fort [*right:*] *F* A Radaux / *G* Slops of Warr / *H* Hutts of Rangers & Indian Wigwams / *I* Part of Lake Champlain [*center:*] *K* Roads from Ticonderoga."
Provenance: Earl of Derby.
Acc. no. 53.189.1.

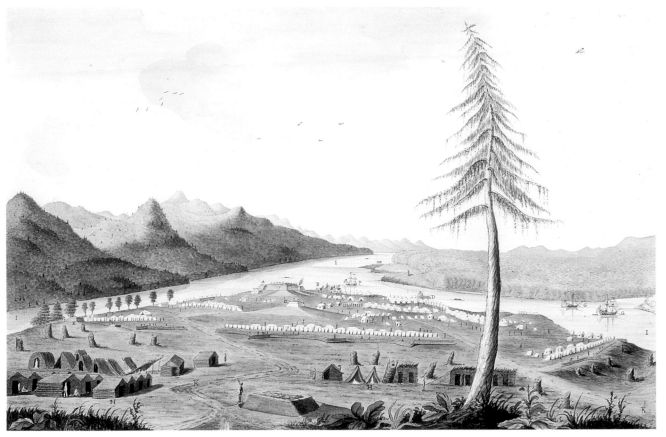

View near Flushing

 Watercolor on paper; 12¹⁄₁₆ × 19¹⁄₁₆ in.
 Signed, dated, and inscribed at bottom margin
 "A View near Flushing, on Long Island in the
 Province of New York North America. taken on
 the Spot by Thos Davies Capt Lt Royl Artillery
 1765."
 Provenance: Earl of Derby.
 Gift of Charles K. Davis, 1953.
 Acc. no. 53.189.3.

Attack against Fort Washington

 Watercolor on paper; 14⁷⁄₁₆ × 20⁵⁄₁₆ in.
 Signed, dated, and inscribed on reverse in mod-

ern hand "A View of the Attack against Fort
Washington / and Rebel redouts near New York
/ on 16 of November 1776 by the British and
Hessian Brigades. Drawn on the Spot by Thos
Davies, Capt. R. R. of Artillery."
Provenance: Earl of Derby.
Acc. no. 53.189.2.

References: Stokes and Haskell (1933), *American
Historical Prints,* no. 1776—B–93, pp. 29–30 (a
version, which belonged to General Amherst, in
the Phelps Stokes Collection, New York Public
Library); Hubbard (1972), *Thomas Davies,* no.
A4, p. 150; no. A7, p. 152; no. A14, p. 156.

65

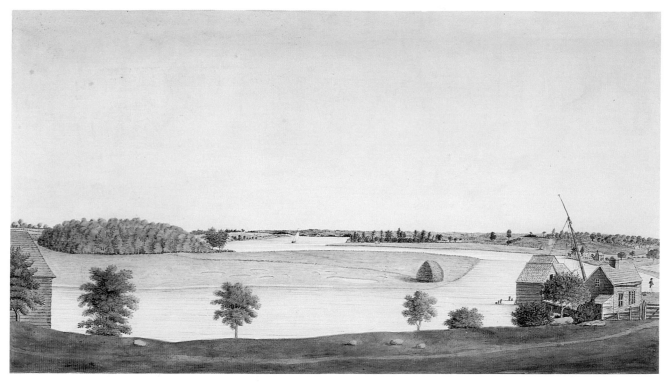

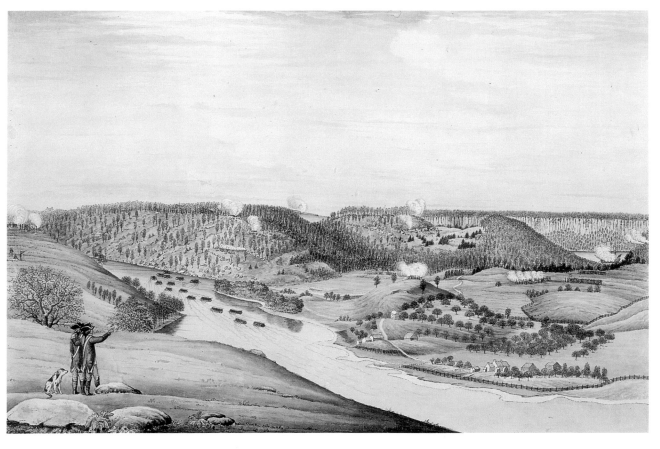

JOHN DOWNMAN (1750–1824)

67. Chief Justice Peter Oliver (after 1776)

The Honorable Peter Oliver became chief justice of Massachusetts in 1771. As associate justice, he had sat at the trial of British soldiers after the Boston massacre in 1770. But as a firm Loyalist and figure of decision and character, he became a marked man when the province drifted toward revolution. In 1774 grand juries in Worcester and Suffolk County refused to serve under him. His position being no longer tenable once the British army had evacuated Boston in 1776, he went into exile in England. He was kindly received by the king, given an honorary degree by Oxford University, and granted a pension by the British government in recognition of his character and services. He spent the remainder of his life in Birmingham, where he died in 1791. His epitaph in Birmingham Cathedral dwells on his departure from America and his subsequent emotions:

> In the year 1776,
> on a Dissolution of Government,
> He left his native Country;
> but in all consequent Calamitie
> His Magnanimity remained unshaken.
> And though the Source of his Misfortunes
> Nothing could dissolve his Attachment
> to the British Government
> nor lessen his Love & Loyalty
> to his Sovereign.

In addition to his great firmness, Oliver had considerable personal charm, as is illustrated by his effect upon a Bostonian named John Marston. In 1783 Marston was traveling from Liverpool to London. At Birmingham, at one o'clock in the morning, an old gentleman and his daughter boarded the coach. "Marston soon discovered that the old gentleman was none other than the celebrated Chief Justice, a Loyalist refugee from his own state, than whom no one more odious to the Whigs of '76. In relating the encounter Marston used to say, 'My first impulse, when I found myself in the same coach with a tory so obnoxious as Judge Oliver, was to dismount and wait for another conveyance, but as we conversed about Boston and its well-known citizens, I became attracted to his conversation. In an hour I regarded him with great respect, and before the sun rose I loved him as I did my own father'" (Oliver, *Faces of a Family*, pp. xiii–xiv).

The picture's history has been confusing. It descended with a number of family portraits to the judge's son, Dr. Peter Oliver, Jr.; to his son, Thomas Hutchinson Oliver; to a cousin, the Reverend Peter Orlando Hutchinson; to another cousin, the Reverend Sanford W. Hutchinson; to his sister, Mrs. Henry Walsham How; and to her son, the Reverend William H. Walsham How. By this time, the identity of the subject had been lost, and the portrait was supposed to be of Gov. Thomas Hutchinson, by one William Williams who worked in the English provinces. William H. P. Oliver reproduced it as such in a pamphlet on the Hutchinson genealogy as did Clifford K. Shipton in *Sibley's Harvard Graduates* (8: facing p. 150). When an unquestioned portrait of Judge Oliver was given to the Harvard Medical School in 1950, the painting at Winterthur was recognized as a portrait of Judge Oliver and not of Governor Hutchinson. The identification of its artist as Williams was also changed. It is the work of John Downman, an English pupil of Benjamin West, who is noted for painting just such small oval portraits of great dignity and charm. An ornate silver sugar box by Boston silversmith Edward Winslow (dated about 1702), which had been given to Judge Oliver's father and mother and then belonged to the judge and the judge's son, keeps the portrait company at Winterthur.

Oil on canvas (oval); 14⅞ × 12 in.
Unsigned.
Provenance: Dr. Peter Oliver, Jr., the son; Thomas Hutchinson Oliver, his son; the Reverend Peter Orlando Hutchinson, his cousin; the Reverend Sanford W. Hutchinson, his cousin; Mrs. Henry Walsham How, his sister; the Reverend William H. Walsham How, Brighton, England, her son.
Acc. no. 53.69.
Reference: Oliver (1960), *Faces of a Family*, pp. xiii–xiv, xvii; no. 8D, pp. 8–9; pl. 8D.

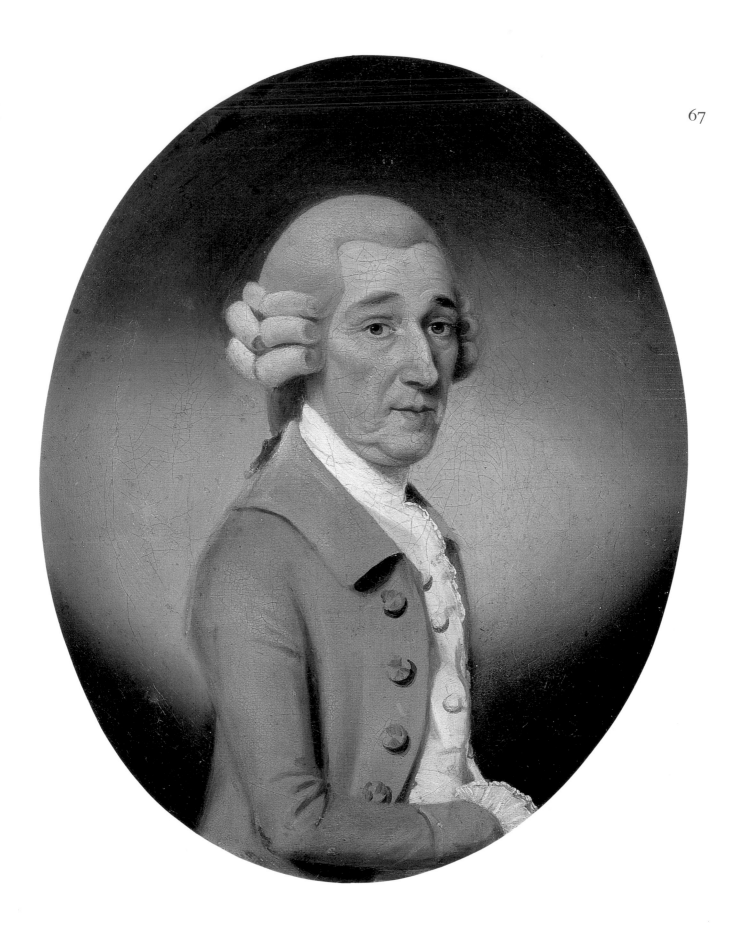

DOMINIC SERRES (1722–93)

68. The Forcing of the Hudson River Passage (1779)

Dominic Serres was born in Gascony, France, in 1722. Intended by his parents for the church, he ran away to sea. In the mid 1750s he was captured by a British frigate and taken as a prisoner to England. He settled in London, probably studied under marine painter Charles Brooking, and became a marine painter himself with a large practice in the depiction of ships and naval battles. Serres soon gained the respect of contemporary London artists. He was a founding member of the Royal Academy and became marine painter to King George III.

The naval action painted here was a victory of great strategic importance in the American Revolution; for it gave the British command of the waters around Manhattan Island. In September 1776, after the Battle of Long Island, General Washington had realized that Howe's army—bigger, better trained, and better armed—could easily thrust aside his small, weak force. The Continental Congress still urged him to hold New York, but Washington knew that his position would be hopeless should the British navy win control of the surrounding waterways. Lacking a navy, he depended on the guns of two strongholds, Fort Washington on Harlem Heights and Fort Lee on the Jersey bank. He had a chevaux-de-frise (spiked barrier) stretched from shore to shore, but on October 9, 1776, he was forced to write to the president of Congress:

About 8 O'clock this morning, two Ships of 44 Guns each, supposed to be the Roebuck and Phoenix and a frigate of 20 Guns with three or four Tenders got under way from about Bloomingdale where they had been laying some time and stood with an easy Southerly breeze toward our Chevaux de frize, which we hoped would have interrupted their passage while our Batteries played upon them, but to our surprize and mortification, they ran through without the least difficulty and without receiving any apparent damage from our Forts, tho' they kept up a heavy fire from both sides of the River. Their destination or views cannot be known with certainty, but most probably they are sent to stop the Navigation and cut off the supplies of boards &ca. which we should have re-

ceived and of which we are in great need. They are standing up and I have dispatched an Express to the convention of that State, that Notice may be immediately communicated to General Clinton, as the Highland Fortifications, to put him on his Guard. [*The Writings of George Washington from the Original Manuscript Sources, 1745–1799,* ed. John C. Fitzpatrick, vol. 6 (Washington, D.C.: U.S. Government Printing Office, 1932), pp. 184–85.]

Control of the Hudson River now passed from American to British hands, and Washington's supplies were cut off. Three days after this event, Howe was able to outflank the Americans on Harlem Heights, and Fort Washington fell to him on November 16. Holding the Hudson, British troops went on to capture Fort Lee and to drive Washington's army in retreat across New Jersey into Pennsylvania.

The captains of the British ships of war were proud of their success in forcing the passage without losing a single vessel, despite the heavy barrage from each shore. Serres, working from an eyewitness description and perhaps sketches, painted three pictures, one for each captain. The version here was for Capt. Cornthwaite Ommanney, who commanded the *Tartar.* It came down in his family to a Mrs. Rowand of Lymington, England, from whom it passed through a London dealer to H. F. du Pont. The remaining two canvases also came to the United States: one, painted for Capt. Hyde Parker of the *Phoenix,* to Pierpont Morgan; the other, painted for Capt. Sir Andrew Hamond of the *Roebuck,* to the United States Naval Academy Museum at Annapolis. A copy by William Joy is in the New-York Historical Society.

Oil on canvas; 28 × 45¹⁵⁄₁₆ in.
Signed at lower left "D. Serres, 1779."
Provenance: By descent in the family of Capt. Cornthwaite Ommanney to Mrs. Rowand, Lymington, England; H. F. du Pont.
Acc. no. 56.563.
Reference: Koke (1952), "Forcing the Hudson River Passage," pp. 465–66.

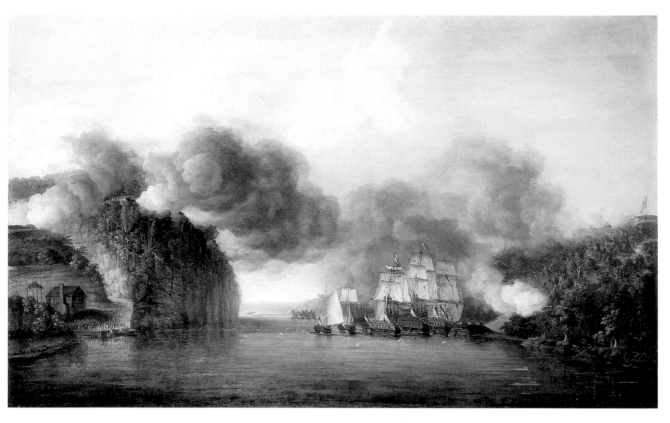

DOMINIC SERRES (1722–93)

69. American Ships off Dover (ca. 1785)

The English school of marine painting to which Dominic Serres belonged had its beginning when King Louis XIV of France invaded Holland in 1673. The Netherlands resisted and survived, but they had received such a shock that two of the greatest Dutch marine painters, William van de Velde, senior and junior, left Amsterdam for London. They brought with them the beautiful pictorial tradition of Dutch marine painting, whose treatment of sky, clouds, water, and the movement of ships was unexcelled. Their example was followed by English-born painters for the next century or more. Among these was Charles Brooking, who certainly influenced and probably taught Dominic Serres.

When painting portraits of ships, Serres followed tradition not only by showing each ship from a different point of view—broadside and astern—but also by making the work a study of wind and light at sea. Here, for instance, he dwells on the scudding clouds' shadows as they race across the water and on the light that gleams upon the distant chalk headlands. In the foreground are the beautiful, buoyant ships, with the wind swelling their sails and snapping their flags.

Serres was painted by Gilbert Stuart, "in the act of fresh pointing his pencil," for a portrait exhibited at the Royal Academy in 1782. A grizzled but sturdy old man, he sits with a portfolio on his knees and an unfinished drawing of a ship before him. He worked as the Dutch painters did: the ship was translated first into a drawing, and the drawing was translated into a finished painting in the studio.

Oil on canvas; 28⅞ × 43¹³⁄₁₆ in.
Acc. no. 61.707.
References: Wilson (1967), *Dictionary of Marine Painters,* s.v. "Dominic Serres, R.A."; Cordingly (1974), *Marine Painting,* pp. 83–85.

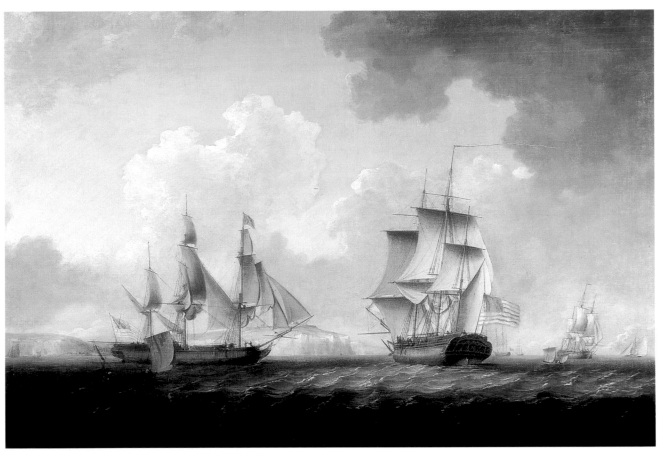

69

ANTOINE ROUX (1765–1835)

70. The U.S. Frigate *President* in the Harbor of Toulon (1803)

Built by Christian Bergh on the East River, New York City, and launched on April 1, 1800, the U.S. frigate *President* led a varied life as a member of this country's early fleet. On August 5, she sailed for the Mediterranean under the command of Commodore Truxton. Her armament was thirty-two 24-pounders, twenty-two 42-pound carronades (short, light cannon made of iron), and one long 18-pounder. She became Commo. Richard Dale's flagship in the Mediterranean, 1801/2; she took part in the action against Tripoli; and she continued in the Mediterranean until 1805. From 1809 to 1812 she cruised off the eastern coast of the United States during a period of increasingly strained relations with Great Britain. On May 16, 1811, before the War of 1812 had been declared, the *President,* now under the command of Commo. John Rodgers, briefly exchanged cannon fire with H.M.S. *Little Belt* after pursuing it for eight hours. The British vessel struck its colors. On September 23, 1813, the *President* captured H.B.M. schooner *High Flyer* but was then blockaded in New York by a British squadron. She remained trapped in New York's harbor until January 15, 1815, when under Capt. Stephen Decatur she made a dash for the sea. She was captured on the following day by H.B.M. *Endymion, Majestic, Pomone,* and *Tenedos.*

Five members of the Roux family of Marseilles were painters of ship portraits. Joseph Roux (1725–93) established a shop on the waterfront, where he published, manufactured, and sold charts, navigational instruments, and maritime gear and where he painted ships and nautical subjects. His son Ange Joseph Antoine Roux (Antoine Roux) (1765–1835) continued his father's occupations. He had three talented sons, Mathieu Antoine (Antoine),

François Joseph Frédéric (Frédéric), and François Geoffroi (François). Frédéric (1805–70) studied in the atelier Vernet at Paris. He attracted the attention of Admiral Willanmez, who commissioned him to paint forty watercolors (1827–28) of ships the admiral had either commanded or designed; most of these watercolors are in the Musée de la Marine, Paris. He did another series of twenty-three watercolors (1831) for the duke of Orleans. About 1835, he set up his studio at Le Havre.

François Geoffroi Roux (1811–82), youngest son of Antoine, also studied with the Vernets but returned to Marseilles to manage his father's shop. He was an active and talented ship painter. The highlight of his career was a series of paintings illustrating the development of naval and merchant vessels from the end of the eighteenth century. Some of these paintings are in the Louvre, and seventy-one are in the Musée de la Marine.

Antoine (the elder) is the painter whose work is most abundant in the United States. He was so popular with American shipowners and captains that, it is said, newly built ships not destined for the Mediterranean trade would still make a first voyage to Marseilles to have their portrait done by Roux before going on their way elsewhere.

Watercolor on paper; 19⅞ × 30⅜ in.
Signed at lower right "Ant. Roux a Marseilles, 1803–42—."
Inscribed at bottom "The U. States Frigate President. Richard Dale Commodore. Repair'd in Toulon. Attended by Stephen [illegible] the 12th of February 1802 [illegible]."
Acc. no. 57.786.
Reference: Smith (1978), *Artful Roux.*

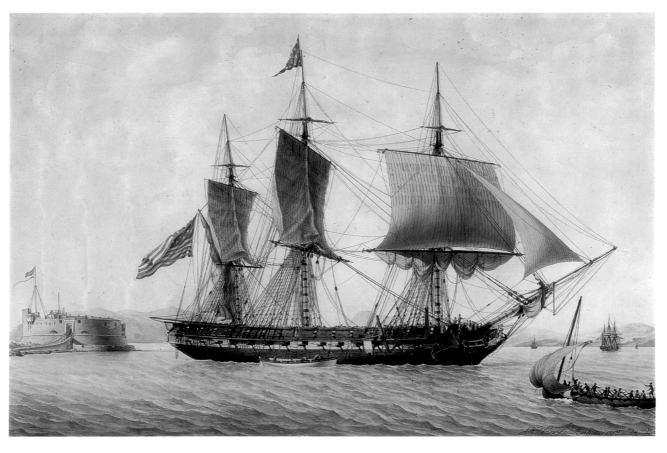

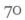

JOHN THOMAS SERRES (1759–1825)

The *Wasp,* an eighteen-gun sloop of war commanded by Capt. Johnston Blakeley for the United States Navy, sailed from Portsmouth, New Hampshire, on May 1, 1814, on a mission to destroy British shipping. She was a replacement for the first *Wasp,* which, on October 18, 1812, had taken the British brig *Frolic* only to be herself taken within two hours by the British seventy-four-gun frigate *Poictiers.*

The second *Wasp* sailed for the English Channel, where, on June 28, 1814, she met and engaged the British sloop of war *Reindeer.* The *Reindeer* had the initial advantage, firing for several minutes on the *Wasp* from a twelve-pound carronade mounted in her top-gallant forecastle before the *Wasp*'s guns could be brought to bear. Finding that the *Reindeer* was drawing gradually ahead, Captain Blakeley put his helm down and ran the *Wasp*'s jibboom into the *Reindeer*'s rigging; he then brought his own guns into action with great effect. The English, led by their commander, Capt. William R. Manners, made several desperate attempts to board the *Wasp* but were each time beaten back. The Americans then boarded the *Reindeer,* which struck her colors. According to James Fenimore Cooper in his history of the U.S. Navy,

It is difficult to say which vessel behaved the best, in this short but gallant combat. The officers and people of the Wasp discovered with the utmost steadiness, a cool activity, and an admirable discipline. For eleven minutes, they bore the fire of a twelve-pounder that was discharging round and grape, at a distance varying from 30 to 60 yards, with a subordination and quiet, that could not possibly be surpassed; and when

it did commence, their own fire was terrible. . . . On the other hand, the attack of the Reindeer has usually been considered the most creditable to the enemy of any that occurred in this war. [*A History of the United States Navy,* 2 vols. (Philadelphia: Lee & Blanchard, 1839), 2:286.]

The *Wasp* put into L'Orient to refit; then, on September 1, she cut a vessel out of a British convoy and sank the British brig of war *Avon.* On September 12, 14, and 21, she again captured valuable prizes. On October 9 off the Azores she spoke to a Swedish brig. She was never heard from again.

Fame is a lottery. Other captains and ships of the small American navy—Isaac Hull and the *Constitution,* Stephen Decatur and the *United States*—won victories and became legendary names in the navy. Captain Blakeley also was voted the thanks of Congress and a gold medal for his victory over the *Reindeer,* but he and his ship and crew disappeared at sea. The battle of the *Wasp* and the *Reindeer* was virtually forgotten and is a rare subject in the maritime paintings of the War of 1812.

John Thomas Serres, the elder of the two sons of Dominic Serres, both of whom were marine painters, was appointed draftsman to the admiralty and marine painter to George III in 1793, succeeding his father in the latter post. He had a successful career as an artist but died in debtors' prison, ruined by his wife's extravagance. Although the clean elegance of his watercolors speaks for itself, he and his father wrote a treatise on marine painting. Entitled *Liber Nauticus, and Instructor in the Art of Marine Drawing* (London, 1805), the folio volume is

filled with engravings of naval architecture and reproductions of Dominic Serres's work. Winterthur Museum owns one of the few copies known in the United States.

Commencement of Action on the Reindeer
Watercolor on paper; 14 × 18 in.
Unsigned.
Acc. no. 57.643.1.

Wasp with Gib Boom in the Reindeer's Lee Rigging
Watercolor on paper; 14¾ × 18¾ in.
Unsigned.
Acc. no. 57.643.2.

Vessels Are alongside Each Other
Watercolor on paper; 14³⁄₁₆ × 19 in.
Unsigned.
Acc. no. 57.643.3.

Hull of the Wasp in the Act of Sinking the Reindeer
Watercolor on paper; 14⅜ × 19 in.
Unsigned.
Acc. no. 57.643.4.

Reference: *Loubat (1878), Medallic History of America,* no. 38, pp. 200–202.

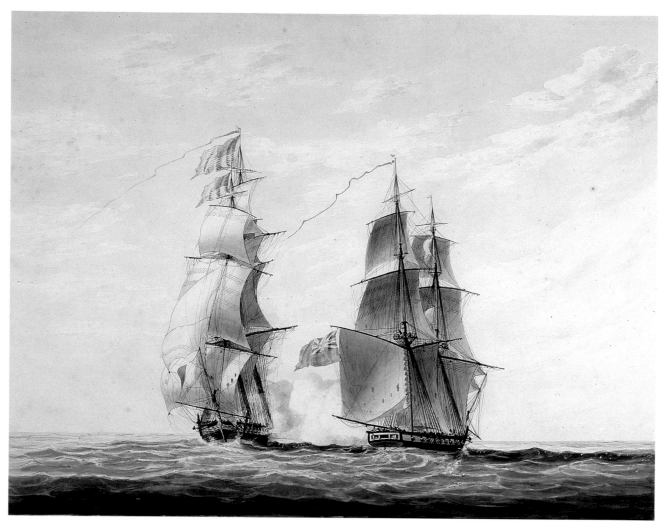

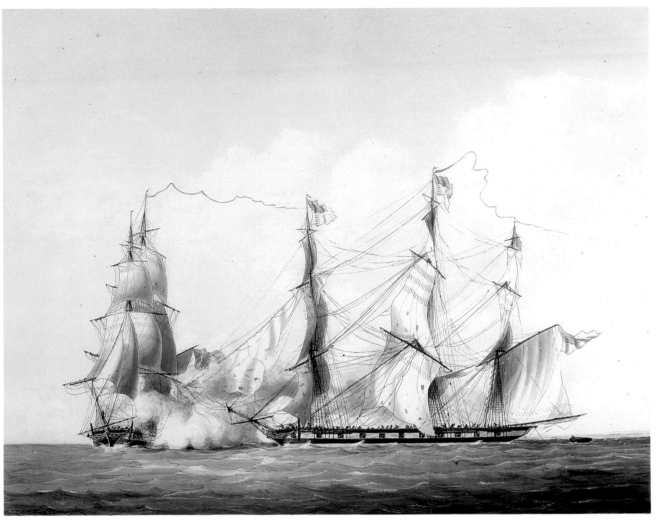
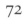

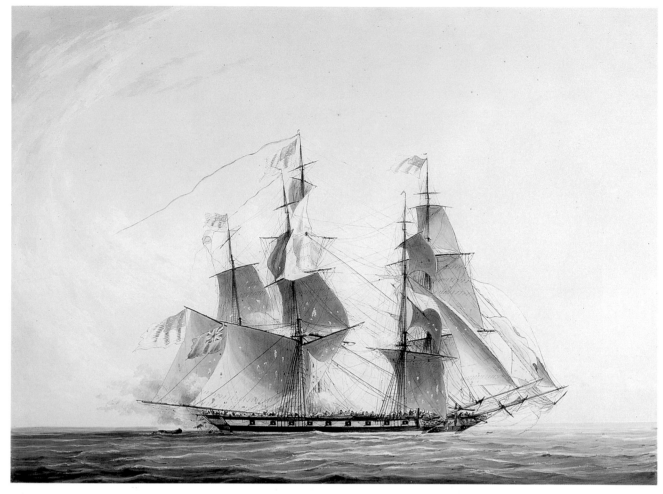

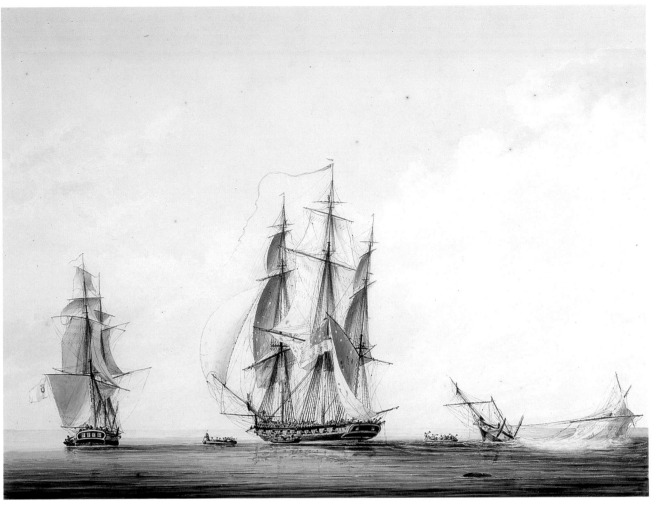

LOUIS GARNERAY (1783–1857)

75. The *Constitution* and the *Guerrière* (ca. 1818)

76. The *Frolic* and the *Wasp* (ca. 1818)

77. The *Hornet* and the *Peacock* (ca. 1818)

78. The Battle of Lake Champlain (ca. 1818)

79. The Battle of Lake Erie (ca. 1818)

80. The *United States* and the *Macedonian* (ca. 1818)

In the late 1920s a set of six paintings of naval battles in the War of 1812 appeared on the Paris art market. Framed in handsome empire-style moldings carved with American emblems, they formed an attractive ensemble that was especially appealing to H. F. du Pont's taste. Their earlier history—for whom they may have been painted and exactly when—remains unknown. The artist, Louis Garneray, is an obscure figure in French art, whose life has been little documented.

Born in 1783, Garneray was the oldest son of Parisian painter François Jean Garneray, who apparently gave him his earliest—and perhaps only—instruction in painting. At age thirteen Garneray joined the French navy, and in 1806 he fell captive to the British, who imprisoned him for nine years. Shortly after his release he won a contest for the post of marine painter to the duke of Angoulême, a victory that convinced him to paint full time. His work, dominated by maritime scenes, was often based upon contemporary engravings. Some of the battles shown here, for example, of which he could not have been an eyewitness, were depicted in a similar way in a set of four engravings printed in Paris. Garneray died in Paris in 1857, and his account of his life as a sailor was published in 1886 by Victor Tissot.

The six battles depicted in *The Constitution and the Guerrière* (August 19, 1812), *The Frolic and the Wasp* (October 18, 1812), *The Hornet and the Peacock* (February 24, 1813), *The Battle of Lake Champlain* (September 11, 1814), *The Battle of Lake Erie* (September 10, 1813), and *The United States and the Macedonian* (October 25, 1812) were famous naval actions in the War of 1812. Congress awarded gold medals of honor to captains Isaac Hull of the *Constitution,* Jacob Jones of the *Wasp,* Stephen Decatur of the *United States,* and James Lawrence of the *Hornet;* it awarded medals also for the fleet action on Lake Champlain—to Thomas Macdonough, who commanded the fleet, Robert Henley of the *Eagle,* and Stephen Cassin of the *Ticonderoga*—and for the battle of Lake Erie to Oliver Hazard Perry, the commander in chief, and to Jesse Duncan Elliott, the second in command. The Cassin gold medal is in the Winterthur collections.

These victories at sea were particularly sweet to the Americans, who had so far been humiliated by defeats on land. At the commencement of the war, the British navy, the most famous in the world, had as many as 1,060 vessels under sail, of which perhaps 800 were in commission. The United States entered the war with something between 16 and 18 warships. Its ships were soon bottled up in port by the overwhelming strength of its opponent, but before that happened the Americans gave a most gallant account of themselves. Particularly propitious were the victories of Lake Champlain and Lake Erie, which secured the American frontier against Canada and won control of the Great Lakes and the Old Northwest for the United States.

Constitution and Guerrière
Oil on canvas; 20 × 27⅝ in.
Signed at lower left "L. Garneray 1818."
Acc. no. 57.1404.

Frolic and Wasp
Oil on canvas; 19⅞ × 27¾ in.
Unsigned.
Acc. no. 57.1406.

Hornet and Peacock
Oil on canvas; 19¾ × 28 in.
Unsigned.
Acc. no. 57.1403.

Battle of Lake Champlain
Oil on canvas; 21⅛ × 32⅛ in.
Unsigned.
Acc. no. 57.1402.

Battle of Lake Erie
Oil on canvas; 20¹⁵⁄₁₆ × 32³⁄₁₆ in.
Unsigned.
Acc. no. 57.1405.

United States and Macedonian
Oil on canvas; 19⅞ × 28⅛ in.
Unsigned.
Acc. no. 57.1401.

References: Olds (1951), *Bits and Pieces of American History*, pp. 117, 133, 146; Smith (1974), *American Naval Broadsides*, p. 218; M. Knoedler and Co. (undated), *Louis Garneray, 1783–1857, American Battle Scenes*, n.p.

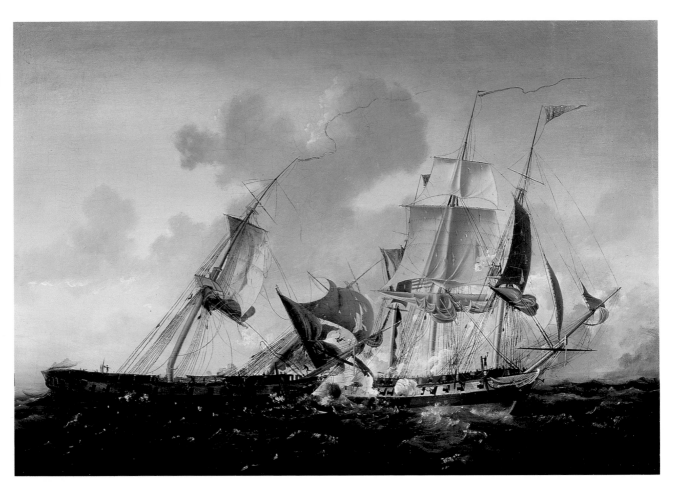

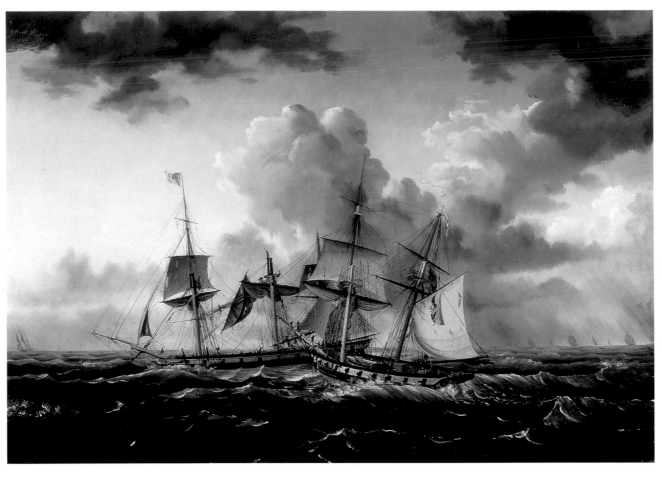

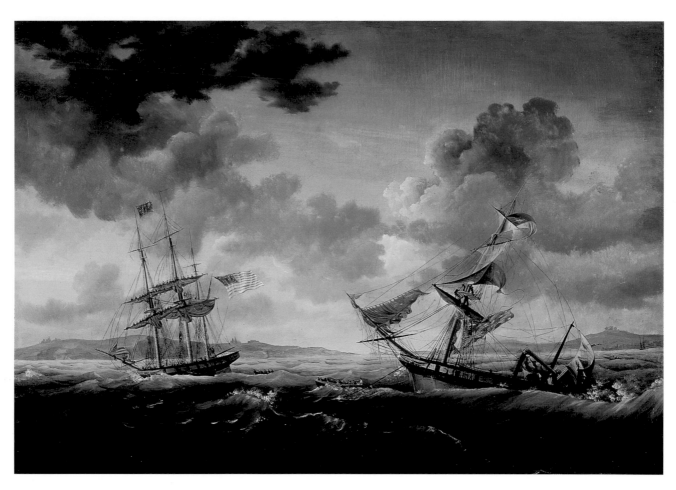

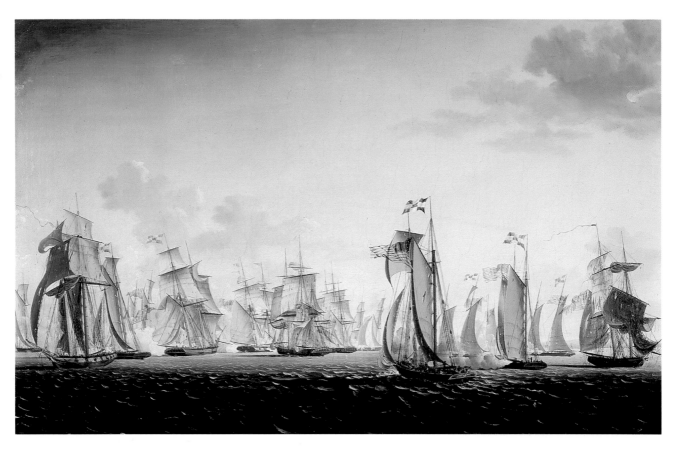

Bibliography

Alberts, Robert C. *Benjamin West: A Biography.* Boston: Houghton Mifflin Co., 1978.

Ayres, James. "Edward Hicks and His Sources." *Antiques* 109 (February 1976): 366–68.

Balch, Thomas. *Letters and Papers Relating Chiefly to the Provincial History of Pennsylvania, with Some Notices of the Writers.* Philadelphia: Crissy & Markley, 1855.

Baltimore. Museum of Art. *A Century of Baltimore Collecting, 1840–1940.* Baltimore: Museum of Art, 1941.

———. *The Baltimore Antiques Show, 1984.* Baltimore: Museum of Art, 1984. "Nicolino Calyo's *A View of the Port of Baltimore*" by Sona K. Johnston.

———. *Two Hundred and Fifty Years of Painting in Maryland.* Baltimore: Museum of Art, 1945. "A Survey of Painting in Maryland" by J. Hall Pleasants, pp. 5–13.

Baur, John I. H. "The Peales and the Development of American Still Life." *Art Quarterly* 3 (Winter 1940): 81–92.

Bayley, Frank W. *The Life and Works of John Singleton Copley, Founded on the Work of Augustus Thorndike Perkins.* Boston: Taylor Press, 1915.

———. *A Sketch of the Life and a List of Some of the Works of John Singleton Copley.* Boston: Garden Press, 1910.

Belknap, Waldron Phoenix, Jr. *American Colonial Painting: Materials for a History.* Cambridge, Mass.: Harvard University Press, Belknap Press, 1959.

Biddle, Edward, and Mantle Fielding. *The Life and Works of Thomas Sully, [1783–1872].* Philadelphia, 1921.

Black, Mary C. "Pieter Vanderlyn and Other Limners of the Upper Hudson." In *American Painting to 1776: A Reappraisal,* edited by Ian M. G. Quimby, pp. 217–49. Charlottesville: University Press of Virginia, 1971.

Blanton, Wyndham B. *Medicine in Virginia in the Eighteenth Century.* Richmond: Garret & Massie, 1931.

Bolton, Theodore. *Early American Portrait Draughtsmen in Crayons.* 1923. Reprint. New York: Kennedy Graphics, 1970.

———, and George C. Groce, Jr. "John Hesselius: An Account of His Life and the First Catalogue of His Portraits." *Art Quarterly* 2 (Winter 1939): 77–91.

Boston. Museum of Fine Arts. *John Singleton Copley, 1738–1815.* Loan Exhibition of Paintings, Pastels, Miniatures, and Drawings. Boston: Museum of Fine Arts, 1938.

Bowen, Clarence Winthrop, ed. *The History of the Centennial Celebration of the Inauguration of George Washington as First President of the United States.* New York: D. Appleton, 1892.

Brooklyn Museum Quarterly. 1917.

Bulletin of the Metropolitan Museum of Art. 1936.

Burroughs, Alan. "Three Portraits by Matthew Pratt." *Art in America* 40 (Spring 1952): 93–98.

Bye, Arthur Edwin. "Edward Hicks, Painter-Preacher." *Antiques* 29 (January 1936): 13–16.

Colwill, Stiles Tuttle. *Francis Guy, 1760–1820.* Baltimore: Maryland Historical Society, 1981.

Cooper, Helen A., et al. *John Trumbull: The Hand and Spirit of a Painter.* New Haven: Yale University Art Gallery, 1982.

Copley-Pelham Letters. See *Letters and Papers of John Singleton Copley and Henry Pelham, 1739–1776.*

Cordingly, David. *Marine Painting in England, 1700–1900.* New York: Clarkson N. Potter, 1974.

Craven, Wayne. "John Wollaston: His Career in England and New York City." *American Art Journal* 7 (November 1975): 19–31.

Dickason, David H. "Benjamin West on William Williams: A Previously Unpublished Letter." In *Winterthur Portfolio 6,* edited by Richard K. Doud and Ian M. G. Quimby, pp. 127–33. Charlottesville: University Press of Virginia, 1970.

———. *William Williams, Novelist and Painter of Colonial America, 1727–1791.* Bloomington and London: Indiana University Press, 1970.

Dickson, Harold E. *Arts of the Young Republic: The Age of William Dunlap.* Chapel Hill: University of North Carolina Press, 1968.

Dillenberger, John. *Benjamin West: The Context of His Life's Work, with Particular Attention to Paintings with Religious Subject Matter.* San Antonio: Trinity University Press, 1977.

Doud, Richard K. "John Hesselius: His Life and Work." Master's thesis, University of Delaware, 1963.

———. "John Hesselius, Maryland Limner." In *Winterthur Portfolio 5,* edited by Richard K. Doud, pp. 129–53. Charlottesville: University Press of Virginia, 1969.

Dresser, Louisa. "Edward Savage, 1761–1817." *Art in America* 40 (Autumn 1952): 157–212.

Dunlap, William. *History of the Rise and Progress of the Arts of Design in the United States.* 2 vols. New York: G. P. Scott, 1834.

Egbert, Donald Drew. "General Mercer at the Battle of Princeton as Painted by James Peale, Charles Willson Peale, and William Mercer." *Princeton University Library Chronicle* 13 (Summer 1952): 171–94.

Eisen, Gustavus A. *Portraits of Washington.* 3 vols. New York: Robert Hamilton, 1932.

Ewers, John C. "'Chiefs from the Missouri and Mississippi' and Peale's Silhouettes of 1806." *Smithsonian Journal of History* 1 (Spring 1966): 1–26.

Flexner, James Thomas. "The Amazing William Williams: Painter, Author, Teacher, Musician, Stage Designer, Castaway." *Magazine of Art* 37 (November 1944): 242–46.

———. *First Flowers of Our Wilderness, American Painting.* Boston: Houghton Mifflin Co., 1947.

———. *John Singleton Copley.* Boston: Houghton Mifflin Co., 1948.

Foley, William E., and Charles David Rice. "Visiting the President: An Exercise in Jeffersonian Indian Diplomacy." *American West* 16 (November–December 1979): 4–15.

Foote, Henry Wilder. *John Smibert, Painter.* With a Descriptive Catalogue of Portraits and Notes on the Work of Nathaniel Smibert. Cambridge, Mass.: Harvard University Press, 1950.

———. *Robert Feke, Colonial Portrait Painter.* Cambridge, Mass.: Harvard University Press, 1930.

Ford, Alice. *Edward Hicks, 1780–1849.* A Special Exhibition Devoted to His Life and Work with an Introduction and Chronology by Alice Ford. Abby Aldrich Rockefeller Folk Art Collection, Williamsburg, Va., September 30–October 30, 1960.

Frankenstein, Alfred. *The World of Copley, 1738–1815.* New York: Time-Life Books, 1970.

Gardner, Albert Ten Eyck, and Stuart P. Feld. *American Paintings: A Catalogue of the Collection of the Metropolitan Museum of Art. I. Painters Born by 1815.* Greenwich, Conn.: Distributed by New York Graphic Society, 1965.

Groce, George C. "John Wollaston (Fl. 1736–1767): A Cosmopolitan Painter in the British Colonies." *Art Quarterly* 15 (Summer 1952): 133–49.

Harding, Anneliese E. *J. L. Krimmel, Genre Painter of the Early Republic.* Forthcoming.

Harris, John. *The Artist and the Country House: A History of Country House and Garden View Painting in Britain, 1540–1870.* London: Sotheby Parke Bernet, 1979.

Hart, Charles Henry. "Gilbert Stuart's Portraits of Men. I. George Washington." *Century* (February 1902): 509.

Herring, James, and James B. Longacre. *The National Portrait Gallery of Distinguished Americans.* 4 vols. New York: Monson Bancroft, and Philadelphia: Henry Perkins, 1834–39.

Historical Society of Pennsylvania. Thomas Sully's register of paintings, 1801–1871.

Hood, Graham. *Charles Bridges and William Dering: Two Virginia Painters, 1735–1750.* Williamsburg: Colonial Williamsburg Foundation, 1978. Distributed by University Press of Virginia.

Hoppin, Martha J. *The Emmets: A Family of Women Painters.* Pittsfield, Mass.: Berkshire Museum, 1982.

Hubbard, R. H., ed. *Thomas Davies, ca. 1737–1812.* An Exhibition Organized by the National Gallery of Canada, Ottawa. Ottawa: National Gallery of Canada, 1972.

Jaffe, Irma B. *John Trumbull, Patriot-Artist of the American Revolution.* Boston: New York Graphic Society, 1975.

Johnson, Mary. "Victorine du Pont: Heiress to the Educational Dream of Pierre Samuel du Pont de Nemours." *Delaware History* 19 (Fall–Winter 1980): 88–105.

Johnston, Christopher. "Lloyd Family." *Maryland Historical Magazine* 7 (December 1912): 420–30.

Johnston, Elizabeth Bryant. *Original Portraits of Washington, Including Statues, Monuments, and Medals.* Boston: James R. Osgood, 1882.

Jolly, Pierre. *Du Pont de Nemours, Apostle of Liberty and the Promised Land.* Translated by Elise du Pont Elrick. Wilmington, Del.: Brandywine Publishing Co., 1977.

Kaynor, Fay Campbell. "Thomas Tileston Waterman: Student of American Colonial Architecture." *Winterthur Portfolio* 20 (Summer/Autumn 1985): 104–47.

Kenny, Alice P. *The Gansevoorts of Albany: Dutch Patricians in the Upper Hudson Valley.* Syracuse: Syracuse University Press, 1969.

Klein, Randolph Shipley. *Portrait of an Early American Family: The Shippens of Pennsylvania across Five Generations.* Philadelphia: University of Pennsylvania Press, 1975.

Knoedler, M., and Co. *Louis Garneray, 1783–1857: American Battle Scenes.* New York: M. Knoedler, 194–.

Koke, Richard J. "Forcing the Hudson River Passage, October 9, 1776." *New-York Historical Society Quarterly* 36 (October 1952): 459–66.

Letters and Papers of John Singleton Copley and Henry Pelham, 1739–1776. Massachusetts Historical Society Collections, vol. 71. Edited by the Committee of Publication (Charles Francis Adams, Guernsey Jones, and Worthington Chauncey Ford). Boston: Massachusetts Historical Society, 1914. (Cited as *Copley-Pelham Letters.*)

Lockwood, Luke Vincent. "The St. Memin Indian Portraits." *New-York Historical Society Quarterly Bulletin* 12 (April 1928): 3–26.

London. Royal Academy of Arts. *Andrew Wyeth.* London: Royal Academy, 1980.

Loubat, J. F. *The Medallic History of the United States of America, 1776–1876.* 2 vols. New York: By the author, 1878.

McNamara, Brooks. "David Douglass and the Beginnings of American Theater Architecture." In *Winterthur Portfolio 3,* edited by Milo M. Naeve, pp. 112–35. Winterthur, Del.: Winterthur Museum, 1967.

Marks, Arthur S. "Benjamin West and the American Revolution." *American Art Journal* 6, no. 2 (November 1974): 15–35.

Mason, George C. *The Life and Works of Gilbert Stuart.* New York: Charles Scribner's Sons, 1879.

Mather, Eleanore Price. *Edward Hicks: His Peaceable Kingdoms and Other Paintings.* Newark: University of Delaware, 1983.

Monaghan, Frank. *John Jay, Defender of Liberty.* Indianapolis: Bobbs-Merrill, 1935.

Mooz, R. Peter. "The Art of Robert Feke." Ph.D. dissertation, University of Pennsylvania, 1970.

Morgan, John Hill. *Early American Painters, Illustrated by Examples in the Collection of the New-York Historical Society.* New York: New-York Historical Society, 1921.

———, and Mantle Fielding. *The Life Portraits of Washington and Their Replicas.* Philadelphia: Privately printed, 1931.

Mount, Charles Merrill. *Gilbert Stuart, a Biography.* New York: W. W. Norton, 1964.

New York. Metropolitan Museum of Art. *Benjamin Franklin and His Circle.* A Catalogue of an Exhibition at the Metropolitan Museum of Art, New York, from May 11 through September 13, 1936. New York: Plantin Press, 1936.

Newark. Newark Museum. *American Art in the Newark Museum: Paintings, Drawings, and Sculpture.* Newark: By the museum, 1981.

Norfleet, Fillmore. *Saint-Mémin in Virginia: Portraits and Biographies.* Richmond: Dietz Press, 1942.

Olds, Irving S. *Bits and Pieces of American History.* New York: By the author, 1951.

Oliver, Andrew. *Faces of a Family: An Illustrated Catalogue of Portraits and Silhouettes of Daniel Oliver, 1664–1732, and Elizabeth Belcher, His Wife, Their Oliver Descendants and Their Wives, Made between 1727 and 1850.* Portland, Maine: Privately printed, 1960.

Park, Lawrence, comp. *Gilbert Stuart: An Illustrated Descriptive List of His Works.* 4 vols. New York: William Edwin Rudge, 1926.

Parker, Barbara Neville, and Anne Bolling Wheeler. *John Singleton Copley: American Portraits in Oil, Pastel, and Miniature, with Biographical Sketches.* Boston: Museum of Fine Arts, 1938.

Pennsylvania Archives. Series 3.

Perkins, Augustus Thorndike. *A Sketch of the Life and a List of Some of the Works of John Singleton Copley.* Boston: Privately printed, 1873.

Philadelphia Museum of Art. *Benjamin West, 1738–1820.* Philadelphia: Pennsylvania Museum of Art, 1938.

Piwonka, Ruth, and Roderick H. Blackburn. *A Remnant in the Wilderness.* Annandale-on-Hudson, N.Y.: Bard College Center, 1980.

Pleasants, J. Hall. "Francis Guy—Painter of Gentlemen's Estates." *Antiques* 65 (April 1954): 288–90.

———. "A Survey of Painting in Maryland." In *Two Hundred and Fifty Years of Painting in Maryland,* by the Museum of Art, Baltimore, pp. 5–13. Balti-

more: Museum of Art, 1945.

Pollock, Thomas Clark. *The Philadelphia Theatre in the Eighteenth Century.* Philadelphia: University of Pennsylvania Press, 1933.

Port Folio. 1803.

Prime, Alfred Coxe, comp. *The Arts and Crafts in Philadelphia, Maryland, and South Carolina . . . Gleanings from Newspapers.* 2 vols. Series 1. *1721–1785.* [Topsfield, Mass.]: Walpole Society, 1929. Series 2. *1786–1800.* [Topsfield, Mass.]: Walpole Society, 1932.

Prown, Jules David. *John Singleton Copley.* Vol. 1. *In America, 1738–1774.* Cambridge, Mass.: Harvard University Press, 1966. (Cited as *John Singleton Copley in America.*)

Richardson, Edgar P. "Copley's Portrait of Mrs. Roger Morris: I. Copley's New York Portraits." In *Winterthur Portfolio 2,* edited by Milo M. Naeve, pp. 1–13. Winterthur, Del.: Winterthur Museum, 1965.

———. "A Penetrating Characterization of Washington by John Trumbull." In *Winterthur Portfolio 3,* edited by Milo M. Naeve, pp. 1–23. Winterthur, Del.: Winterthur Museum, 1967.

———. "William Williams—A Dissenting Opinion." *American Art Journal* 4 (Spring 1972): 5–23.

Robbins, Christine Chapman. *David Hosack: Citizen of New York.* Philadelphia: American Philosophical Society, 1964.

Rush, Benjamin. *The Autobiography of Benjamin Rush: His "Travels through Life" Together with His Commonplace Book for 1789–1813.* Edited with Introduction and Notes by George W. Corner. 1948. Reprint. Westport, Conn.: Greenwood Press, 1970.

Rutledge, Anna Wells. *Artists in the Life of Charleston through Colony and State from Restoration to Reconstruction.* Philadelphia: American Philosophical Society, 1949.

———. "Henry Benbridge (1743–1812?), American Portrait Painter." *American Collector* 17 (October 1948): 8–10; pt. 2, 17 (November 1948): 9–11.

Scharf, J. Thomas, and Thompson Westcott. *History of Philadelphia, 1609–1884.* 3 vols. Philadelphia: L. H. Everts, 1884.

Schmiegel, Karol A. "Encouragement Exceeding Expectation: The Lloyd-Cadwalader Patronage of Charles Willson Peale." In *Winterthur Portfolio 12,* edited by Ian M. G. Quimby, pp. 87–102. Charlottesville: University Press of Virginia, 1977.

———. "Pastel Portraits in the Winterthur Museum."

Antiques 107 (February 1975): 323–31.

Sellers, Charles Coleman. *Charles Willson Peale.* New York: Charles Scribner's Sons, 1969.

———. *Charles Willson Peale.* Vol. 3. *Portraits and Miniatures by Charles Willson Peale.* Philadelphia: American Philosophical Society, 1952.

———. *Charles Willson Peale with Patron and Populace.* A Supplement to "Portraits and Miniatures by Charles Willson Peale," with a Survey of His Work in Other Genres. Philadelphia: American Philosophical Society, 1969.

Simmons, Richard C. "Copley's Portrait of Mrs. Roger Morris: II. Mrs. Morris and the Philipse Family, American Loyalists." In *Winterthur Portfolio 2,* edited by Milo M. Naeve, pp. 14–26. Winterthur, Del.: Winterthur Museum, 1965.

Sizer, Theodore. "A Portrait of the Mysterious Sarah Trumbull." In *Winterthur Portfolio 2,* edited by Milo M. Naeve, pp. 139–41. Winterthur, Del.: Winterthur Museum, 1965.

———. *The Works of Colonel John Trumbull, Artist of the American Revolution.* Rev. ed. New Haven: Yale University Press, 1967.

———, ed. *The Autobiography of Colonel John Trumbull, Patriot-Artist, 1756–1843.* New Haven: Yale University Press, 1953.

Smibert, John. *The Notebook of John Smibert.* With Essays by Sir David Evans, John Kerslake, and Andrew Oliver, and with Notes Relating to Smibert's American Portraits by Andrew Oliver. Boston: Massachusetts Historical Society, 1969.

Smith, Edgar Newbold. *American Naval Broadsides: A Collection of Early Naval Prints (1745–1815).* New York: Clarkson N. Potter, 1974.

Smith, Helen Burr. "John Mare (1739–c. 1795), New York Portrait Painter, with Notes on the Two William Williams'." *New-York Historical Society Quarterly* 35 (October 1951): 355–99.

Smith, Philip Chadwick Foster. *The Artful Roux: Marine Painters of Marseille.* Salem: Peabody Museum of Salem, 1978.

Smith, Robert C. "*Liberty Displaying the Arts and Sciences:* A Philadelphia Allegory by Samuel Jennings." In *Winterthur Portfolio 2,* edited by Milo M. Naeve, pp. 84–105. Winterthur, Del.: Winterthur Museum, 1965.

———. "A Philadelphia Allegory." *Art Bulletin* 31 (December 1949): 323–26.

Sotheby Parke Bernet, New York, Sale 5141, January 26, 27, 1984, lot no. 358.

Stebbins, Theodore E., Jr. *American Master Drawings*

and Watercolors: A History of Works on Paper from Colonial Times to the Present. New York: Harper & Row, 1976.

Stewart, Robert G. Henry Benbridge (1743–1812): American Portrait Painter. Washington, D.C.: Smithsonian Institution Press, 1971.

Stokes, I. N. Phelps. The Iconography of Manhattan Island, 1498–1909. 6 vols. New York: Robert H. Dodd, 1915–28.

————, and Daniel C. Haskell. American Historical Prints, Early Views of American Cities, etc., from the Phelps Stokes and Other Collections. New York: New York Public Library, 1932.

Stoner, Joyce Hill, et al. "A Portrait by C. W. Peale Restored by C. Volkmar: Techniques of an 18th-Century Artist and a 19th-Century Restorer." Preprints 1979.

Sweeney, John A. H. "Further Identification of Portrait." Winterthur Newsletter 3 (January 23, 1957): 2.

Third Annual Exhibition of the Columbian Society of Artists and the Pennsylvania Academy, 1813. Philadelphia: T. & G. Palmer, 1813.

Thomas, Ralph W. "William Johnston, Colonial Portrait Painter." New Haven Colony Historical Society Journal 4 (March 1955): 4–8.

Tolles, Frederick B. "The Primitive Painter as Poet (with an Attempted Solution of an Iconographical Puzzle in Certain of Edward Hicks's Peaceable Kingdoms)." Bulletin of Friends Historical Association 50 (Spring 1961): 12–30.

Wainwright, Nicholas B., comp. Paintings and Miniatures at the Historical Society of Pennsylvania. Rev. ed. Philadelphia: Historical Society of Pennsylvania, 1974.

Walpole, Horace. Anecdotes of Painting in England. 3d ed. London: Printed for J. Dodsley, Pall-Mall, 1782.

Warren, Phelps. "Badger Family Portraits." Antiques 118 (November 1980): 1043–47.

Washington, D.C. National Portrait Gallery. A Nineteenth-Century Gallery of Distinguished Americans. Washington, D.C.: Smithsonian Institution Press, 1969.

Waterman, Thomas Tileston. The Mansions of Virginia, 1706–1776. Chapel Hill: University of North Carolina, 1946.

Wharton, Anne Hollingsworth. Salons Colonial and Republican. Philadelphia and London: J. B. Lippincott Co., 1900.

Wheeler, Robert G. "The Albany of Magdalena Douw." In Winterthur Portfolio 4, edited by Richard K. Doud, pp. 63–74. Charlottesville: University Press of Virginia, 1968.

————. "Hudson Valley Religious Paintings." Antiques 63 (April 1953): 346–50.

Whitley, William T. Gilbert Stuart. Cambridge, Mass.: Harvard University Press, 1932.

Williams, Hermann Warner. Mirror to the American Past: A Survey of American Genre Painting, 1750–1900. Greenwich, Conn.: New York Graphic Society, 1973.

Wilson, Arnold. A Dictionary of British Marine Painters. Leigh-on-Sea, England: F. Lewis, 1967.

Wolf, Edwin, 2nd. "The Library of Edward Lloyd of Wye House." In Winterthur Portfolio 5, edited by Richard K. Doud, pp. 87–121. Charlottesville: University Press of Virginia, 1969.

Wollon, Dorothy, ed. "Sir Augustus J. Foster and 'The Wild Natives of the Woods,' 1805–1807." William and Mary Quarterly, 3d ser., 9 (April 1952): 191–214.